CONTEMPORARY
WINDOWS

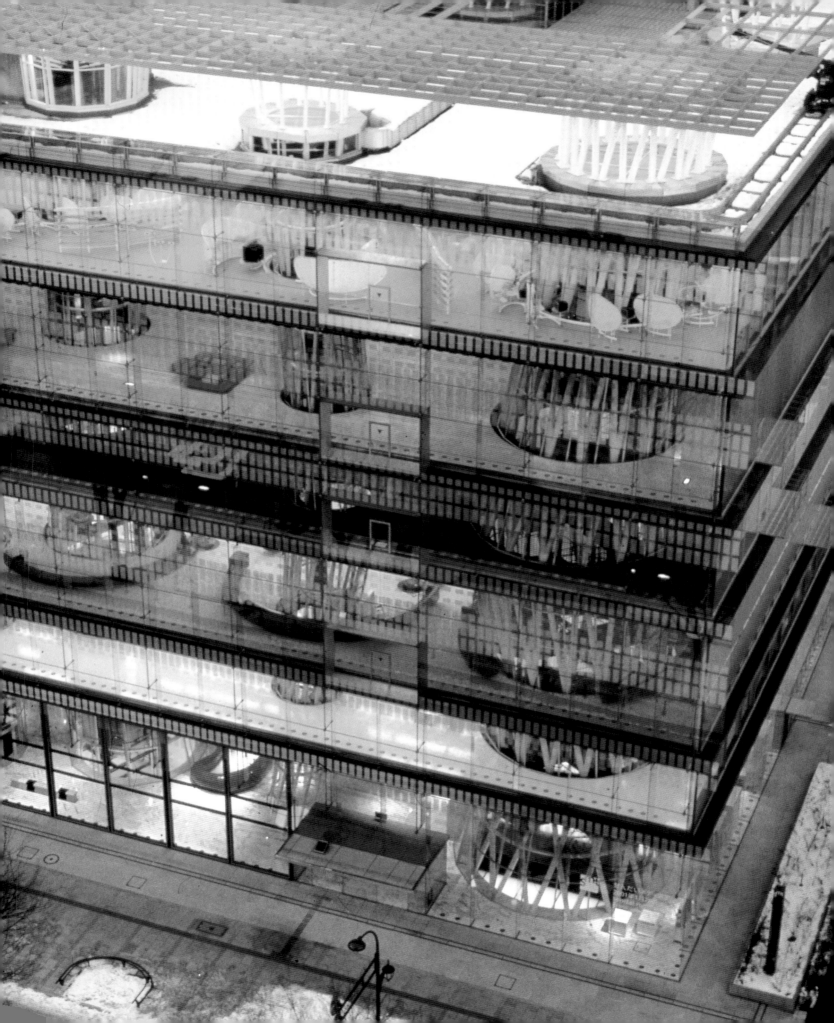

CONTEMPORARY WINDOWS

AMANDA BAILLIEU

MITCHELL BEAZLEY

CONTEMPORARY WINDOWS

AMANDA BAILLIEU

Copyright © Octopus Publishing Group Ltd 2003

First published in Great Britain in 2003 by Mitchell Beazley,
an imprint of Octopus Publishing Group Ltd,
2–4 Heron Quays, Docklands, London E14 4JP

Commissioning Editor **Mark Fletcher**
Executive Editor **Hannah Barnes-Murphy**
Art Director **Vivienne Brar**
Project Editor **Emily Asquith**
Editor **Kirsty Seymour-Ure**
Designer **Colin Goody**
Production **Kieran Connelly**
Picture Research **Helen Stallion**
Proof Reader **Joan Porter**
Indexer **Richard Bird**

A CIP catalogue record for this book is
available from the British Library

ISBN 1 84000 638 2

Set in Helvetica and AvantGarde
Produced by Toppan Printing Co., (HK) Ltd.
Printed and bound in China

title page *Mediatheque, Sendai, Japan, by Toyo Ito*

contents page *Bibliothèque Nationale de France, Paris, by Dominique Perrault*

page 6 *Inigo Jones's Banqueting House (1619–21) in London was part of James I's ambitious plans for the rebuilding of Whitehall. Directly influenced by Palladio, it bore no resemblance to anything ever before built in England. The windows are particularly intricate, crowned by alternating segmental and triangular pediments on brackets separated by Ionic columns. In 1685 the original windows were stripped out and replaced with sashes.*

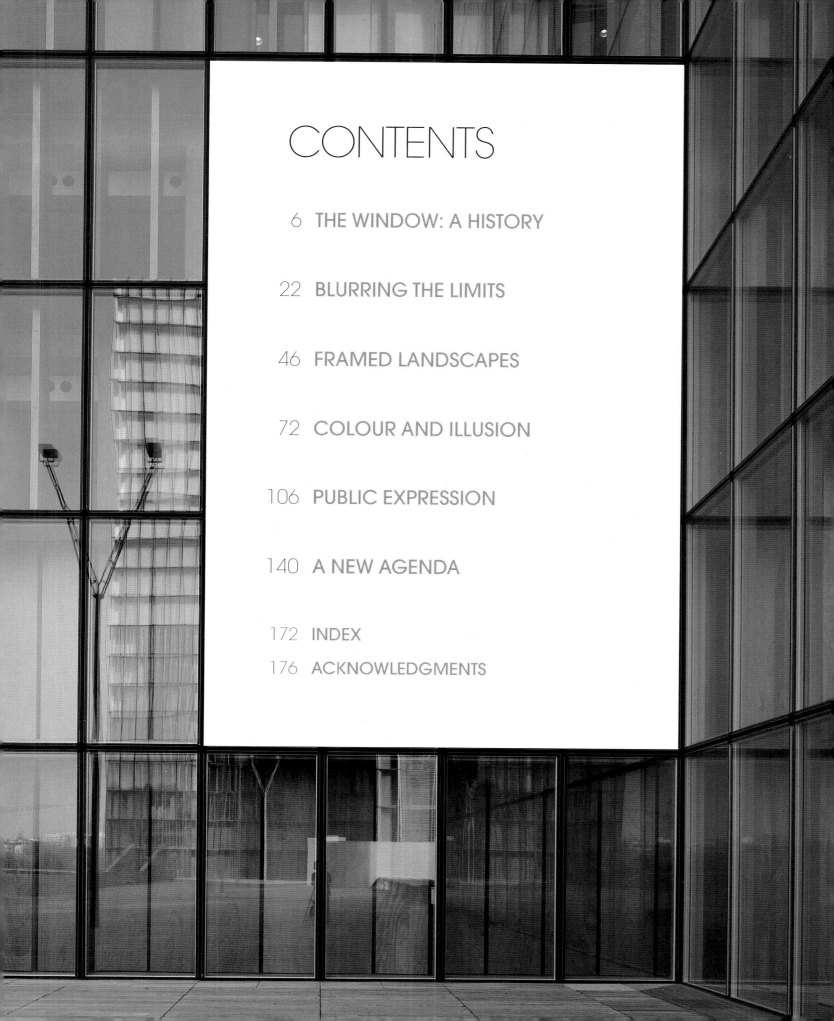

CONTENTS

THE WINDOW: A HISTORY

In literature as in painting, the window is a motif used to alter a mood or change a sentiment – a symbol of an enclosed space abruptly separated from the world that lies beyond.

Van Gogh's view of a window in the mental hospital at St-Rémy could hardly be confused, despite its sunny atmosphere, with the cheerful window views of Matisse, but becomes rather a record of a private experience in which every detail – the bottles in front of the window, the pictures on the wall – seems a projection of the artist's personality or state of mind.

The window is also a familiar metaphor – Elizabeth I's remark that she "did not want to make windows into men's souls" is a succinct explanation of the religious tolerance of her reign – while for the Romantic poets, windows were "magic casements", symbols of dreams and yearning. Beyond the window, life is somehow better.

In a more contemporary work, Philip Larkin's poem "High Windows", the window symbolizes regret and emptiness. The window is a view out to a sort of radiant nothingness, perhaps Larkin's view of approaching old age and death.

As well as a place for looking out, the window is a place for looking in. Unlike with a painting, which is an opening onto another reality, in the early days of window panes looking through the window was a form of peep show – but the reality is fixed. As Alan Macfarlane and Gerry Martin point out in *The Glass Bathyscaphe*, "for richer Europeans, houses became like camera lenses or peep shows: one sat in muted light and looked out on the richness of colour. Or, as in Dutch interiors, one looked into rooms filled with light through the windows".

Spying is an extension of peering through the window into someone else's home. Alfred Hitchcock's film *Rear Window* centres on what can – or cannot – be seen through a living-room window, but the director turned conventional ideas about openness and visibility on their head, using the window to suggest voyeurism, confusion, and intrigue.

For painters the window is a way of expressing spatial depth or of framing the sitter. Artists such as Vermeer captured light filtering through the leaded windows of prosperous Dutch interiors. But perhaps the most significant role of the window was in the development of perspective. For those who wanted to perfect the art, Leonardo da Vinci recommended using a pane of glass: "Fix your head with a device so you cannot move at all",

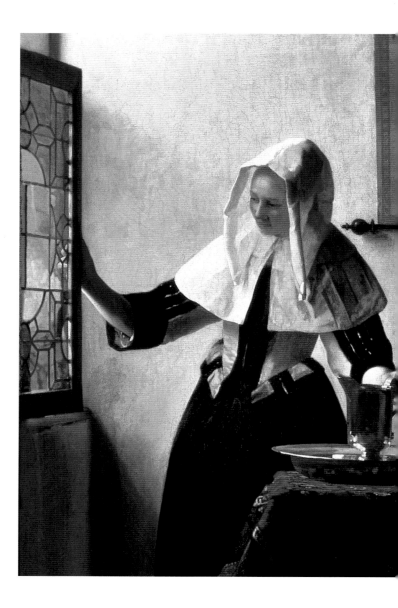

he wrote, then mark on the glass "what you see beyond it", tracing the resultant image onto paper from the glass. In other words, looking through the window put the world in perspective and it was simply a matter of perseverance before the artist caught up.

The relationship of architects with the window is no less complex. Just as it has for writers and artists, the window can have a symbolic role for building designers, but for them it also has to perform the triple function of providing light, ventilation, and views within the limits of the available technology. In Genesis, Noah was instructed to include just one window in the Ark, with dimensions of 46 centimetres (18 inches) square. Such precise instructions were almost certainly imposed by the Ark's building material – wood – and the method of construction. Another window and the Ark might not have lasted forty days and forty nights.

above *Johannes Vermeer, Young Woman with a Water Pitcher, c.1664–5. Vermeer successfully captures the sense of light filtering through leaded windows and the way that it interacts with the objects in the room, binding them together.*

right *Chartres Cathedral, north transept rose window. In Gothic architecture pictorial art is almost entirely confined to the tapestries of light that are the windows.*

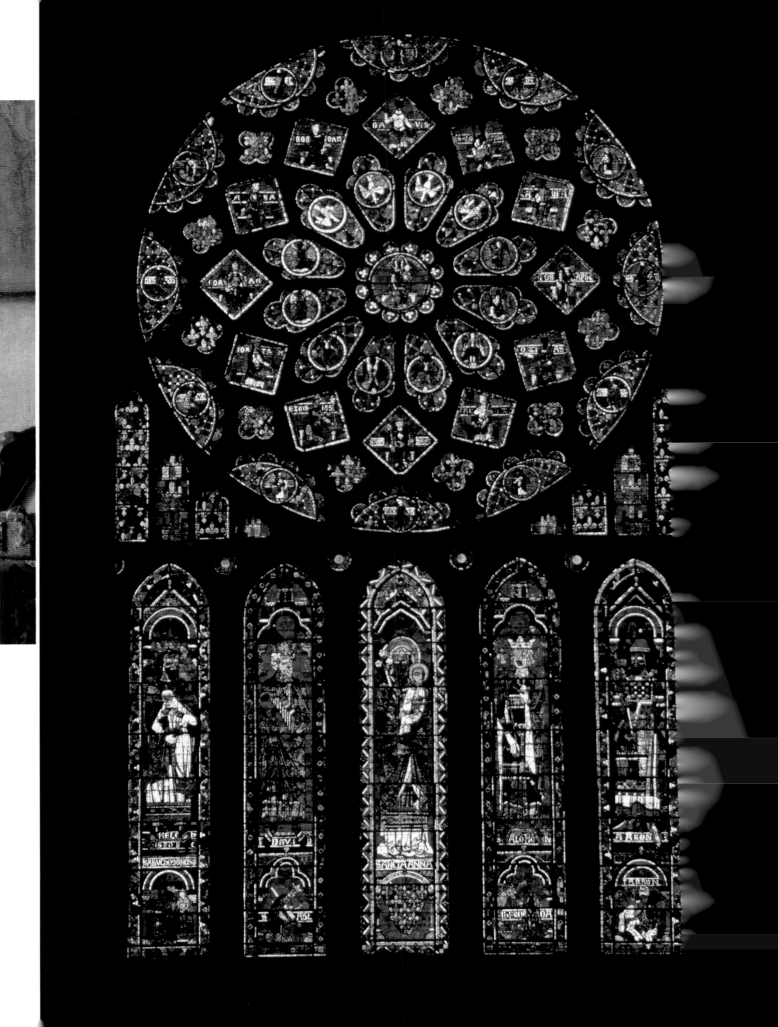

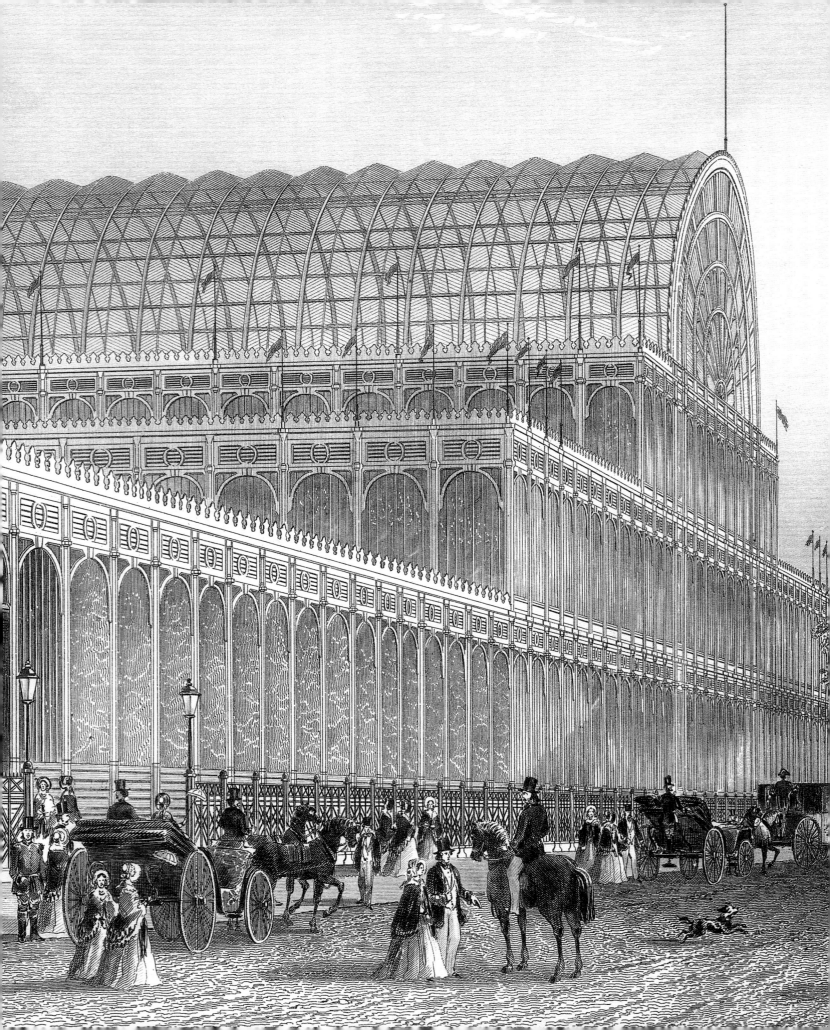

The English word "window" derives from the Old Icelandic *vindauga*, meaning "wind eye", literally an opening protected by a lattice of reeds or withes. In its crudest form the window was simply a modification of the doorway and another way of letting light into the building while still offering some protection from the weather. Other materials were also used in those first Northern European windows: thin parchment from the skin of sheep or goats, thin shavings of horn, paper oiled with linseed – anything in fact so long as it was translucent enough to admit light. Such alternatives to glass were also cheaper and this fact, coupled with the warm Mediterranean climate, also helps to explain why windows progressed in Northern Europe while the Greeks, who designed for the heat, developed a sophisticated architecture based on porticoes and colonnades, and the Moors and Spaniards built around shaded interior courtyards with fountains in the centre to cool the air. Windows were also unnecessary in Japan because of the hot and humid climate; the Japanese preferred to apply their glass-making skills to decorative objects, and earthquakes and tremors would have shattered early glass windows, so paper screens were used instead to let through light but not wind.

The Romans did use glass for windows – the largest known pane was used in the public baths at Pompeii and measured 112 x 81cm (44 x 32in) – but it was a long time before glass was used in any quantity. This is not because the technology became cheaper or more efficient, but owing to the intervention of the Christian church. By the 11th century, painted glass is mentioned quite frequently in church records, particularly of the Benedictine order, which poured time and money into the development of window glass as a way of glorifying God. But no window of either the 10th or the 11th century has survived and there is very little of the 12th century that can be identified with any certainty. What we do know is that the windows in these churches were tiny and very dark, so the window became an intrinsic part of the interior by not permitting or encouraging a view of the world outside. Not all church builders relied on glass. At the tiny 5th-century mausoleum of Gallia Placida in Ravenna, Byzantine builders created sombre nocturnal darkness pervaded by a strange mild light – the result of light filtering through thinly sliced alabaster panes.

left *Joseph Paxton's Crystal Palace, which took just 17 months to complete, became the centrepiece of the 1851 Great Exhibition in London, and despite burning down in 1936, is acknowledged to be the first major example of prefabrication.*

below *The Long Gallery at Haddon Hall in Derbyshire shows the flexibility of the small mullion window, which, when placed side by side or one on top of the other, could form a long window.*

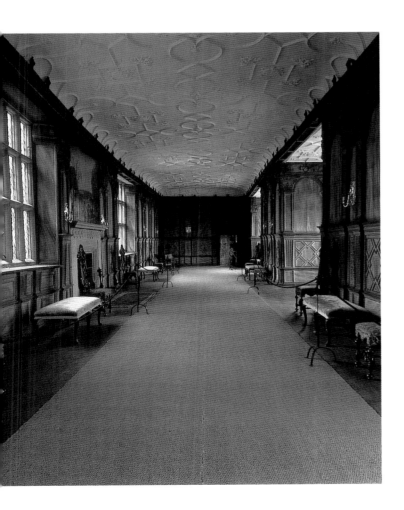

11

When, in the 12th century, churches were built that rested on a skeleton of piers, shafts, and ribs instead of relying on the solidity of the loadbearing wall, the thickness of the walls was reduced and the windows enlarged. The arrival of the Gothic style was a turning point for the window. No longer small and humble, it was used to render the church and cathedral interior as a mysterious place where form is reduced to nothing, while every objective perception of the interior is demolished. The shapes of coloured glass at Chartres Cathedral dazzle our eyes like enormous gems; the glass seems not simply to transmit the light of day but to emit its own astonishing light.

There can be no doubt about the effect of glass on Gothic architecture. The conception of structure as a fluent concentration of essentials leaving large voids for illumination could never have been realized without the existence of glass. Gothic masons introduced tracery, a French invention, to support ever-larger window openings with mullions and wider expanses of stained glass.

Away from church building, however, the story was rather different. In Northern Europe, windows stayed small, keeping out the wind and rain as well as any marauding invaders. The Normans built windows high in walls, round- or square-headed, 30 to 46cm (12 to 18in) wide and about 122cm (48in) high. These were essentially sentry boxes, as safety was considered more important than light, and what large windows there were had louvres or shutters. Even churches had to be mindful of attack. At the cathedral of Torcello on an island near Venice, windows were built high up and secured in times of attack by massive one-piece stone shutters.

The other reason was cost. Until the manufacture of thin glass sheets in the 19th century, glass was expensive and could be obtained only in relatively small pieces. The latticework window of the 15th and 16th centuries, which required only small "quarries" of glass set in lead "cames", remained popular and it was only when glass was in more plentiful supply that systems were devised that offered the flexibility to create windows of various sizes and shapes. This led eventually to the Tudor or mullion window, formed by small glazing units placed side by side or one on top of another, allowing for elaborate fenestration that can still be seen in large Elizabethan houses such as Haddon Hall in Derbyshire, England. The grandest buildings always had glazed windows, but glazing only became standard in larger farmhouses and town houses from the late 16th century. Smaller houses had to wait until the late 17th century, when larger panes were available and arranged in rectangles.

Windows were flush with the façade until the 17th century, when projecting versions, from the bay and oriel to the bow or bower, began to appear. All of them had their roots in the medieval oriels – from the Latin *oratoriolum*, a little place of prayer – built out from the

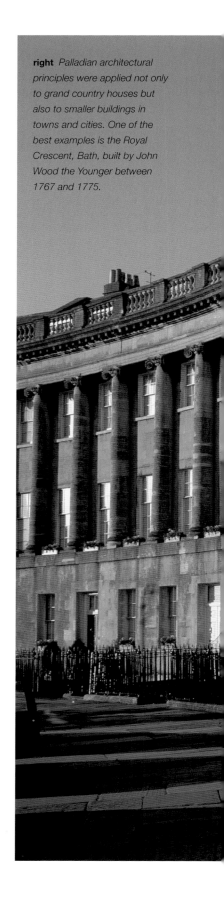

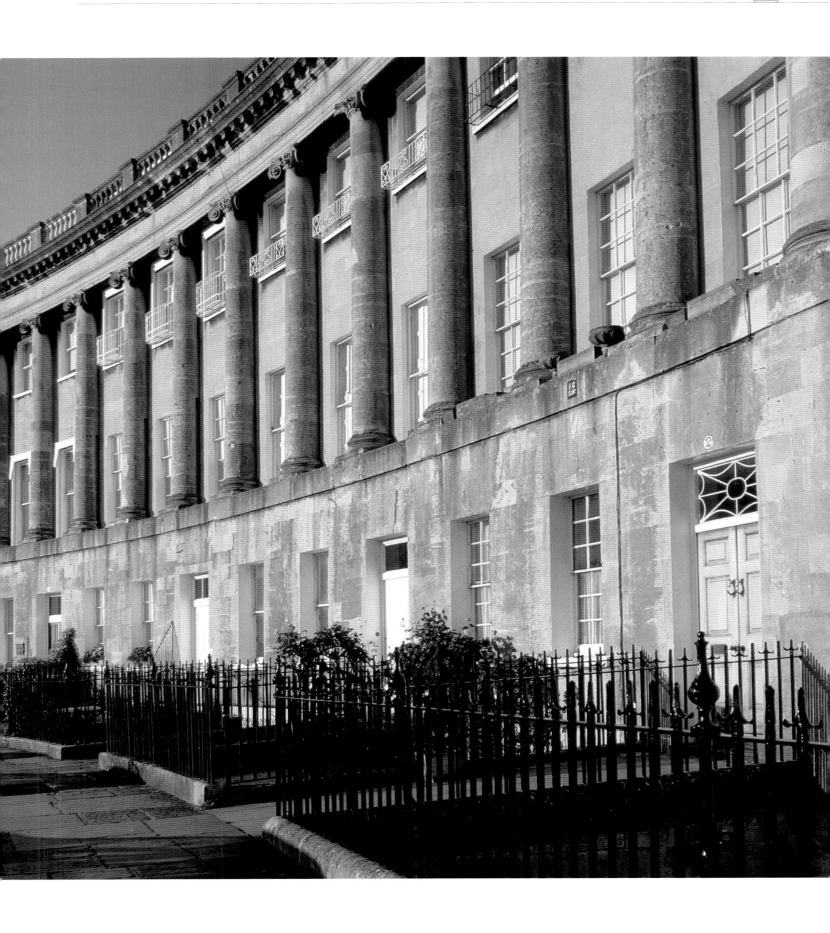

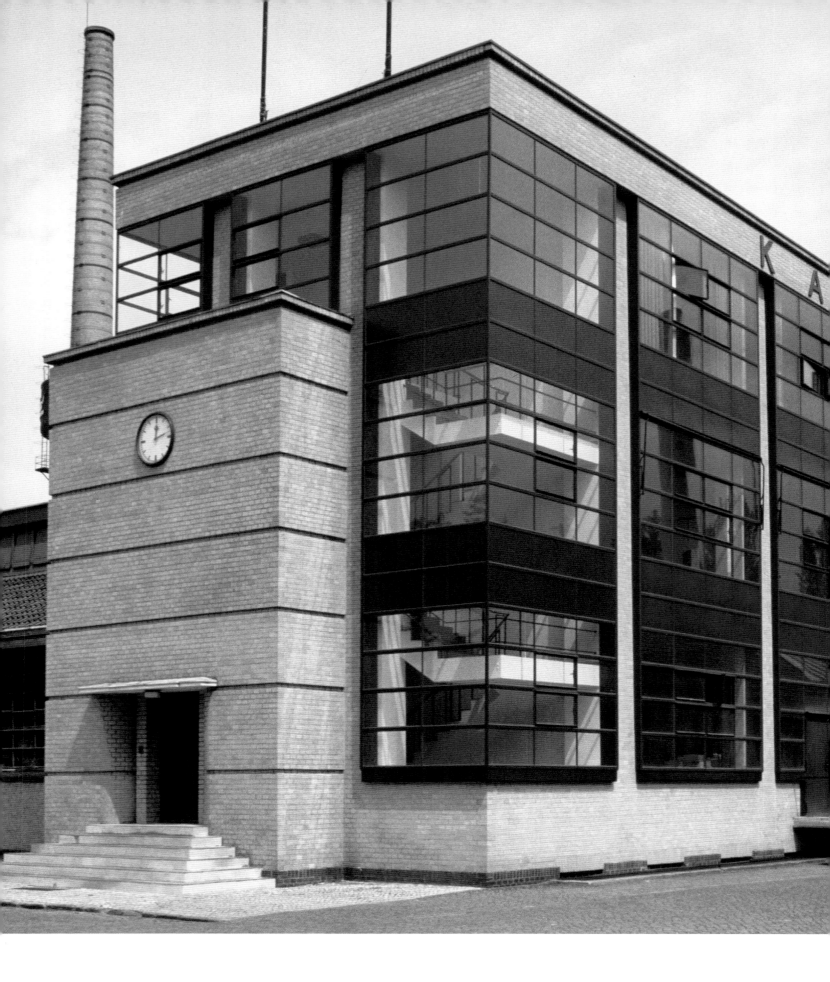

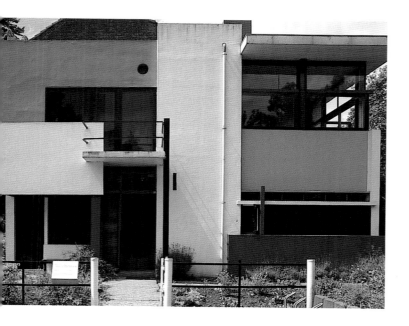

above *The Schroder House (1925) by Gerrit Rietveld is deliberately asymmetrical and full of quirks that change its composition. For example, when the two windows on the first floor are opened at right angles it has the effect of completely eliminating the south-west corner.*

left *The Fagus Factory was Walter Gropius' first architectural commission. Completed in 1911 and designed with his then partner Adolf Meyer, the factory, with a glass curtain wall that hung from the floor slabs and slender corner mullions, was way ahead of its time.*

upper floor for the lord or his guests to attend the service held below in the domestic oratory. Builders in the 15th and 16th centuries also introduced the dormer window, so called because it was originally a window in the sleeping apartment, or dormitory, which was pierced through sloping roofs and often surmounted by a small gable projecting out of the roof.

When the sash was introduced by the Dutch in the late 17th century, it took less than thirty years before most old houses were stripped of their original mullions and fitted with sashes. The sash window opened by sliding vertically, unlike the casement, which was suspended on hinges. It consisted of two framed sections overlapping at the transom bar and sliding up and down in grooves set in the frame, their movement controlled by weighted pulleys. The sash was much more effective in providing a large glazed area without the spatial interruption of the old-fashioned looking casement. In England the demand for larger panes was helped by the arrival of numerous Huguenot glassmakers after the revocation of the Edict of Nantes in 1685 – coincidentally the same year as the panes were needed for the re-glazing of Banqueting House in London – and a consequent improvement in the quality and size of the glass available.

The sash window predominated through the 18th century, mainly thanks to the Georgian and Palladian quest for order and discipline. Writing at the turn of the 19th century, the architect Sir William Chambers summed up the concern with appropriate exactness: "The first consideration with regard to windows is their size: which depends on the climate and the extent of the rooms they are to light. Palladio observes that the window should not be broader than one quarter of the room, nor narrower than one fifth of it; and that their height should be twice and one sixth of their breadth." In other words, there was little flexibility if one wanted to be true to the master.

Under the London Building Acts of 1774, which raised the standards both of accommodation and of construction of the typical Georgian house, window frames were required to be rebated within the wall face. This drew the eye away from the frame and towards the proportions of the glazing bars, which had already become more delicate as the century progressed. Yet something else was shifting and that was man's relationship with nature. Until the 18th century, the idea of a "room with a view" would have been anathema to most people. Houses were built as places of shelter or to separate

humankind from the natural world, and windows were functional – not vantage points from which to contemplate or admire nature. Economic and scientific progress in the 18th century created a new point of view: that nature could be appreciated for its own sake. The reappearance of the bay window in the middle of the 18th century was not simply architectural nostalgia, but a desire by newly prosperous landowners to admire nature from the luxury of the drawing-room.

The development of the window after 1800 was practically negligible. Although there was a conviction that new technologies and aesthetic forms were needed to express progress, the 19th-century architect was more interested in playing around with styles than in experimenting with technology. An exception to this was Joseph Paxton's Crystal Palace. The prefabricated iron and glass construction was the first transparent or windowless wall, but the ideas it embodied lay dormant for sixty years until buildings, mostly industrial, finally blew the conventional window away.

The Fagus Factory at Alfeld, Germany, designed by the young Walter Gropius in 1911, had no windows, or at least it was all window. Its glass curtain walls and glazed corners mark it out as one of the most stylistically advanced buildings of its date. Early Modernism is littered with buildings whose windows break the old rules, including Charles Rennie Mackintosh's Glasgow School of Art (1897–1909), which fused Scottish vernacular, English Gothic Revival, and Baroque to create something totally new. The finest space – the library – also yielded the most original elevation, dominated by three oriel windows. Tall, narrow and crystalline and divided by a taut, square grid, there had been nothing quite like these windows before.

Less than twenty years later, a completely different type of window was being advocated by the young Dutch architect Gerrit Rietveld. His 1925 Schroder House in Utrecht is a major landmark of modern architecture. The windows have been reduced to planes that, like the other elements in the house, have to fulfil Rietveld's ambition of creating a piece of abstract design, rather like one of Piet Mondrian's abstract compositions from roughly the same date. But the house was also designed to be flexible, and introduced a new concept that allowed the interior to be transformed by sliding partitions and the windows, which opened at right angles, to dissolve the corner and change the composition.

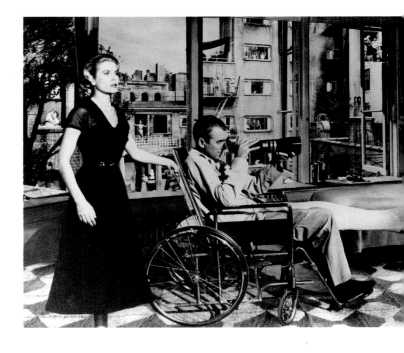

above *The film director Alfred Hitchcock was fascinated by voyeurism – the pleasurable act of watching someone, usually when they are not aware of being watched – around which he based the film Rear Window.*

right *The west façade of Charles Rennie Mackintosh's Glasgow School of Art is a daring and innovative composition of metal and glass windows juxtaposed against large plain areas of masonry. The half-cylinders that flank the windows were intended for sculptures, but these were never executed.*

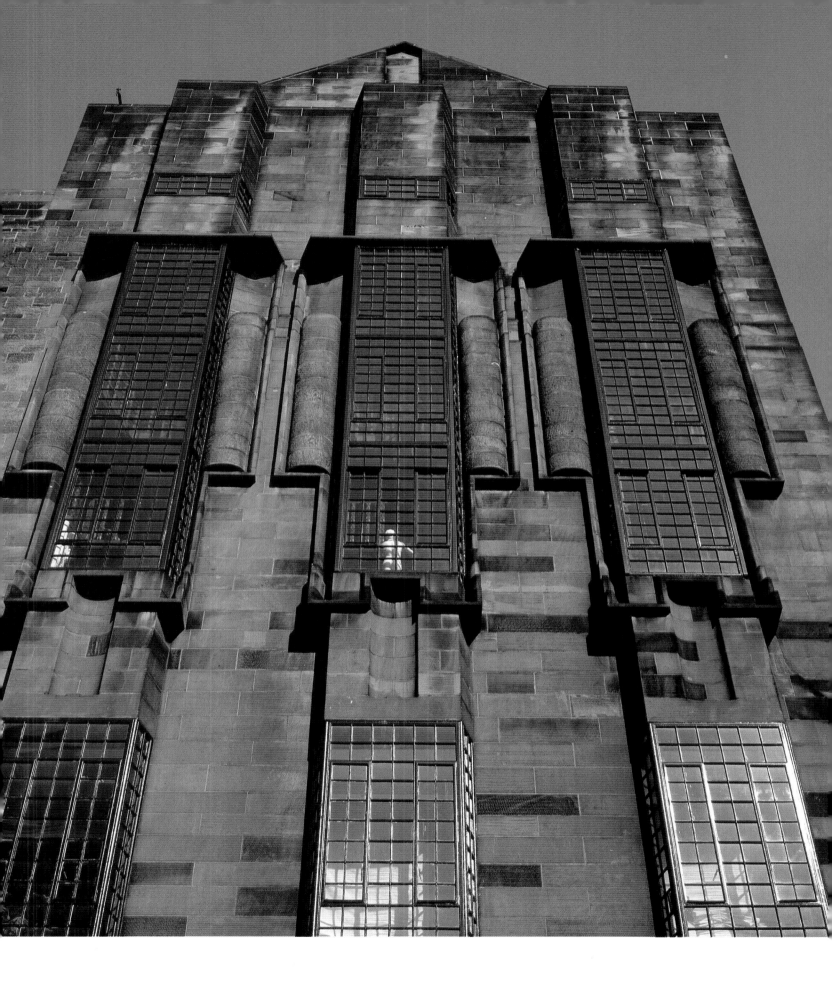

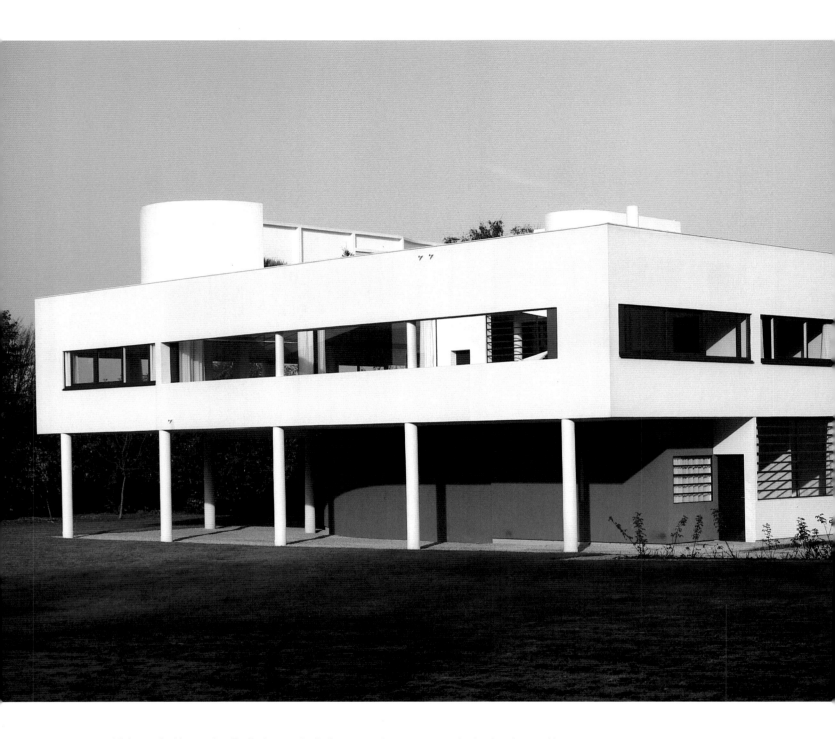

Maison de Verre, the Paris house built for an eminent gynaecologist by the architects Pierre Chareau and Bernard Bijvoet, opened up other possibilities. This house was built almost entirely from glass, doing away with the need for windows at all. But, unlike the glass houses that followed, the Maison de Verre did offer privacy. The glass bricks, which the architects pioneered, maximized light but did not allow views in – an essential part of the brief, as the ground floor was a surgery. Although the house is often described as

above *Le Corbusier's Villa Savoie is the clearest application of his architectural credo, which included the point that houses should have long horizontal windows, both for light and for views.*

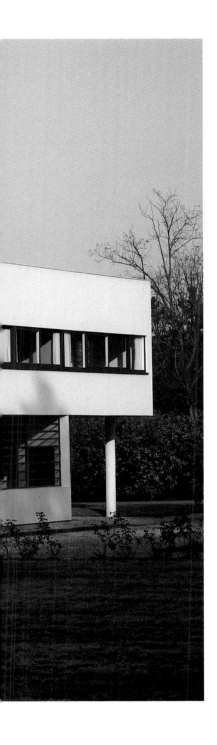

windowless, it had openable windows, but, as one can see from one of the studies in this book, Renzo Piano's Hermes store in Tokyo, it influenced the way that glass has been used as a curtain to veil the building but emit a diffused light to the interior so that view and framing become conceptually, if not structurally, irrelevant.

Le Corbusier's championing of the horizontal window was also a response to contemporary constructional possibilities – those of steel and reinforced concrete – and formed one of the "Five Points for a New Architecture" outlined in his 1924 book *Vers une Architecture*. And like the 18th-century sash window free of its too-heavy glazing bars, the "*fenêtre en longueur*" was a novel way of framing a landscape. But it was not just about framing; Le Corbusier's Villa Savoie at Poissy (1925–30) plays with the notion of a visual and functional ambiguity between outside and in. The whole house is designed to try to break down such divisions, and the windows – unglazed openings, floor-to-ceiling windows, and narrow picture windows – are full of optimism for the new way of life. For architects this meant a break with past styles and the forging of a new one that was precise, logical, and unsentimental.

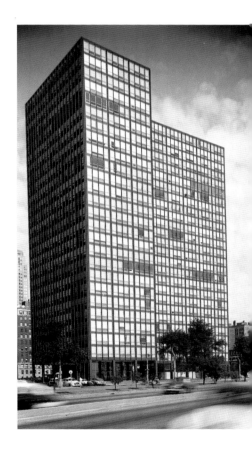

Le Corbusier claimed that the history of architecture was the same as the history of the window, the point being that regular perforations of the façade were the pure expression of a system of construction. When that system of construction changed, as it had with the introduction of steel and reinforced concrete, so too should the expression. Inevitably, he ran up against those who did not agree. The well-documented argument with his colleague Auguste Perret was over two types of window: the vertical, or "French", window favoured by Perret and the horizontal window championed by Le Corbusier. Yet at the heart of their disagreement lay not simply the functional merits of each type but what Perret saw as Le Corbusier's efforts to wipe out a tradition firmly embedded in French culture.

By the time Le Corbusier died in 1965 there were houses that had entire walls of glass instead of windows – perhaps the logical conclusion to his desire to have the

above *To ensure that all the glass façades were uniform, seen from outside, each flat in Mies van der Rohe's Lake Shore Drive apartments had a set of grey curtains behind which tenants could install hangings of their choice.*

"landscape so close it is as if you were in your garden". Philip Johnson's house that he built for himself at New Canaan, Connecticut, considered to embody one of the finest uses of plate glass in a modern house, confused even Frank Lloyd Wright. "Do I take my hat off, or leave it on?" enquired the great architect. "I can't tell whether I'm indoors or out."

The steel frame allowed buildings to go up more quickly and economically, and these buildings actually looked different. As architecture grew lighter and freer of structural limitations, so the window was no longer an opening set in the façade. If Mies van der Rohe's all-steel and glass Farnsworth House was a one-off, his Lake Shore Drive apartments in Chicago (1948–51) were emulated worldwide. These were the first steel and glass curtain-walled towers, and the windows clearly express the steel structure beneath the fireproof concrete.

As a method of construction the curtain wall has served the needs of the commercial office sector efficiently, allowing it to build high and cheap and, together with the advent of air-conditioning, has changed forever the role of the window. But since the great office boom of the 1980s, there are other issues shaping the modern window. First there is the need to improve the window's thermal performance, leading to the development of mullions that can take two planes of glass rather than one. Second there is standardization to keep construction costs low; many buildings are put together from off-the-shelf products, including glazing systems, in which it is difficult to be inventive.

Within these limitations, the window continues to develop and change. On the one hand, there are architects such as Jean Nouvel and Toyo Ito for whom the window is simply part of the façade to be broken down so that perceptions of a solid and static enclosure disappear. For the Americans Rick Joy and Wendell Burnette, whose one-off houses are set in extraordinary scenery, the window is still mediating, Le Corbusier-style, between inside and out. In historic cities such as London, Berlin, and Vienna, the challenge is different. Here, the mania for conservation can make it hard for the architect to do anything other than follow rules laid down by the planners, yet, as the following case studies show, this has not stifled innovation – rather the opposite. While there is no longer a need to open a window to admit air – denying it perhaps its most important function – the window has not, as some critics once feared, disappeared, swallowed up by repetition to become a monotonous curtain wall. What was once a simple opening has become a powerful means of expression and one of the purest forms of communication available to the contemporary architect.

right *Philip Johnson, Glass House, New Canaan, Connecticut, 1949. The transparent glazing and the views through to the landscape combine with the earth tones of the brick and steel to form just one element of the Glass House's enduring appeal.*

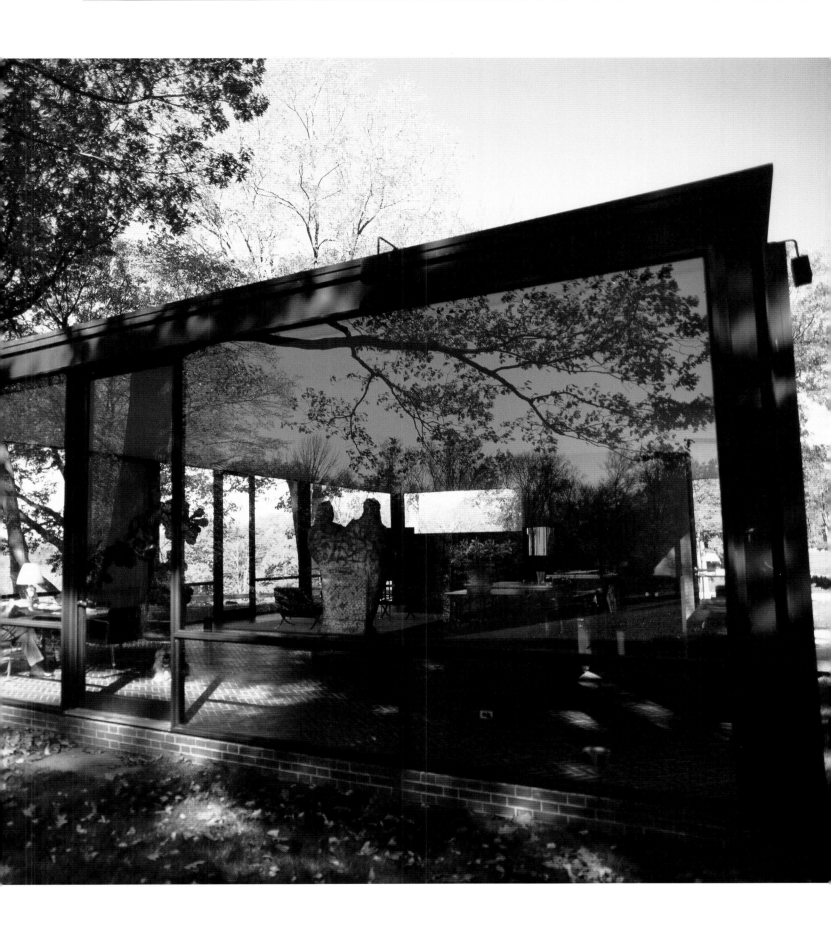

BLURRING THE LIMITS

Architects are always pushing at the boundaries of what is possible and, while it may seem contradictory to want to design a building to seem as if it were not really there, the quest for transparency has become an obsession that shows no sign of abating. In the mid-20th century the development of plate glass was the first tentative step towards an architecture that could break down the boundaries between outside and in, but soon architects were looking at ways to use the building's structure to increase the sense of openness and weightlessness. Light, because of its ability to dissolve surfaces through reflection and refraction, is central to the idea that a building's physicality can be dissolved. But for a growing number of architects, this blurring between what is solid and what is not is a challenge of a different sort. Rather than the Miesian box, which, as this chapter shows, still influences architects, blurring the boundaries is about an architecture that is unconfined and freely floating.

right This family home in Belgium borrows ideas from Mies van der Rohe's Farnsworth House; like its famous predecessor its façades reflect the meadow in which it sits, but by using sandblasted rather than clear glass the architect allows for more enigmatic glimpses of the interior.

VIIVA ARKKITEHTUURI
EMBASSY OF FINLAND, BERLIN, 2000

For its new Berlin embassy, the Finnish government decided to collaborate with its four Nordic neighbours, Sweden, Norway, Denmark, and Iceland, to create an enclave whose architecture would convey the balance of homogeneity and variety between their respective cultures. A wall of copper scales encloses the whole site, on the southern edge of the Tiergarten, but each country has its own embassy; a sixth plot houses the Fellehus, a shared building containing the public facilities. The position of each embassy loosely reflects its country's geographical location; pools of water represent the rugged coastlines.

Viiva's design for the Finnish embassy picks up on the theme of a modern, stylized representation of national identity that the master plan by Berger and Parkkinen implies. Wood is the most common construction material across the region, and daylight, whose strength and tone varies greatly throughout the year, has always been enormously important in building design. Viiva has refined these two characteristics and translated them into a contemporary idiom. The copper cladding of the enclave's outer wall transforms into a skin of timber slats within the Finnish compound. At first glance it may look inscrutable but, as the sun moves round, the slats can open or close to filter daylight to the building's inner skin of triple-glazed glass sheets. The timber slats are arranged within precisely constructed, hinged panels, which are able to open fully.

The two very different skins of timber and glass give the interior a mannered, almost surreal air, where effects are carefully controlled. A single-storey entrance lobby leads to a triple-height atrium. Beyond, at first-floor level and lit by a window in the copper outer wall, is a rowan – a tree traditionally believed to have magical properties. Light suffuses the space, enhancing the enchantment of the tree, and picks out the crisp aluminium form of the staircase and the sensuous bent-plywood enclosure of the conference room that floats just below the roof.

In its competition-winning design, Viiva found a means of expressing Finland's national character in a contemporary way that fits with the overall master plan without compromising the identities of the building's neighbours. The easy updating of Finland's historical interest in timber and daylight implies that such Nordic traditions are still vital and that other aspects of traditional life may also survive in the modern world.

right The glass façades are entirely covered with slats of aspen wood, which act like Venetian blinds, protecting the interior and filtering the incoming light.

Section through building

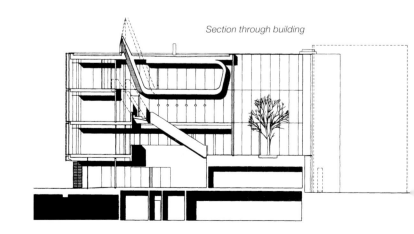

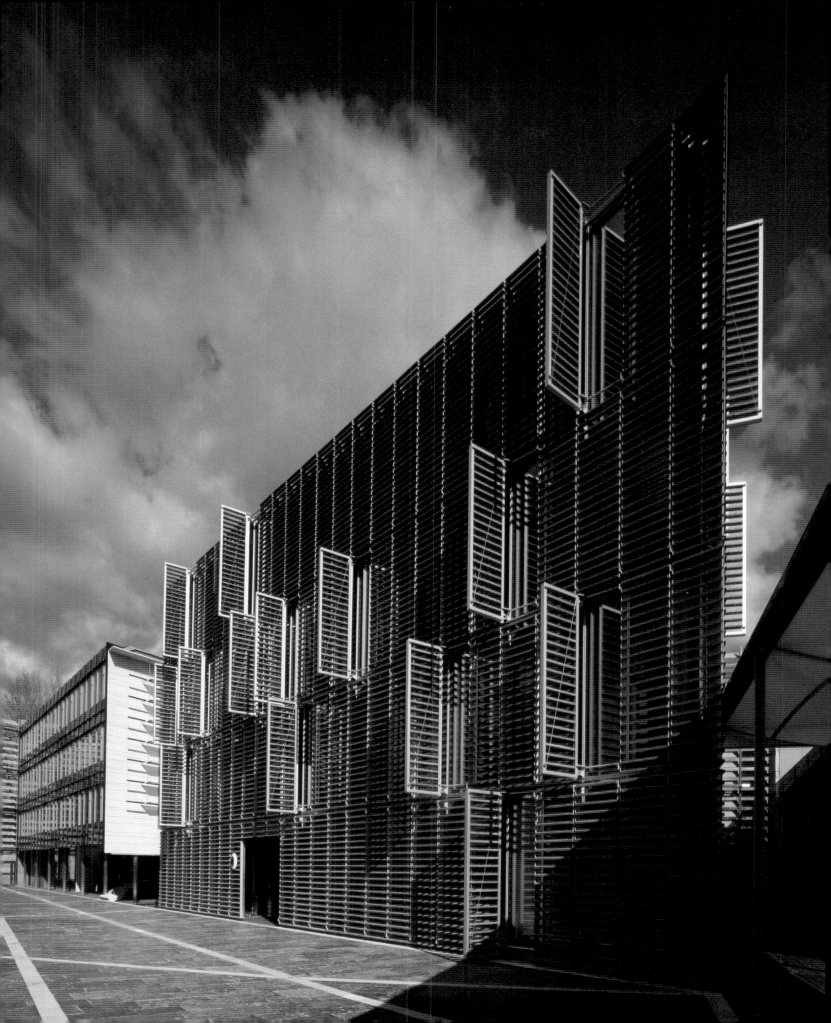

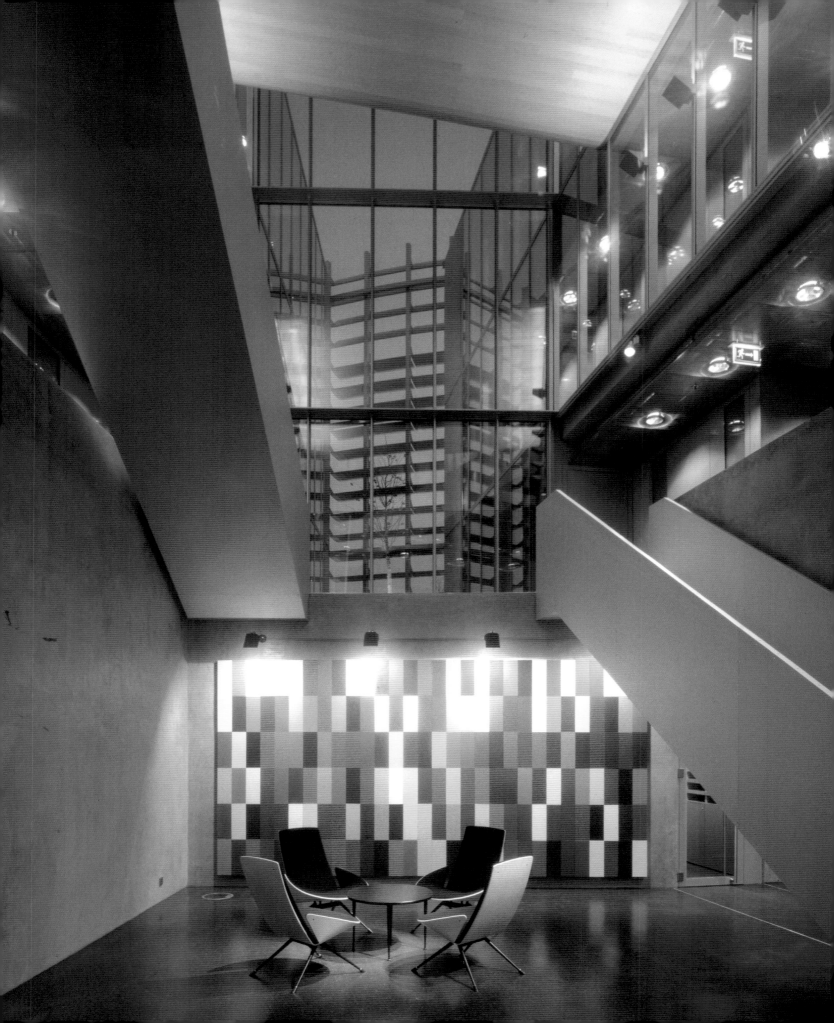

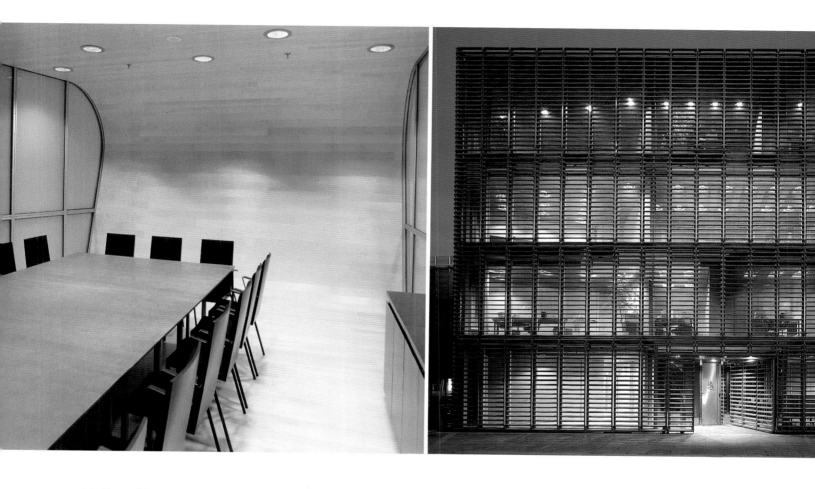

left The straight-run stair is the dominant element in the central hall and is clad in aluminium panels. Just visible are the rounded contours of the wooden box of the conference room, which appears to hang from the ceiling.

above The suspended conference room with its rounded forms and continuous floor, wall, and ceiling has gained the nickname the "skateboard room" because of its resemblance to a skateboarding ramp. Its shape, texture, and colour are a conspicuous contrast to the rest of the building.

above right At night the slatted screen is closed and the building's basic form becomes easier to read. The individual panels can be opened manually from the outside so that the glass can be cleaned and maintained.

SHIGERU BAN
NAKED HOUSE, KAWAGOE, 2001

Naked House, about 9 kilometres (15 miles) north of Tokyo, is the tenth in a series of experimental houses that architect Shigeru Ban has built in his native Japan. The name suggests that convention has been flouted and that the barrier between private and public realms has broken down. In fact, Ban attempts to achieve various levels of transparency so that the client can choose his or her own level of privacy. Ban also likes to experiment with pushing materials such as paper and fabric in new and unexpected directions.

For Naked House Ban's inspiration was the greenhouses that, along with a Buddhist temple, were the nearest buildings to the site, which is bordered on three sides by paddy fields. But how to achieve the desired level of transparency proved to be Ban's biggest challenge to date. First he tried sandwiching shredded waste paper between corrugated reinforced plastic and a fabric skin, but the fill blocked too much light. His next experiment was with synthetic "noodles", a type of packing material used in Japan for wrapping fruit, which let in the light but also acted as an insulator from the cold.

Working with the "noodles" proved too much even for Japan's willing contractors. In the end Ban's staff did the job themselves, filling sealable plastic bags with the packing material, which had first been hand-sprayed with a fire-resistant substance. The 122cm and 152cm (48in and 60in) long plastic bags, divided into squares to stop the fill sinking to the bottom, are fixed to the slender timber structure with steel clips. On the façade, two layers of corrugated, glass-fibre-reinforced plastic sheets form a weather-resistant skin, while internally the wall is sealed with a nylon canopy attached to the frame by Velcro so that it can be easily removed for washing.

The narrow ends of the house are glazed to give views out over the paddy fields and the Shingashi River. But apart from the main entrance on the north façade and door-like windows on the south leading to a small terrace, the 38cm (15in) thick walls are punctured only by square hinged ventilation windows. Conventional windows, though, are not required in order for the interior to be flooded with daylight.

right *The quilted walls are punctured by small square windows; the overall effect is reminiscent of the rice-paper screens of traditional Japanese houses.*

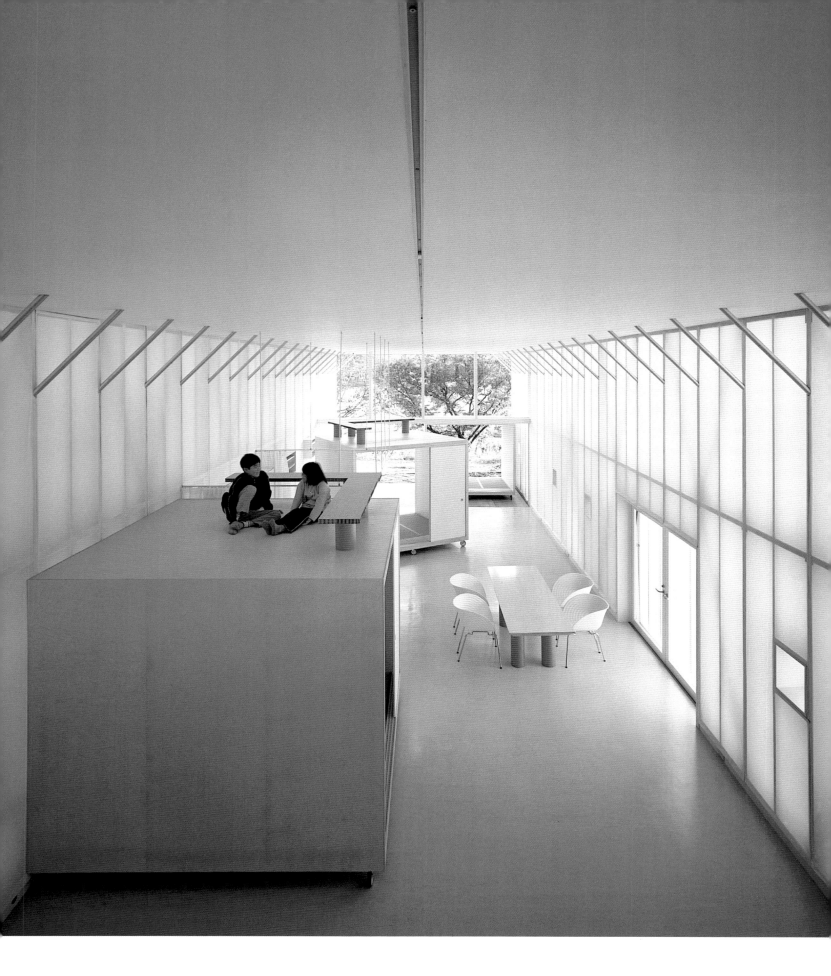

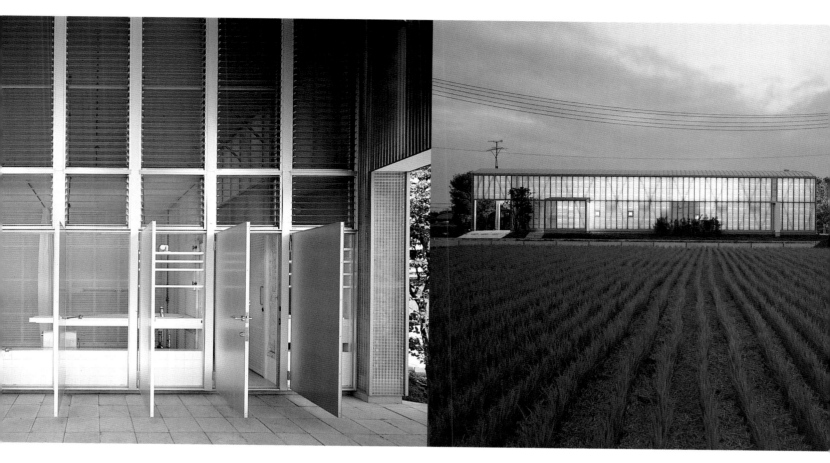

above Door-like windows on the south façade lead to a small terrace.

left As the name of the house implies, there is little privacy. Boxes made of brown-paper honeycomb panels on wooden frames act as the family members' private retreats. Intended mainly for sleeping, each is a traditional Japanese room on wheels, easy to manoeuvre and complete with tatami mats and sliding partitions.

above right From a distance the house, bordered on three sides by paddy fields, resembles one of the neighbouring greenhouses.

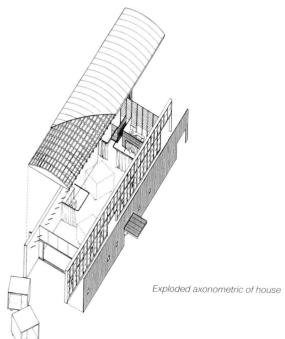

Exploded axonometric of house

31

DANIEL DETHIER
FAMILY HOUSE, VERVIERS, 1999

Ever since Mies van der Rohe's Farnsworth House, architects have tried to emulate its lightness and diaphanous interior spaces. Although it was completed in the middle of the last century, it remains a turning point in modern architecture, a building that stands apart from the architecture of any previous era. Yet the choice of glass for domestic buildings raises a number of problems. First and most obviously, it does not offer much in the way of privacy. A home, traditionally, is a place of refuge in which the window has to satisfy the changing demands for light and the desire for security and a sense of well-being.

An all-glass house such as the one designed by Belgian architect Daniel Dethier gives off a rather different message. Like the Farnsworth House, this house, designed for the Denis-Otmans family, is entirely visible to prying eyes – there are not even curtains to draw. But, given its quiet rural setting in the middle of an orchard in Verviers, the owners must be confident that passers-by will be few. While the house may resemble Farnsworth, it has the 21st-century convenience of insulated glass, with a steel roof covered in turf. The architect explains that the idea was to design a house that used contemporary technology and was also prefabricated and assembled on site.

Windows of course are not expressed: the whole house is a window that reflects the surrounding area and also merges with the interior. The only openings are the sliding doors at the front, side, and entrance. The plan is simple: a 3m (46in) wide bay at one end is walled off and allocated to garage and laundry with a storeroom and spare bedroom above it. All the services are grouped in a ground-floor island unit: two bathrooms either side of the master bedroom recess and a kitchen bench with sink and hob attached to the outside. Above is an open study mezzanine that shares a lift-up access stairway with the spare bedroom, which is accessed though a door in the cross wall. This solid dividing wall acts as the building's main cross-bracing. The tendency of the frame to collapse longitudinally is resisted by diagonal rods cross-bracing one full-height bay in each elevation.

Although there is a form of air-conditioning, vines grown up cables stretched over the sanded glass of the south façade shade the interior of the box from the more intense heat of the sun, as well as providing changing patterns of colour, light, and shade.

Cross section through house

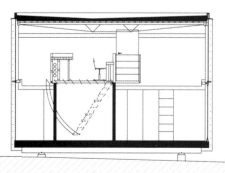

above *The glass is insulated with a steel roof covered in turf, but the structure is unusually light so as to make as little mark as possible on the orchard.*

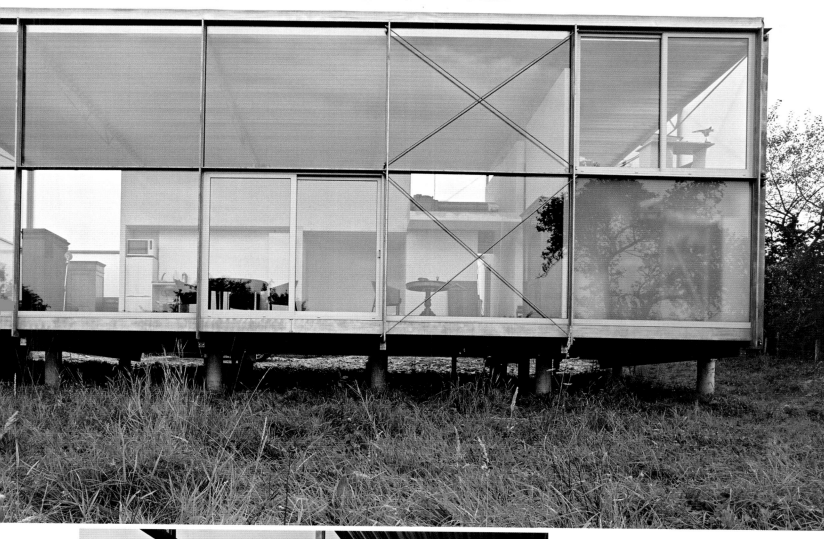

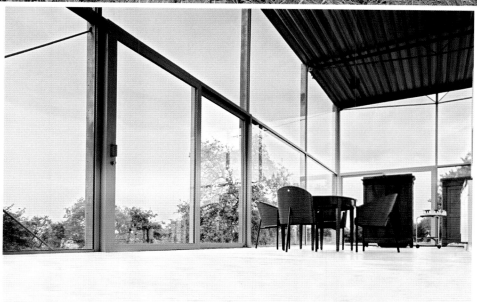

left *The entire house is a window that has been prefabricated and assembled on site. The main space is usually left open, but there are sliding partitions that can divide it if necessary*

TEN ARQUITECTOS
HOTEL HABITA, MEXICO CITY, 2000

Architects Enrique Norten and Bernardo Gomez-Pimenta, who set up Ten Arquitectos in 1985, work in a minimalist palette of glass and steel that best serves their ideas of transparency and abstraction. When the office was asked to convert a run-down apartment building into a hotel in Mexico City's Polanco district, they came up with a typically robust response: to wrap the building in a new glass skin. Planning restrictions meant that the 1950s block could not be demolished and any conversion had to be able to withstand fierce wind and earthquakes.

The new skin is of translucent green-blue sand-blasted glass, which floats a few metres away from the old concrete frame. Each of the hotel's 36 rooms is filled with light diffused through two pieces of glass – a translucent outer one and a transparent inner one. In order not to break this flush, urbane composition there are no vents or openable windows on the external walls, while the original windows and sliding glazed doors now open onto enclosed balconies. The balconies are sited in the buffer zone between the old and new façades, which has created physical space and acts as a climatic and acoustic baffle.

The idea of a hermetically sealed box may be questionable but, with such a difficult site, the architects' options were limited. And it is not as if there were stunning views to play with. In fact the reverse is true, so Ten decided to control views out by incorporating clear, non-sandblasted strips, like windows, in the outer façade. The strips look as if they have been placed at random but their position is deliberate, so that guests have an edited version of the city while passers-by get tantalizing glimpses of the minimalist bedrooms.

Just as the hotel's private domain is veiled or screened by the opaque glass, so its public areas at ground level are opened up by a new wall of butt-jointed glass recessed to the original building. This allows an unimpeded view of the bar–foyer restaurant, which becomes a kind of affluent urban theatre. It is only on the rooftop that Ten has created an area of privacy while allowing the connection with the city to be made. Six storeys up, the city no longer reads as a chaotic blur and offers instead a dramatic skyline.

above Clear strips control views out of the bedrooms.

right At night the building looks like a lantern as the pattern of illumination changes with the occupancy of the rooms.

Longitudinal section through building

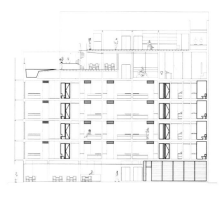

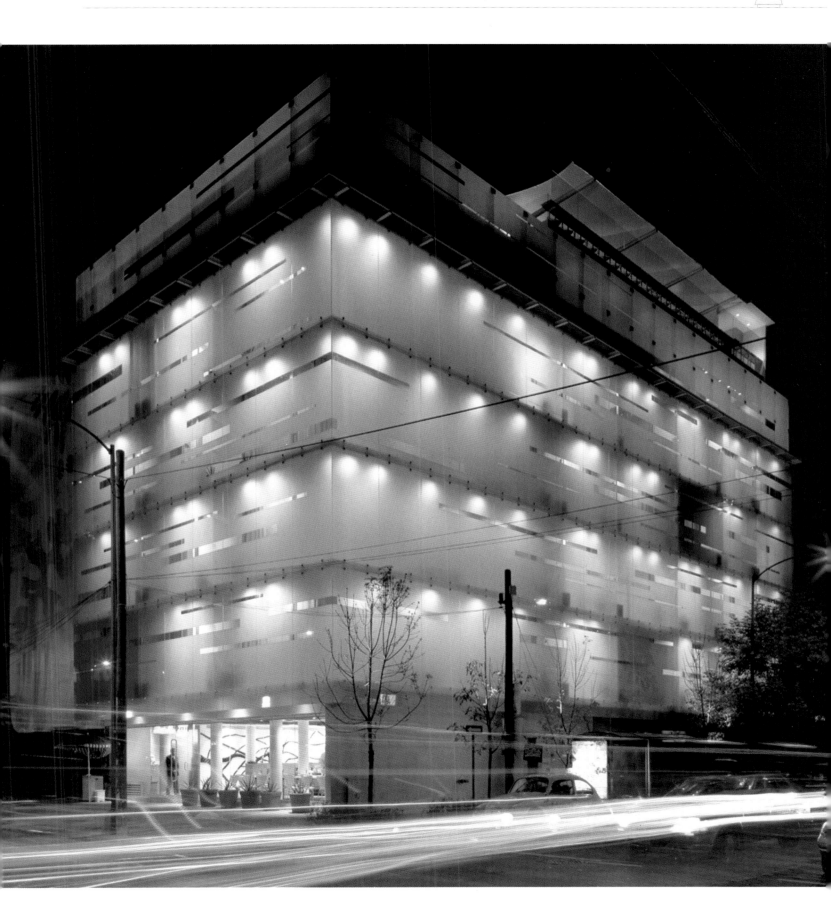

SEAN GODSELL
CARTER TUCKER HOUSE, BREAMLEA, VICTORIA, 2000

Sean Godsell's interest in developing an architectural language that responds to regional vernacular but is also imbued with a knowledge and appreciation of Eastern and Western design has resulted in a series of intriguing one-off houses. Most recently he completed the Carter Tucker house, a weekend home at Breamlea in Victoria.

In all the houses, the Australian architect investigates ways of accentuating the buoyancy of changing light conditions using a system of adjustable louvres. The effect is to blur the edges of the building and, even when using industrial materials such as rusted steel, the subtle shifts of surface that are achieved have closer parallels with the timber screens of Japanese buildings than with the aluminium screens of his countryman Glenn Murcutt.

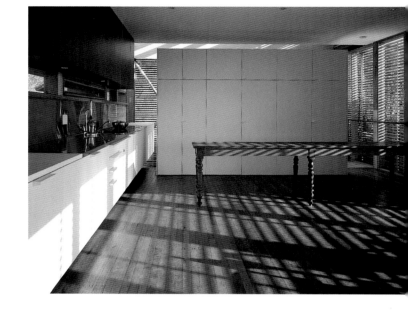

above *The hardwood slats allow striated light to infuse the three levels of the house.*

Godsell's interest in Chinese and Japanese architecture is most thoroughly explored at the Carter Tucker House, where he has taken the veranda, a feature common to both East and West, and abstracted it. Australian homesteads traditionally have generous verandas, sometimes partly enclosed by fly wire or glass to form a sunroom, but also intended to help shade the vertical surfaces of the building from direct sun. At first glance, the house appears impervious: it is a 12 x 6m (39 x 20ft) box embedded in the side of a sand dune and shrouded in a skin of local hardwood slats. However, when the panels, or shutters, are raised the house is revealed to the rugged landscape beyond.

When fully raised, the panels become awnings at the same height as the ceilings, so that the interiors are fully open and seem to extend into the landscape, particularly on the top floor. The opening and closing of the panels is achieved by a rather complicated system involving pulleys and adjustable gas-powered brackets.

The house consists of three rooms. The lower ground floor is for guests; the middle level is the owner's bedroom plus a small living area; the top floor is for living and eating. The spaces can be enclosed by sliding safety screens or glass, according to the time of day or season. On the middle level, for example, the bedroom may become the veranda while the corridor becomes the inner room. Internally, sliding screens allow spaces to be divided or joined together according to requirements.

Wall section showing the openable and fixed timber screens

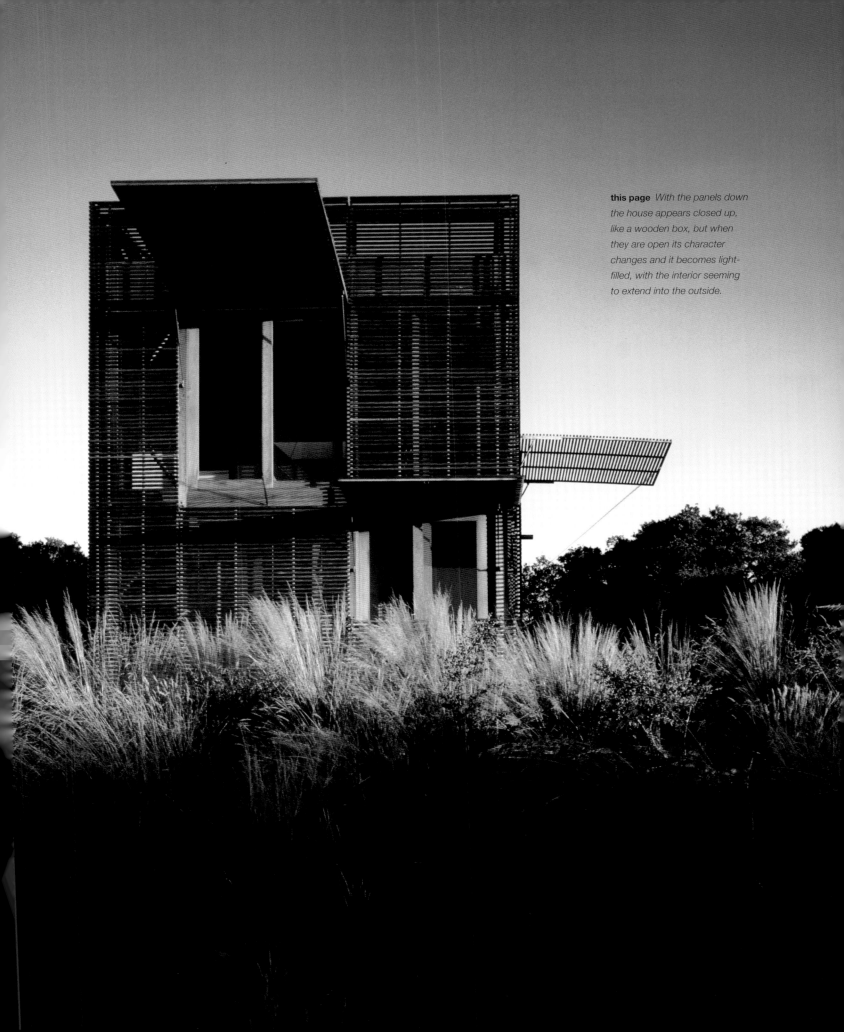

this page *With the panels down the house appears closed up, like a wooden box, but when they are open its character changes and it becomes light-filled, with the interior seeming to extend into the outside.*

JEAN NOUVEL
FONDATION CARTIER, PARIS, 1994

The much-decried curtain wall – the window that literally became a wall – has strayed so far from its experimental beginnings that it no longer holds much fascination for contemporary architects. Yet at their most sophisticated, glazed buildings can create arresting optical illusions and evoke an unmatched sense of openness and weightlessness. More recently architects have been interested in creating façades that seem to dissolve and almost disappear.

Jean Nouvel took up the challenge with his Fondation Cartier in Paris, an office and contemporary exhibition space for the watchmaker Cartier. Nouvel established an international reputation with L'Institut du Monde Arabe in Paris. In that building, the architect was inspired by the camera lens – the windows are stainless-steel irises that open and shut according to the amount of natural light – and the patterns of Arab weaving.

Here the architectural sleights of hand are no less astonishing. The building is set back from the street, from where the visitor sees a screen of mature chestnut trees through a six-storey-high free-standing wall of frameless clear-glass panels. When the eye travels back to a second screen, twice the height of the first, a moment is needed to realize that this is the front façade of the building. It extends without interruption three bays beyond the building proper and one bay along the eaves, blurring the distinction between a two-dimensional screen and a three-dimensional building enclosure. A third screen plays a similar game along the rear elevation.

The dematerialization continues inside. The reception area is little more than a passageway through the heart of the building leading to the stairs and lifts. On either side are two rectangular galleries surrounded on four sides by glazed curtain walls. The galleries seem to be extensions of the gardens – an effect that is increased by sliding the entire front and rear glass walls sideways beyond the side elevations – and function as flexible, well-lit spaces for both exhibitions and performances, with their great glazed walls serving as shop windows to passers-by.

Section through office floor

right *The architect has described the building as being about "lightness, glass and fine steel gridwork. … a poetry of haze and effervescence", and it is hard not to be mesmerized by the shimmering screens and the trees.*

below *Daylight flows through transparent window walls into the galleries of the building, which increase the sense of space and blur the boundaries between inside and outside.*

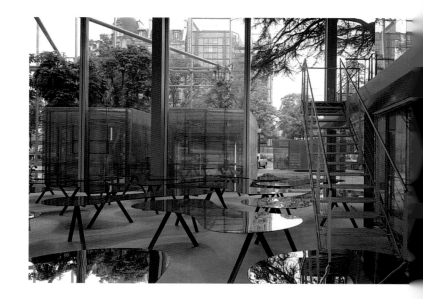

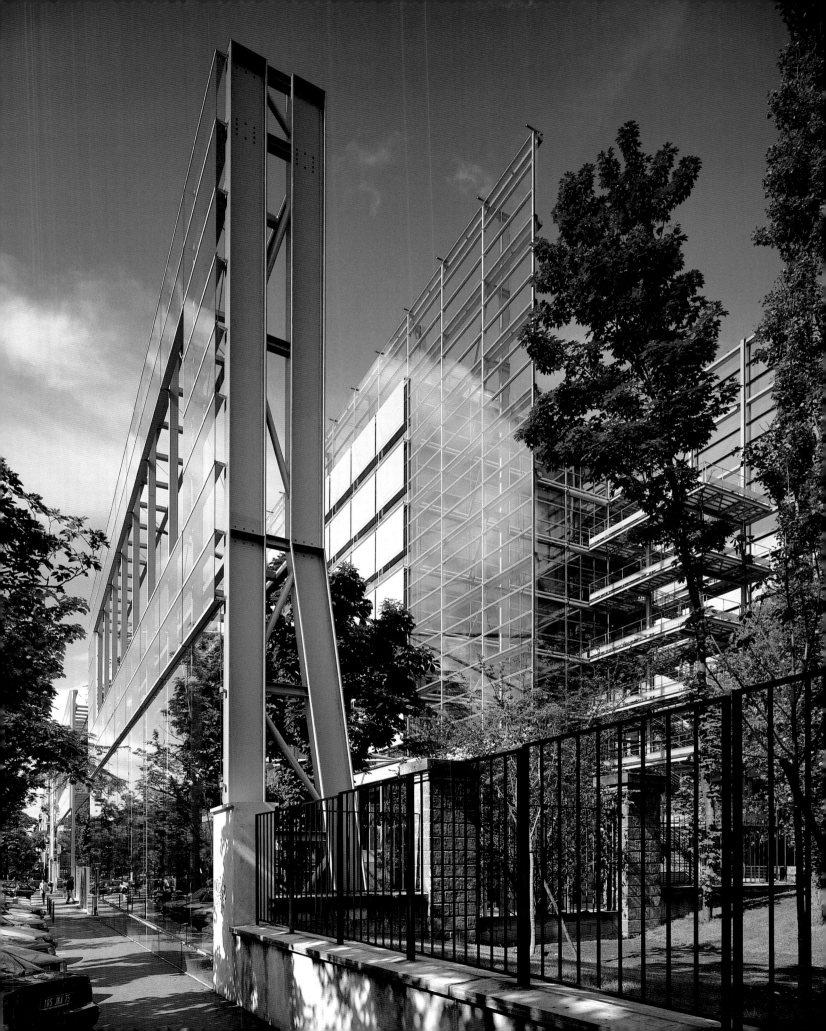

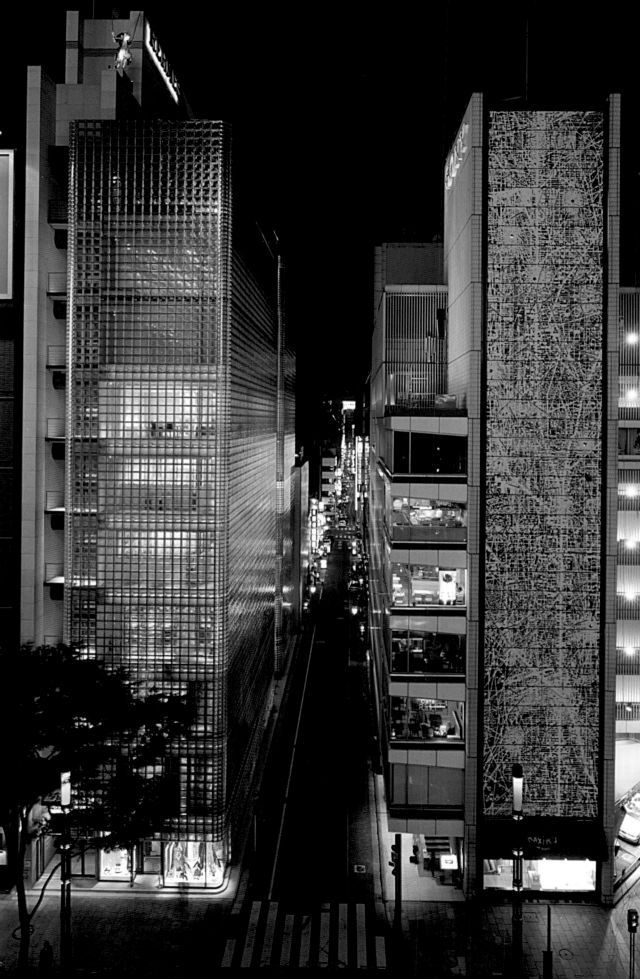

RENZO PIANO
HERMES, TOKYO, 2000

Renzo Piano's Hermes emporium in Tokyo's Ginza district defies all the conventions about what a shop should look like. The rules state that shop windows are meant to whet the appetite for what is inside. But Hermes is not simply a shop: it also includes a museum, a gallery, and a cinema, effectively turning it into a themed public building.

Occupying a long, narrow site only 12m (40ft) wide, the 15-storey tower has a relatively simple structure comprising a narrow reinforced-concrete service core from which open-plan floors are cantilevered. Most extraordinary is the skin, which consists of a continuous curtain of glass bricks that appears to hang off the steel structure like a veil delicately thrown over the building.

Although glass may seem a strange choice of material in a city so vulnerable to earthquakes, Piano persisted with the idea. "The glass is the key to everything," he says. "The transparency sets out to recreate intimacy – seeing but not really seeing."

While architecture buffs will spot the homage to Pierre Chareau's 1932 Parisian masterpiece Maison de Verre, Piano is also referring to Japanese paper screens – traditionally used instead of glass in windows – which let a beautifully diffused light into a room, as well as bending gently to the tremors of the earth.

In shadow the glass seems solid but in the light it catches and picks up images and colours from neighbouring buildings as well as from its own contents. But even when it acts as a vast mirror, the building is discreet – in contrast to its neighbours, most of which seem to be no more than supports for gigantic neon advertising hoardings

Piano's quest for transparency has been pushed even further by "silvering" the slender steel bars that hold the glass bricks, rendering them almost invisible when viewed together. By night the building becomes what Piano describes as a "magic lantern" – a vast glowing crystal that radiates light.

The individual glass blocks, the largest ever made, are allegedly based on a multiple of the Hermes silk scarf. Each consists of a smooth side and a dimpled one and is hand-finished with mirror-varnished edges, while the smooth side – the side that is also used as a window – is polished.

Yet because Hermes is not a conventional retail space, Piano has seen no need to provide conventional shop windows. There are modest window displays but they are tiny – the size of one glass block – only big enough to display a single handbag or one of Hermes' famous silk scarves.

Section through glass wall

left *Creating a landmark building in the architectural diversity of Tokyo that would also meet Japan's strict anti-seismic standards was both an aesthetic and a technical challenge.*

41

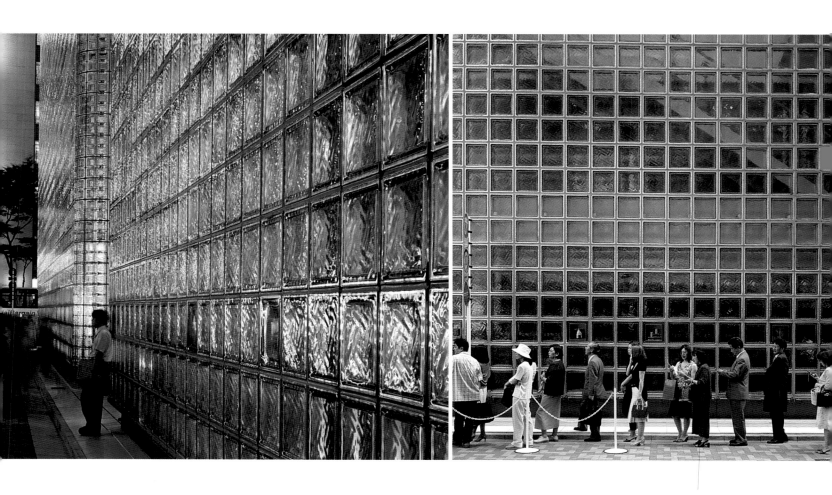

above For a world-famous brand like Hermès the decision to place so little emphasis on shop windows may be surprising. However, the minimal display, in which single smooth glass blocks act as display windows, gives the individual items an almost jewel-like quality.

above right The façades are made up of 45 x 45cm (18 x 18in) glass blocks that were specially developed for this project. Although on a giant scale, the building makes a clear reference to Maison de Verre in Paris, the 1932 masterpiece by Pierre Chareau.

right Exhibition space on the eighth floor: every element has been engineered to absorb its share of any movement that should occur, meaning that the entire building can move during an earthquake.

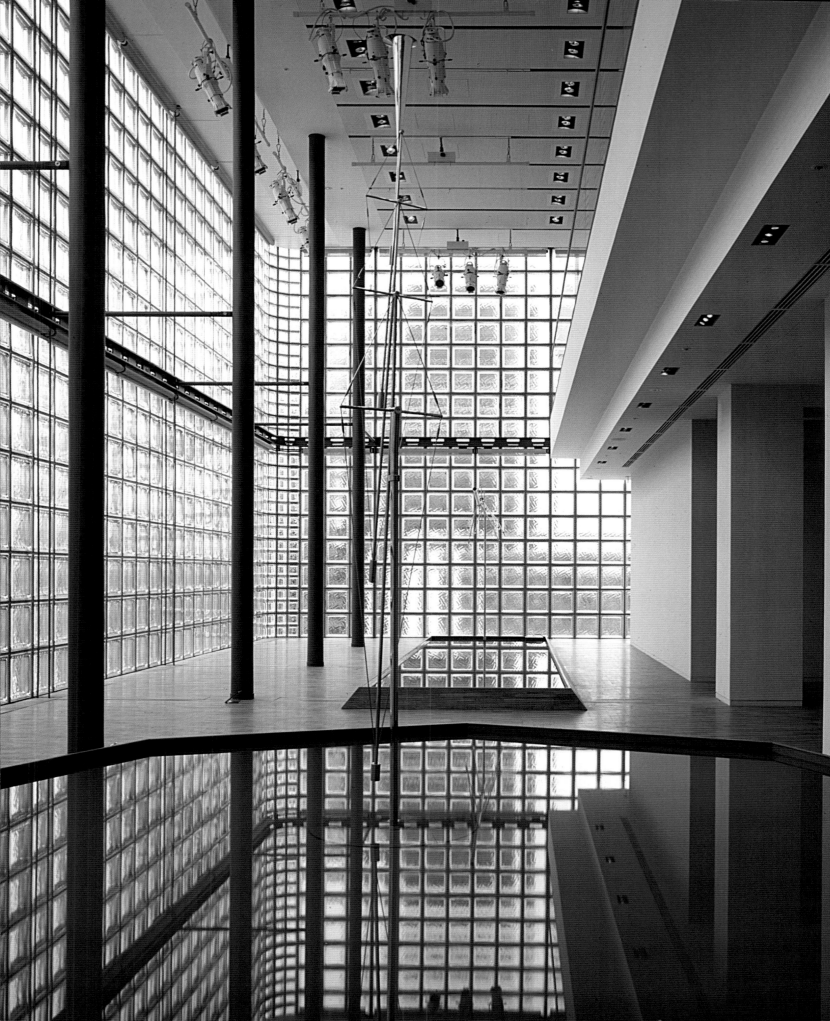

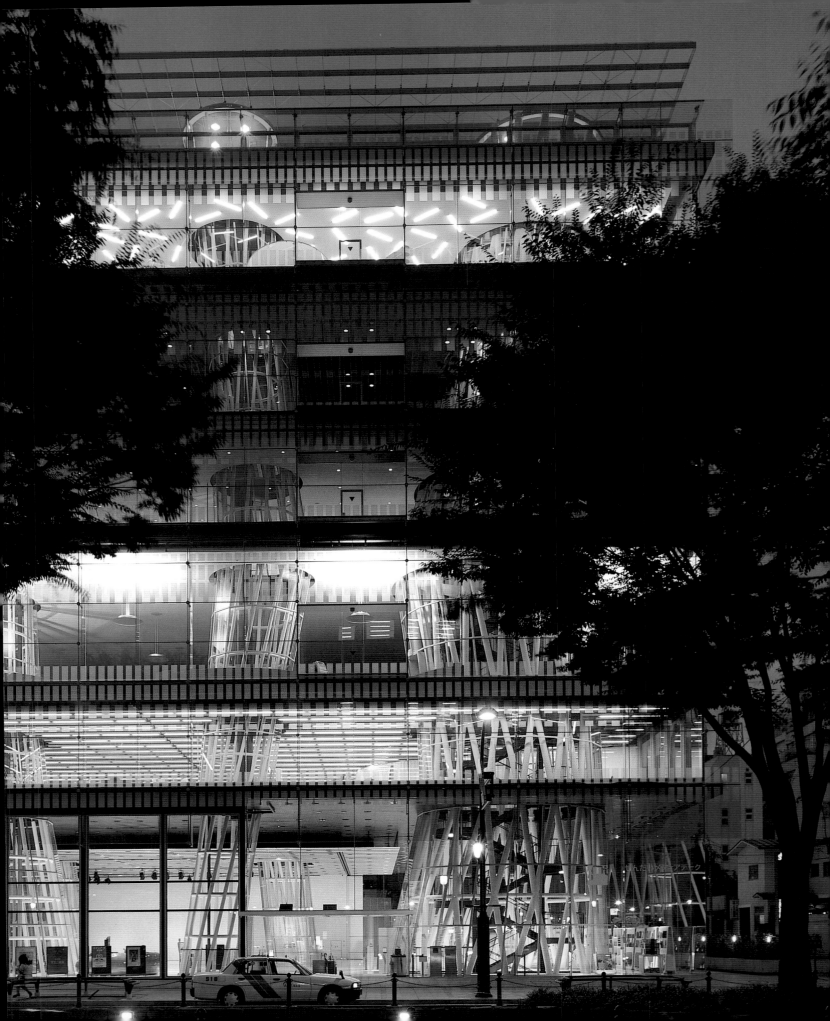

TOYO ITO
MEDIATHEQUE, SENDAI, 2001

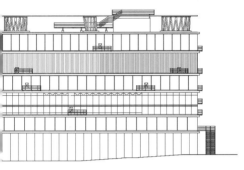

East elevation

left *The main façade has a double skin of glass. The gap between the two layers of glass insulates the building, and allows hot air to be drawn out in the summer.*

below *The building's innovative structural tubes can be seen on all levels of the building (the fifth floor is shown here). Different furniture, lighting, and colour help to create an identity for each floor.*

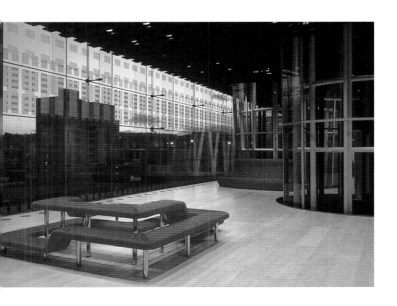

Japanese architect Toyo Ito not only blurs boundaries, but has developed a concept of "blurring architecture" to describe the fluid dynamics of the modern city. He proposes that humans exist on two levels: as physical entities subject to forces of nature and as "flows of electrons", wired through information technology to realms beyond sensory perception. No project shows this concept more clearly than his "mediatheque" in Sendai, a city of a million people 480 kilometres (300 miles) north of Tokyo. Accommodating various forms of new and traditional cultural media, Ito's mediatheque acts as a dramatic urban shop window and so is a particularly appropriate showcase for his ideas.

Ito's design synthesizes the architectural components into three basic elements: tubes, plates, and skin. Rather than vertical columns, the welded steel tubes are twisting frames that act as structure and circulation cores, with steel floorplates topped with concrete. But it is the glass skin that dematerializes the building and encourages use. By day it appears as a shimmering rectangle of glass etched with dots and dashes. At night the south façade disappears completely and only the skeletal structure is visible, animated by a blaze of ceiling lights and tiny accents of colour from furnishings set close to the glass.

In splitting the static components of traditional architecture and imbuing them with dynamism and multilayered meanings, Ito's concept of "blurring architecture" runs even to the role of windows. With a double skin on the south side, the glass wall is more than a window on the workaday world. It is also an environmental buffer. The upper vents on the double skin open in summer, creating a cooling updraft, and close in winter to create an insulating layer of air to stop heat escaping.

Numerous other features in the mediatheque share the allegorical qualities of windows, even if they do not follow the conventions of form, material, or position within the building. As well as providing structure, the steel tubes act as mini light-wells and metaphorical windows into the often hidden labyrinth of wires and conduits that make up the services of cities. And equally the activities that take place inside the mediatheque, whether surfing the Internet, reading a book, or attending a performance, might be seen as windows into an imaginative realm.

45

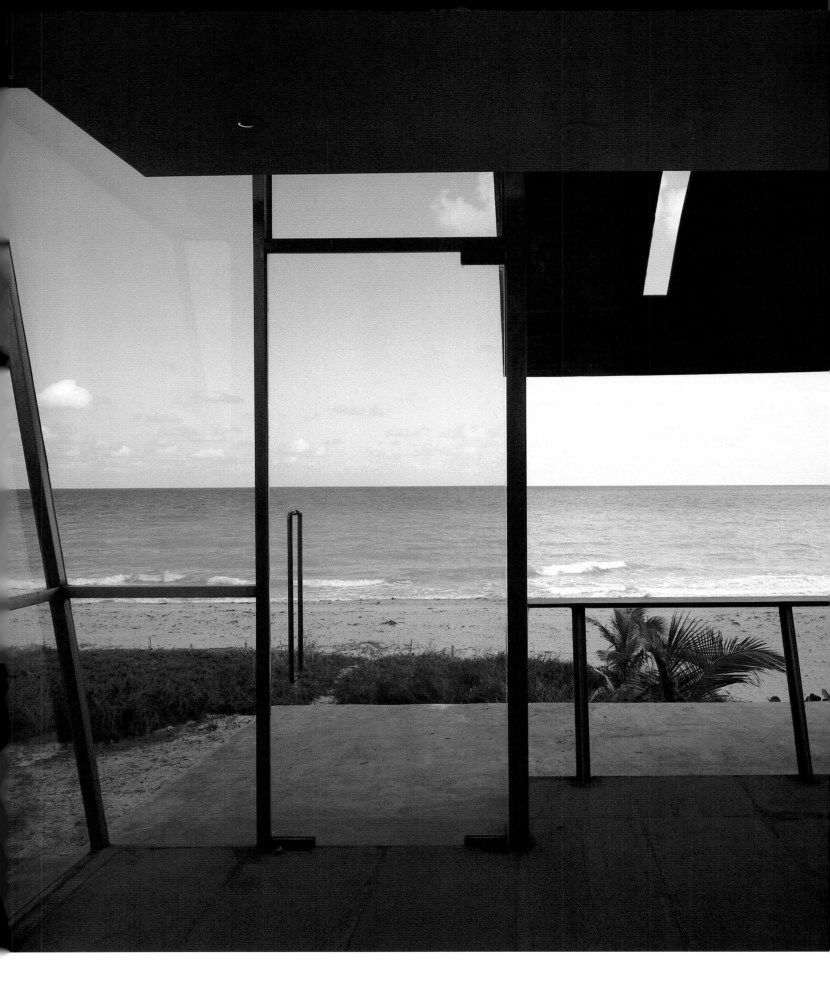

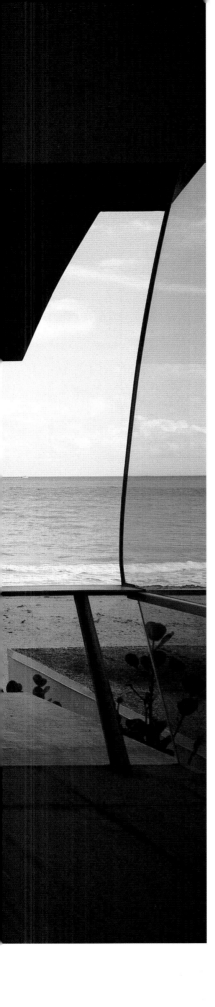

FRAMED LANDSCAPES

The carefully positioned window continues to be a powerful architectural device. The horizontal window that took its cue from the elongated horizontal frames of landscape painting has become the most familiar way for the architect to "fix" the view of the world outside. As buildings became more transparent, the lack of framing not only produced bland, anonymous buildings but also took away the view and with it a sense of security. In domestic buildings, however, the window remains one of the most important elements, for the obvious reason that the client often chooses a site for the beauty of its scenery. As this chapter shows, even the most stunning landscape may be interrupted by creeping suburbia, or a city skyline blighted by ill thought-out speculative development. The window can edit out what the architect wants us not to see. But just as there are no rules about where windows should go, so there are no rules about what size a window should be – or even what shape. What remains important is that the window catches a scene, and presents it in a way we would not otherwise have noticed.

left *This beach house on the Atlantic has a stunning panorama; by cutting a horizontal slit into the copper, the architect has ensured that ocean views can still be seen even when the shield-like contraption is lowered against the sun.*

HIROYUKI ARIMA
MA STUDIO AND GALLERY, FUKOAKA, 1998

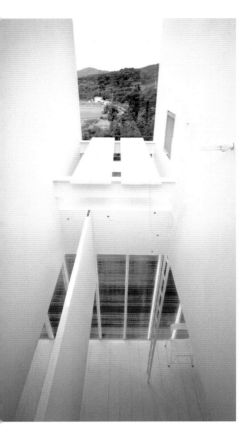

The MA studio and gallery borders Genkai National Park, a rugged landscape about an hour from Fukuoka, the largest city on the southernmost island of Kyushu. Its artist client asked for a working base where visitors could appreciate her work in an exhibition environment; but she also wanted privacy, a space where she could shut herself away to work. The site is on a steep slope, which appealed to its architect, Hiroyuki Arima. The materials are ordinary: cedar strip, cement board, corrugated polycarbonate sheet, tin plate, and stainless-steel net.

From afar, MA looks like a gigantic abstract sculpture. Five cubic volumes are arranged so they appear to tiptoe down the slope, barely touching the earth. This sense of the house connecting with the landscape yet holding its own against the rocky landform is paralleled inside where the architect has designed two sorts of spaces. One is public and the other private, yet there is a strong sense of connection between the two.

On arrival, visitors climb a metal stair to a rooftop gallery overlooking paddy fields and beyond to the sea. Here there are two white-painted boxes: one of these contains stairs leading to what is officially the entrance, the other is a rooftop exhibition space, connected to the main lower gallery by a trapdoor or pivoting panel that lets in light. Yet there is an attempt to mask the outside by diffusing light through windows veiled in corrugated polycarbonate sheeting. The architect describes the curious trapdoors as "reeds", after the part of a woodwind instrument, saying they can "stop" or "flow" light horizontally or vertically. As well as the reed in the gallery roof, similar devices are used either side of the stair down to the studio, which change the configuration of the display areas and seal off or open up areas, according to the position of the reed.

If the atmosphere inside the gallery is deliberately subdued, allowing the visitor to contemplate the art works, the emphasis is very different in the building's most private zone, the client's studio. Here, a large window at one end lets in light and views, creating a focus for this narrow studio jutting out from the cubic gallery volume above.

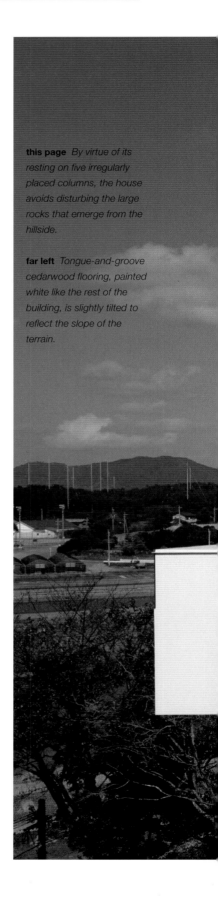

this page *By virtue of its resting on five irregularly placed columns, the house avoids disturbing the large rocks that emerge from the hillside.*

far left *Tongue-and-groove cedarwood flooring, painted white like the rest of the building, is slightly tilted to reflect the slope of the terrain.*

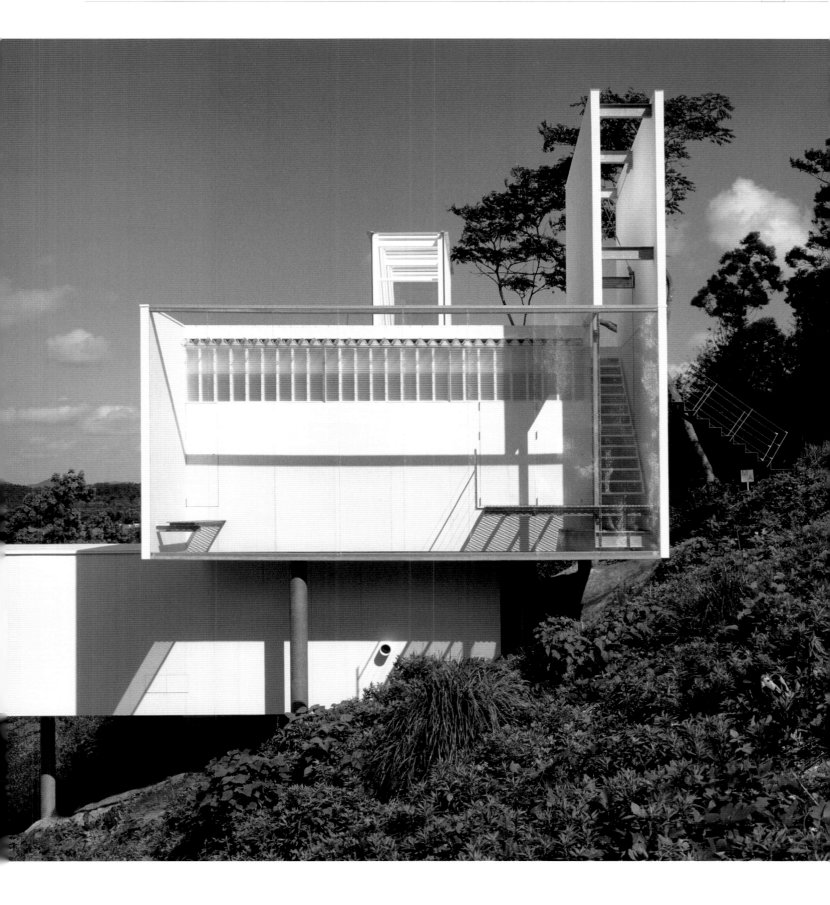

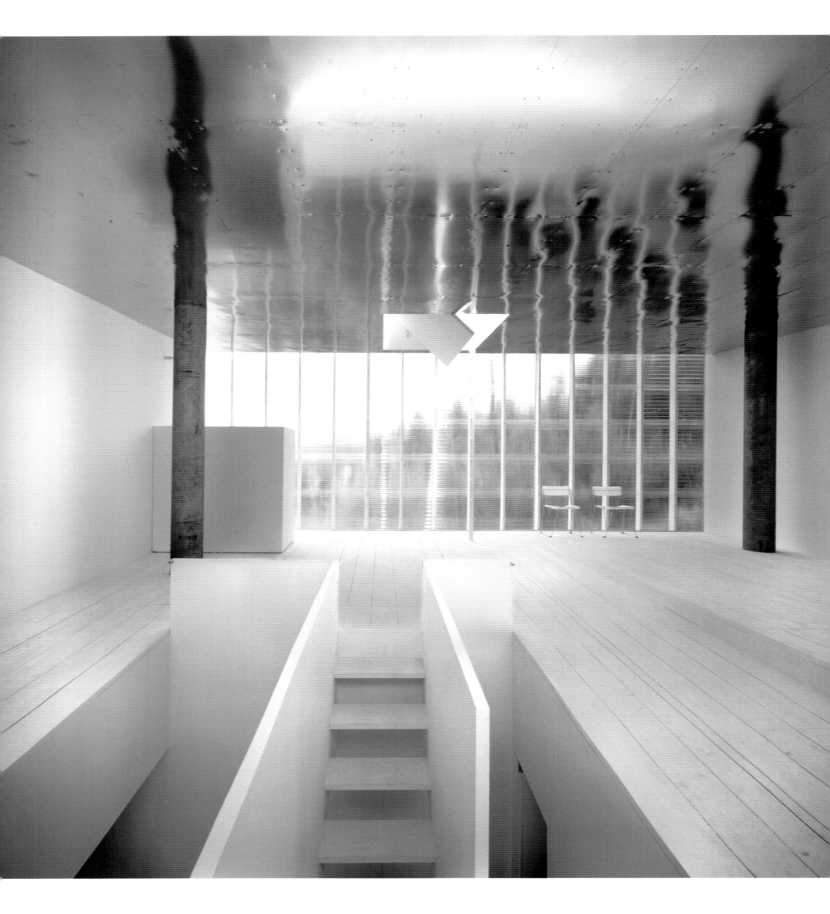

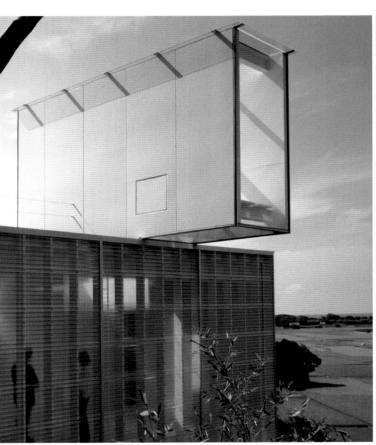

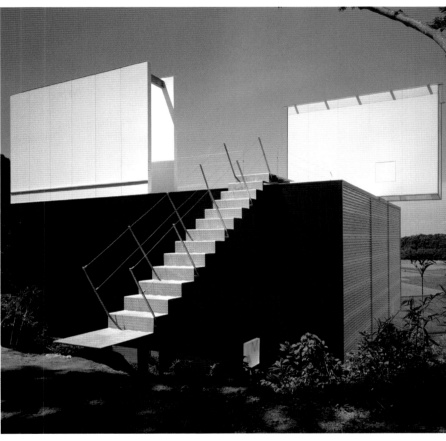

above The rooftop gallery forms an unusual viewpoint over the tapestry of rice fields in the valley below.

left The main exhibition gallery has two light sources: light that filters through translucent polycarbonate sheets and the top light that is controlled by a series of trapdoors, or "reeds".

above The house itself is as much of an artwork as the sculptures that are exhibited there. The roof space is reached via a metal stair that leads up from the parking area.

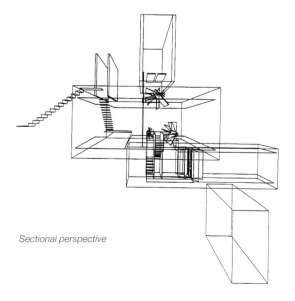

Sectional perspective

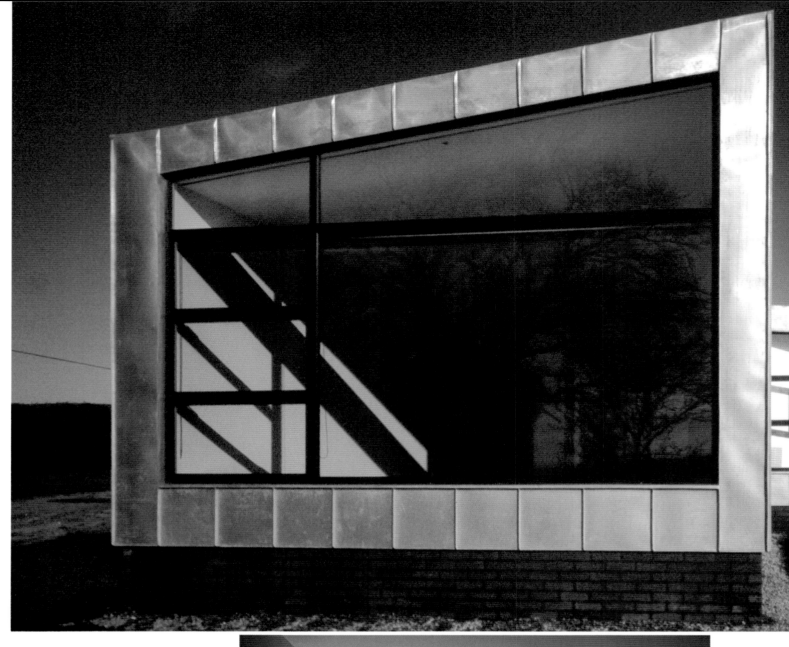

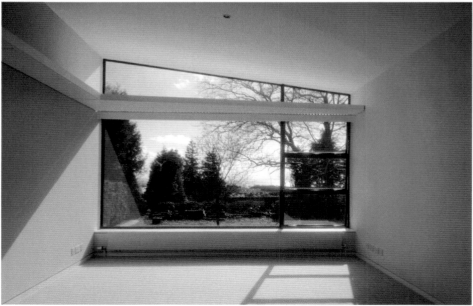

right *The smaller window is described as a "balcony window" and was introduced as a way of distributing the light more evenly through the new living-room extension.*

ALAN JONES

Although rarely considered an interesting part of an architect's repertoire, the domestic extension can deliver surprising results. Alan Jones, based in Belfast, was asked to extend a farmhouse near Randlestown in County Antrim. The owners needed more space for their family and their business. Projecting south into the garden, the extension comprises a study, a breakfast room, and a living-room. The kitchen it is attached to has also been revamped. This was all achieved on a modest budget, yet the architectural ambitions are far from modest. Jones says the idea was to create a "background" that does not compete with the landscape but just "is", allowing the natural beauty to be appreciated.

The steel frame of the extension is just visible from the front of the house, gradually revealing itself as one moves from the kitchen into the study, then the breakfast room, and finally the living-room with its framed view of open country.

Northern Ireland is not noted for its warm climate but the clarity and variation of its light is special, so where possible, windows were oriented towards the south. The architect aimed to harness as much sunlight as possible for solar gain. This in turn led to a series of shutters to block the sun when it is at its strongest. The dramatic living-room window has a folding shutter that prevents sun penetrating through the upper portion into the room The study window also has an ingenious metal shutter that folds horizontally and can be closed in three parts. In all rooms, except the study, woven fibreglass blinds allow 20 per cent light through the fabric. The open weave offers a veiled view out into the landscape.

To the west a large double sliding window provides access to a terrace and the garden beyond, while a smaller "balancing" window brings natural light to the back of the new extension. The delicate framing of views continues inside: a folding shutter between the breakfast room and the living-room, in the same material as the external frame, pivots so that views of the landscape can be appreciated from deep within the original house.

above *The steel frame of the extension reveals itself as one moves through the house to the living-room, with its framed view of the garden and beyond to open countryside.*

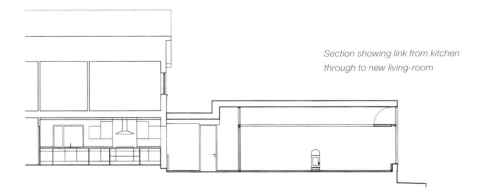

Section showing link from kitchen through to new living-room

CARUSO ST JOHN
NEW ART GALLERY, WALSALL, 2000

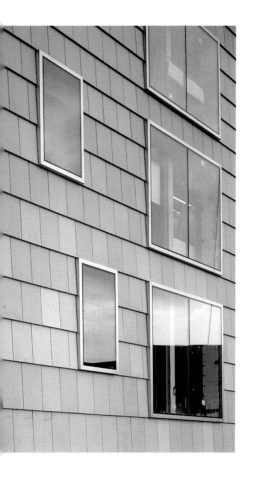

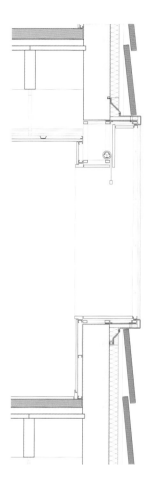

The New Art Gallery of Walsall, in England's West Midlands, looms above its decaying factories, a grey enigma that suggests a world beyond social deprivation and industrial decline. The collection includes works by Rembrandt, Monet, Degas, and Van Gogh, and was put together by local resident Kathleen Garman, widow of the sculptor Jacob Epstein, and her friend Sally Ryan, and left to the town in 1973. National Lottery funding made possible a purpose-built home.

Both the context of decaying industrial buildings and the intimate scale of the works in the collection (most are drawings) had a major bearing on the design. The squat, compact form echoes the factories' functional angularity, while the galleries for the Garman Ryan collection are wood-panelled, small-scale, and lit from windows rather than standard art gallery rooflights. Simply framed in stainless steel and flush with the tiles, they are treated as if they are almost incidental. The interior downplays their importance in a different way. Artfully placed and with minimal timber frames, they take their place on the walls alongside the pictures. In functional terms they have to regulate daylight (roller blinds are concealed in the walls) and complement the artificial light sources in the ceiling.

Above the Garman Ryan collection is a suite of larger, high-ceilinged galleries intended for major travelling exhibitions. Their lighting meets the necessary standards with translucent clerestories which make a continuous band around the top of the building's main volume on the outside. Right at the top, where the volume begins to transform into the tower, is a double-height restaurant, lit by windows on two sides.

The gallery is a series of wilful but carefully contrived gestures. It generates its effects by confronting functional issues directly, with materials finished so as to reinforce their natural character. The way London-based architects Caruso St John use windows is at the crux of this visceral interaction: they are at once functional and symbolic, mute and eloquent testimonials to the strength and coherence of the overall design.

Clerestory window detail

far left *The windows emphasize the building's domestic feel, a deliberate break with the style of most modern galleries.*

right *The windows vary in size but are carefully composed to break up the solidity of the building's boxy form.*

54

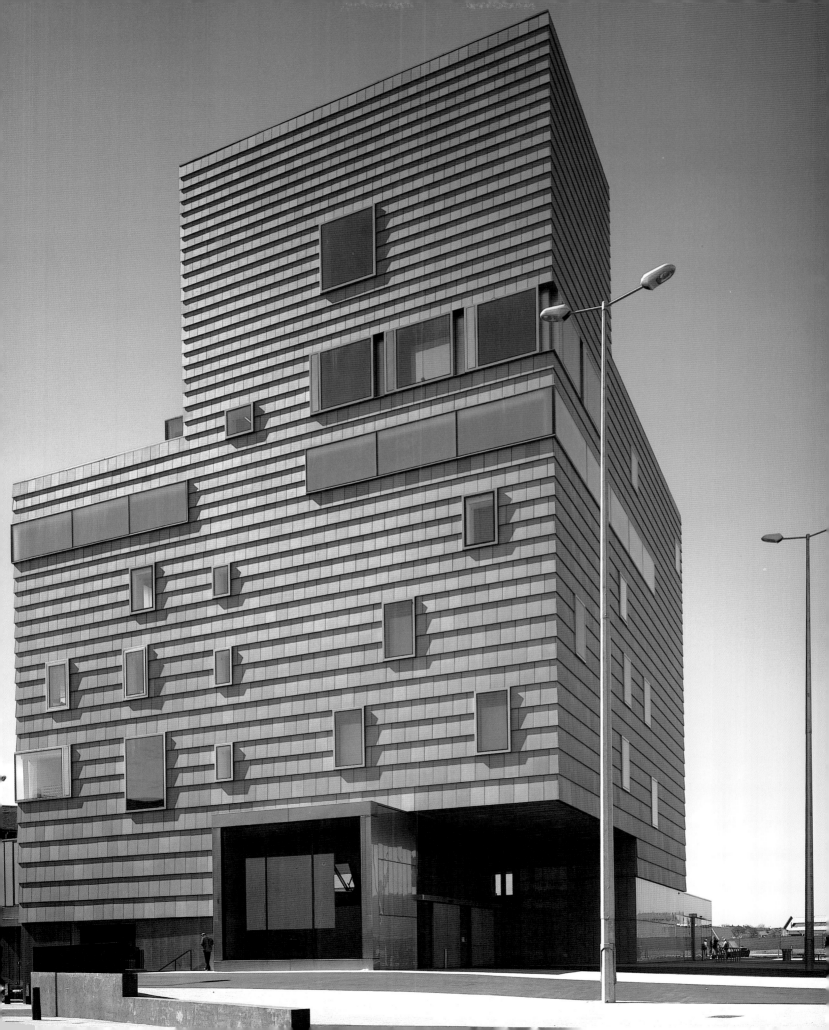

DAVID CHIPPERFIELD
KNIGHT HOUSE, RICHMOND, SURREY, 2002

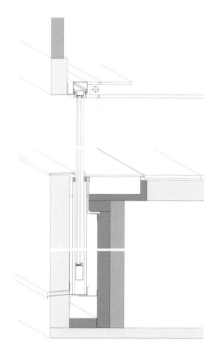

Sectional axonometric showing window fixtures

In 1990 David Chipperfield Architects completed a home for the photographer Nick Knight, extending and reworking an existing 1950s house in Richmond, Surrey. As the photographer's family expanded, they needed more living, working, and storage space.

Knight bought the house next door, an indifferent neo-Tudor affair. Early designs for a second building explored the possibility of extending the architectural language of the 1990 house, but this approach was soon rejected as the unity and coherence of the original project became obscured. Finding an architecture that would exist on its own and in tandem with the older house was complicated further by the resistance of local residents.

When the first house was completed, outraged neighbours had accused the Knights of lowering their property values and attempted to have the house demolished for a technical infringement of its planning permission, an action that would have bankrupted Knight. Second time round, the battles were less acrimonious and the Knights chose to knock down the neo-Tudor house and commission Chipperfield once more. The only condition of planning permission was that the new house should have a pitched roof in slate.

In this way, the architectural concept for the addition placed an archetypal house form (with a pitched roof and two gabled ends) alongside the original house. This new element was then connected to the existing house via an abstracted glass box. Clad in slatted fibreglass shutters, this connecting piece contains the circulation link to the older house at both floors, as well as the main bathroom and storage spaces. During the day these spaces are naturally lit through the translucent cladding, while at night this is reversed with the garden illuminated by an internal electric glow. The main areas of the new house include a master bedroom and a workspace and archive, arranged as two continuous rooms one on top of the other. This gives a sense of openness, exaggerated further by the large bedroom window that slides vertically down to a slot in the wall, transforming the upper room into a kind of internalized balcony or loggia.

above *The bedroom window looks onto the back garden planted with silver birch. The owners wanted the room to be open to the elements, creating an internal rather than an external balcony.*

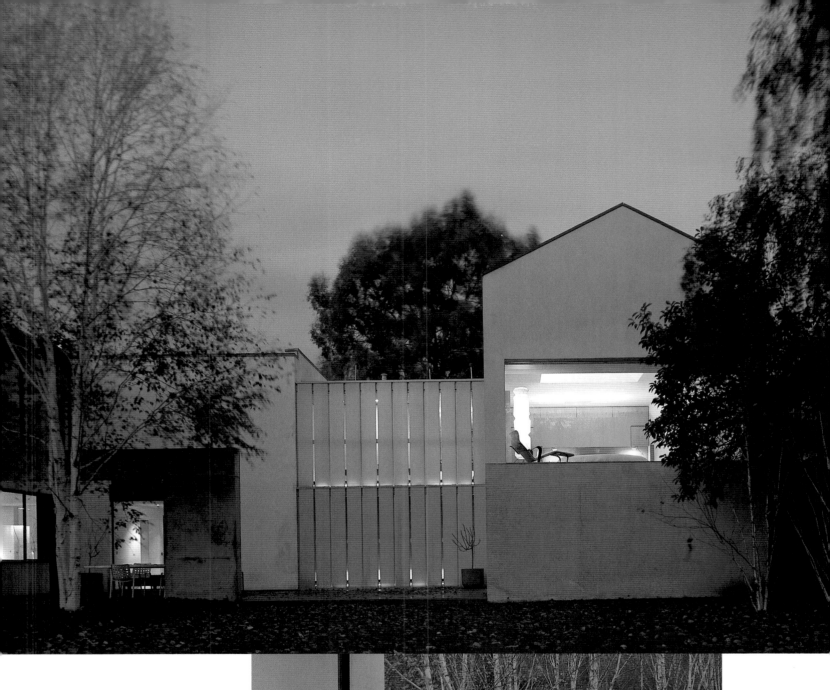

right *The window is designed so that in summer it can drop into a cavity behind the external wall to form a balustrade, which was necessary to comply with building regulations.*
The drawing (far left) shows the fixture for the window in the closed position, when it slides into a cavity in the ceiling, and open, when it drops into the wall cavity.

CARLOS ZAPATA
HOUSE, GOLDEN BEACH, MIAMI, FLORIDA, 1994

Carlos Zapata designs roofs that float and walls that tilt, yet his built projects are also pragmatic and highly liveable spaces. A South American, born in Venezuela and brought up in Ecuador, Zapata worked for the highly successful commercial office of Ellerbe Becket in New York before moving to Miami. His second commission in the city, a house for the Landes family, gave him the freedom to explore his preoccupation with new spatial solutions and his taste for sensuous materials.

The new house sits on the foundations of a 1930s summer house that once belonged to Franklin and Eleanor Roosevelt. The plot is rectangular and narrow, wedged between the ocean on one side and the highway on the other. Although Zapata stuck closely to the original two-wing plan, any resemblance to the original building ends there.

The entrance to the house is from the west and leads to a dramatic two-storey entrance hall. From here a stair leads up to the first floor and either to the south wing, which houses the main bedroom, gym, and study, or to the north wing, which contains children's bedrooms, dining-room, kitchen, and laundry.

So far so normal but, having seemingly begun to play by the rule book, Zapata proceeds to throw it out of the window. It is not entirely clear where rooms begin and end, yet the result is neither discordant nor unsettling. To achieve such an effect, the architect has relied on light. "Light is everything," he says. "Once you detach the roof, the wing, and the walls you get a penetration of light that gives it a sense of time and volume. There are no dark corners."

The way in which light is let into this house is as unconventional as the structure. On the west side, facing the highway, windows are mere slits, which makes the contrast with the east façade even more dramatic. Here, facing the landscape of dunes, vast slabs of onyx and panes of sea-coloured glass are mixed together. The onyx diffuses the light as if whipped by the sea while the glass sharpens views of the ocean. Light is also pulled into the house through a vast curving skylight shielded from the direct sun by a copper fin.

Also facing the ocean is the "casita", or guest house/studio, which in contrast to the swooping curves of the main house is almost a perfect cube. Here, the need to filter the fierce Miami sun has become an excuse to invent a special contraption: a strange copper shield that closes on "jambs" of stainless-steel-wrapped glass and which is raised and lowered by a switch. It is an eccentric detail but one that defines Carlos Zapata's architectural personality: difficult to pin down but never dull.

this page *On the east façade slabs of onyx and glass are mixed together. Laws protecting the local colony of turtles stipulated that the glass be tinted green and double-paned.*

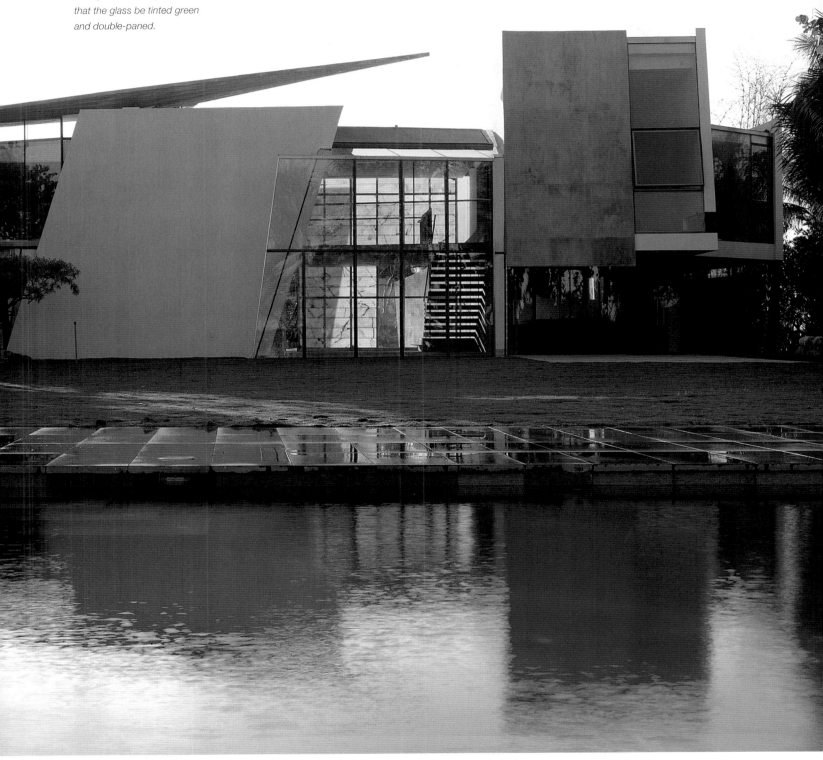

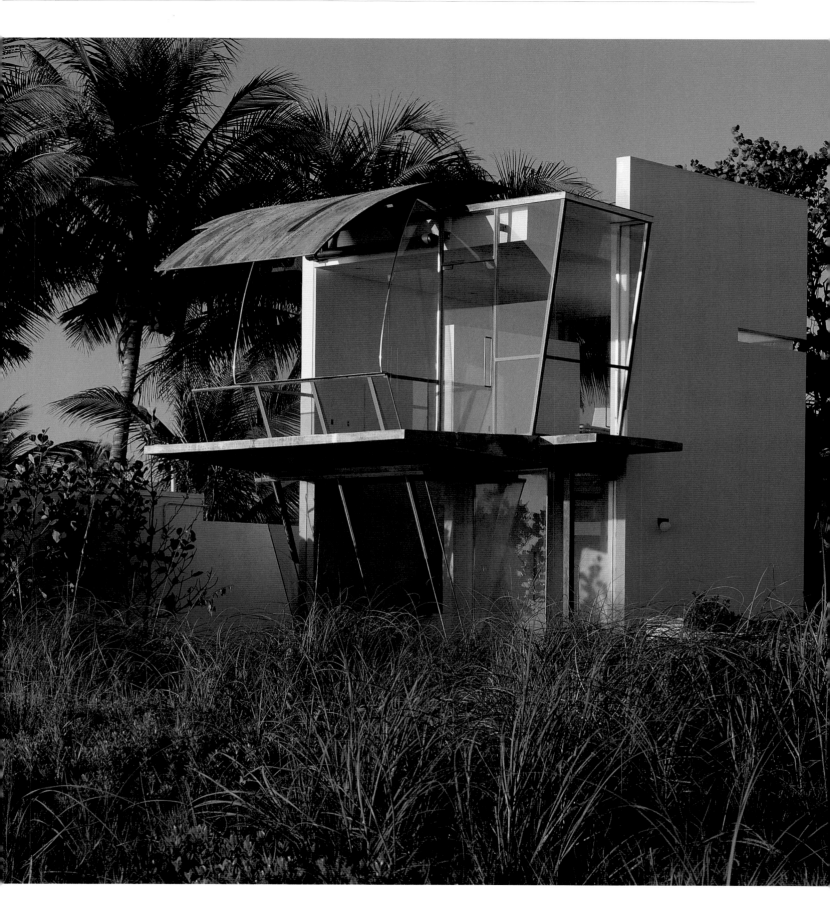

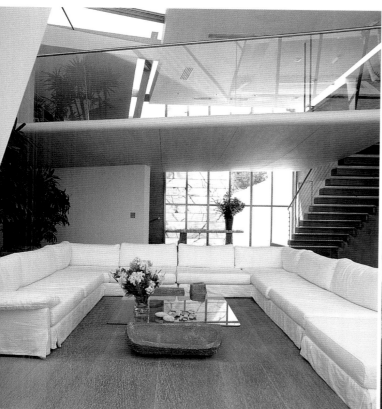

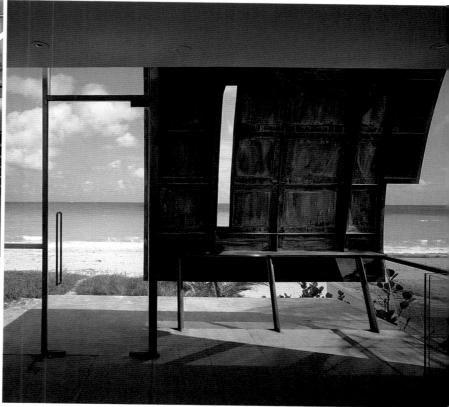

above From the double-height entrance hall
a stair leads up to either the south wing – the adults' area – or the north wing, where the children sleep.

left At the "casita", or guest house, an idiosyncratic copper shield, raised and lowered electrically, acts as a shutter to protect against the strong Miami sun.

above right Detail of the interior of the "casita" looking towards the sea, showing the glass enclosure and the copper shield in the lowered position.

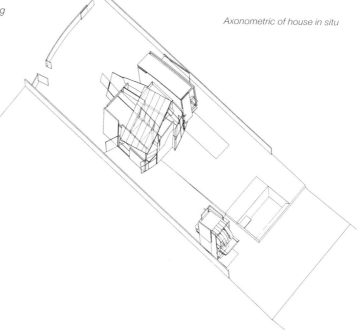

Axonometric of house in situ

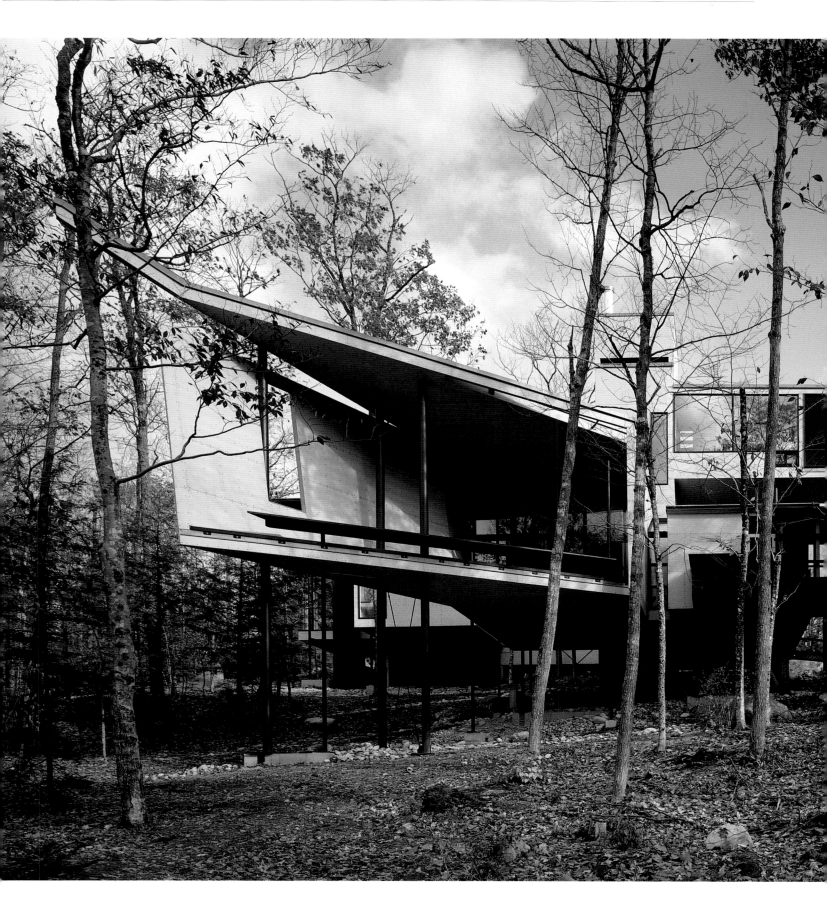

SCOGIN ELAM & BRAY
NOMENTANA RESIDENCE, LOVELL, MAINE, 1997

While the Modernist picture window frames the landscape and keeps the outside at bay, the windows in the Nomentana Residence by architects Scogin Elam & Bray play a very different role. The client, a painter and interior designer, wanted to be close to nature, but living alone and having experienced another sort of nature (in earthquake-prone Los Angeles) she wanted her new house to act as a kind of cloak, with windows that allowed her to look across into different parts of the house, as well as out to the spectacular views.

The unusual pinwheel-shaped plan of the Nomentana Residence is a development of the idea that the house has a motion of its own. "The house is about a forced movement that becomes a companion you constantly have to deal with as you move through it," says Scogin. The various rooms are expressed as a series of small, differentiated volumes yet there seems to be no hierarchy to the plan. The guest bedroom for example is bigger than the main bedroom, and while all rooms have views there is no one place where the view is considered better. Yet moving through the house offers a range of different experiences, from the hallways with their generous window walls reinforcing the idea that nature is everywhere, to a glazed two-storey "impluvium" in the centre of the house that draws in views of the sky.

The decision to lift most of the house on wood and steel columns so it mingles with the trees is an obvious way of bringing nature closer; more unusual is the jutting angular porch on the south façade which has a large opening punched through its thickness. "That gesture is another way of wrapping the house around nature," says Scogin. "The hole lets snow and rain and light come through the house. Nature comes in and falls out."

The Nomentana Residence is a result of form added onto form, spaces adjoining defensively or clustering around each other to resist the long Maine winters. Helped by the positioning of the windows the rooms always seem to be in visual and spatial communication, reaching out to nature without trying to contain it.

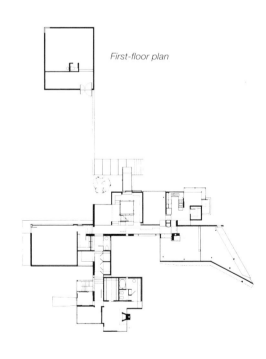

First-floor plan

far left *A window is punched into the cement-board panel of the living-room terrace. The terrace, whose extraordinary sharp angles contrast with the boxy forms in the rest of the house, has views onto a nearby lake.*

63

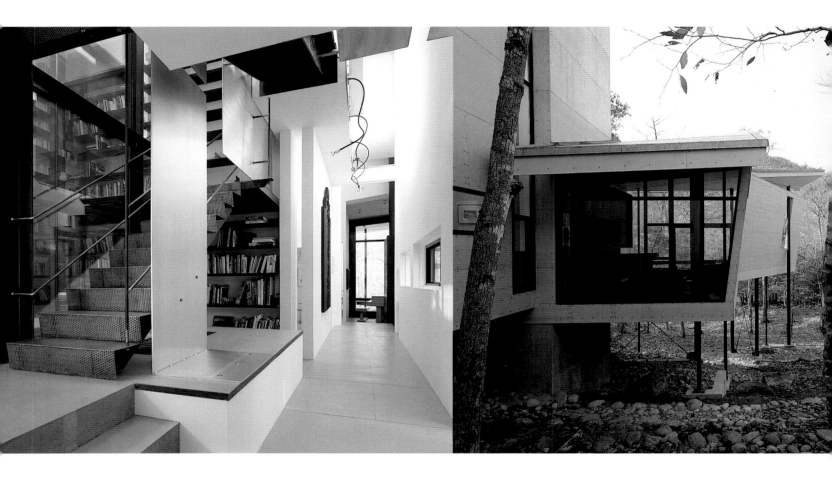

above *Bookshelves and an industrial-looking staircase wrap around a glass-enclosed interior courtyard, or "impluvium", which is there to draw not just light but rain and even snow into the heart of the house.*

above right *The master bedroom features a seat along the windows to take advantage of the forest views. The architect's interest in locating buildings in the perfect spot is a legacy of Frank Lloyd Wright, yet the angular geometry, cantilevers, and complicated plan owe more to deconstruction, a style usually seen in the city.*

right *The house is almost frustratingly hard to read, appearing as a series of white boxes; but the overall objective was to give the client as many views out as possible while also allowing her to see across into other rooms to counter any feeling of isolation.*

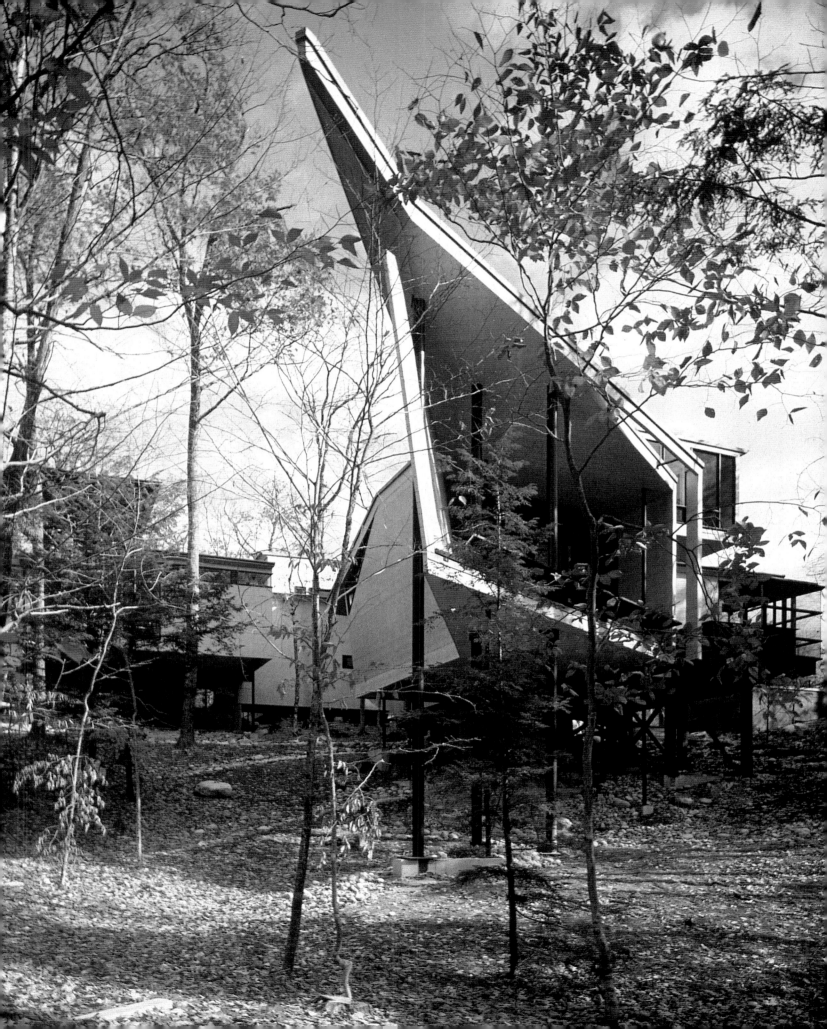

HERZOG & DE MEURON
TATE MODERN, LONDON, 2000

Opened in May 2000, Tate Modern quickly became a destination not just as an art space but as a meeting place and for its spectacular views across the river. The old Bankside Power Station, designed by Sir Giles Gilbert Scott, was in three parts: a central turbine hall, now an eight-storey atrium; a boiler house, which has been turned into galleries; and an as yet unconverted electrical switch station. Visitors enter through central doorways on the second level of the north (Thames) side, or via a ramp at the west end into the first level. There are seven levels. The galleries begin on Level 3 with the Tate's permanent collection. Level 4 has flexible spaces for temporary exhibitions. Level 5 contains two suites of galleries for the permanent collection. Levels 6 and 7 are within the "light beam" – a glazed oblong box that the architect describes as a "huge body of light hovering above the heavy brick structure of the power station".

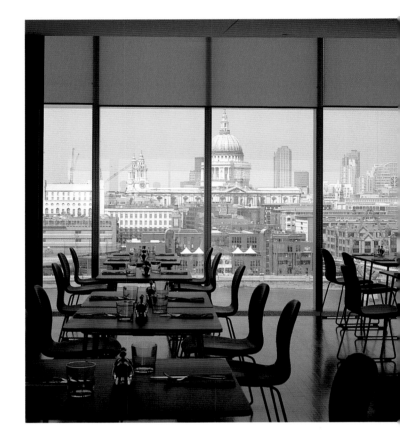

The position, proportion, and scale of the windows are essential to the way the art is experienced. The original vertical strip windows have been retained and upgraded but are secondary to the exhibits, while new horizontal openings on the north façade draw people away from the art to gaze out at the framed views of St Paul's. This connection with the city culminates with the stunning all-round views from the restaurant and public areas in the glass box. Here the theme of social transparency achieves full expression.

The windows are used for looking in as well as out. Being in the gallery can feel like being part of a vast exhibit, and this is part of the architect's aim in making the building as transparent and luminous as possible. The use of glass and the handling of light, most ambitiously in the rooftop light beam, combine to give the impression that the additions are hovering, almost suspended, over the original brick building. This is also true of the internal windows or glazed boxes, places to stop between gallery visits, which the architect describes as clouds floating in the vast turbine hall. These intriguing self-contained spaces are also like benches from which one can simply watch the world go by.

above *The building has seven floors, all but the sixth open to visitors. Lifts, a wooden staircase, and escalators link them. At the top is the restaurant and the quiet East Room, which both have wonderful views of St Paul's on the opposite side of the Thames.*

right *There are two ways in to the gallery. The north entrance on the main façade (seen here) leads directly from the Millennium Bridge; the west entrance takes visitors down a vast ramp and into the Turbine Hall.*

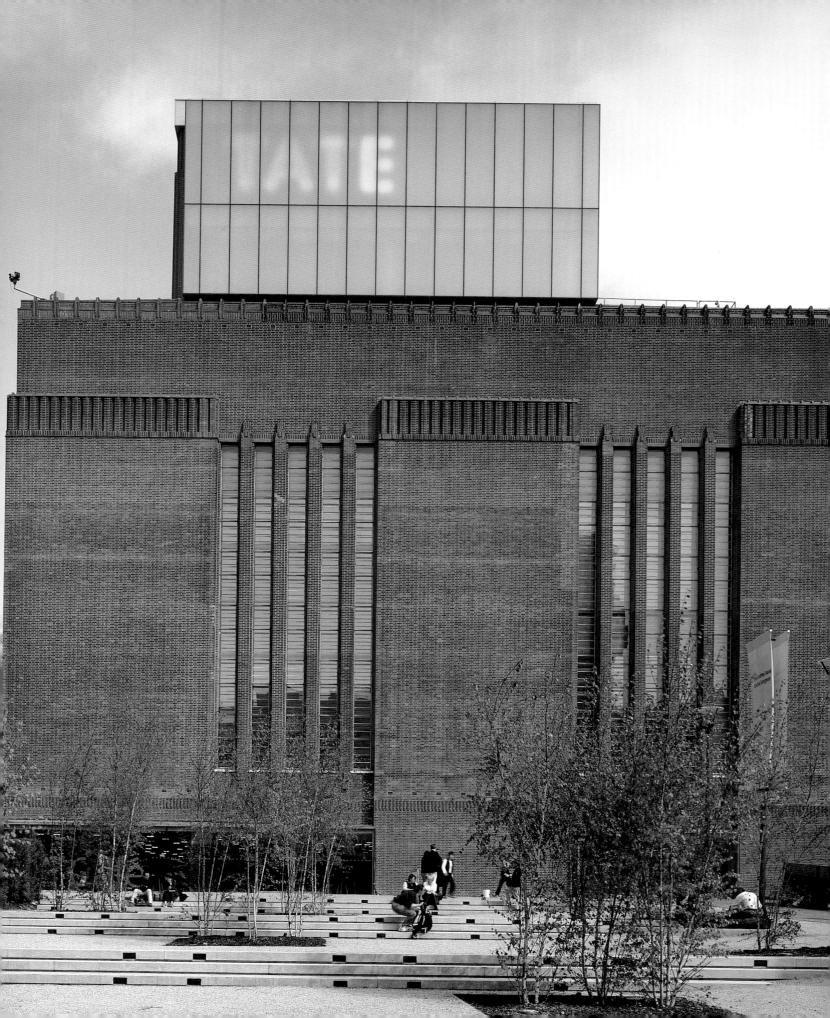

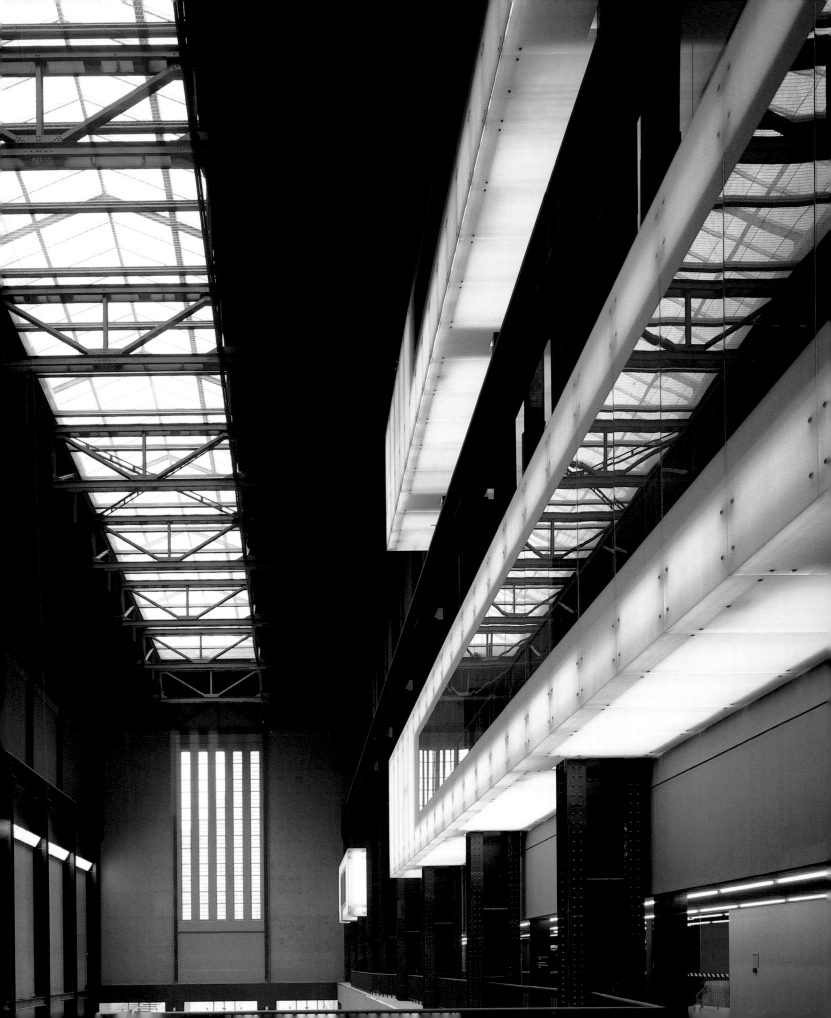

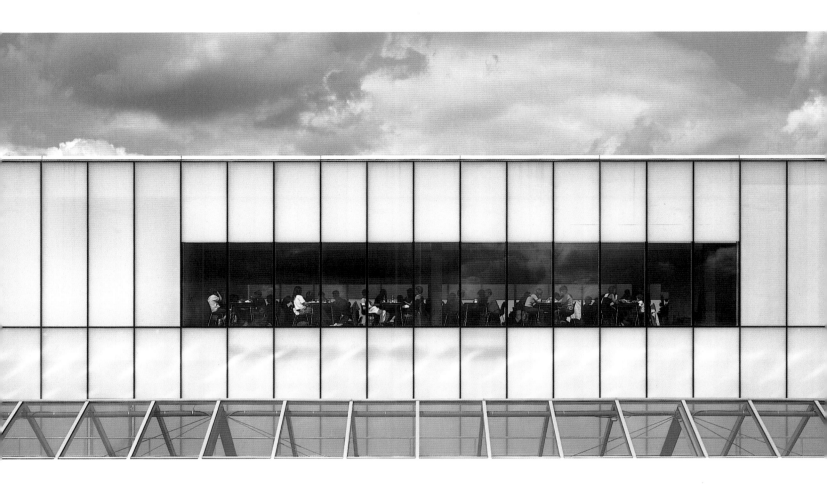

left *The original Turbine Hall roof has been replaced by a pitched skylight, and the aluminium lancet windows refurbished with new glazing added for climatic control. The "light box" windows are interior counterpoints to the exterior light beam.*

above *View of the seventh-floor restaurant's south-facing window. The generous window in the light beam is one of the many framing devices that are used throughout the building.*

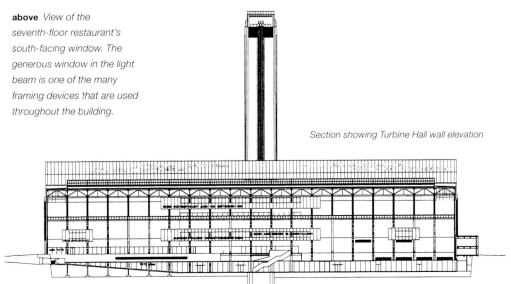

Section showing Turbine Hall wall elevation

WENDELL BURNETTE
SCHALL HOUSE, PHOENIX, ARIZONA, 2000

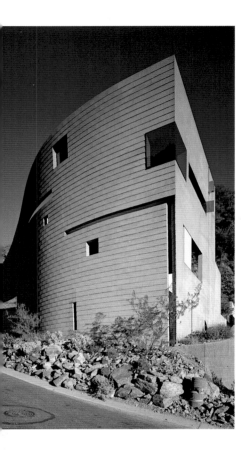

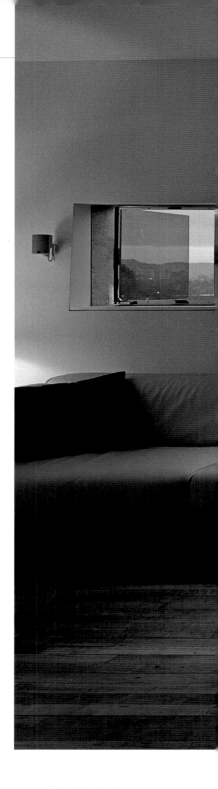

A suburb of Phoenix with the dramatic Sierra Estrella mountains and the Arizona desert beyond would seem an ideal location for a one-off architect-designed house. But the area has been overrun with what local architect Wendell Burnette calls a "hodgepodge of Taco Bells" – the *faux*-Spanish Colonial homes that have become the norm in this neighbourhood. Burnette's design for the Schall House was driven by the need to edit out the context so that his clients, an aeronautical engineer and his wife, could believe they really were living in a modern oasis in a desert. The clients had admired the architect's own house, also near Phoenix, which combined a formal and geometric rigour with windows carefully positioned to maximize views and control Arizona's intense light.

Burnette claims to be carrying on the tradition of Frank Lloyd Wright, "who ... started a tradition of innovation here that is his real legacy". Like Wright, Burnette designs spaces that seem to contract and expand. Set on a winding cul-de-sac, the Schall House appears huge, with a curving concrete-block wall that follows the double curve of the street. But behind this fortress-like exterior, the spaces are intimate and cool. A patio and a courtyard with a pool and a flower garden are reminiscent of houses in Morocco. A vertical slit in the wall allows a breeze to waft across the courtyard and cool the spaces beyond.

It is only once one enters the private domain that the unusual plan reveals itself. The architect has hoisted the main living spaces and bedroom to the second floor while the guest wing and garage are slipped in under the main volume of the house. The point of turning the house upside down is to ensure that what is seen out of the windows are specific views of desert, mountains, city or sky, but not of the house next door. All the windows are individually designed. Some are horizontal strips set flush, others are recessed, and all are fixed. Ventilation comes through 25cm (10in) square openings that have hinged covers, and open sliding glass doors. "My goal," says Burnette, "was to restore serenity to the site." He has succeeded – and the result looks effortless.

far left *The house seems to loom over the site like a vast ocean liner, and the only relief in the solid concrete-block skin is the random window openings.*

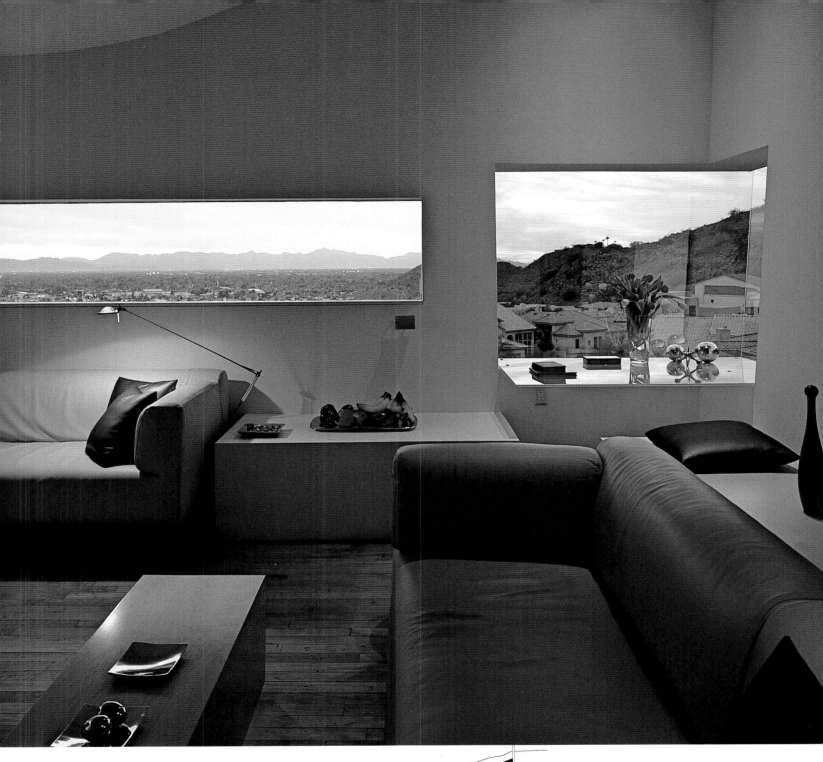

above *Windows are placed only where there are views to enjoy through them. The living-room window wraps around the corner of the building, in one direction framing views of the city and in the other the desert.*

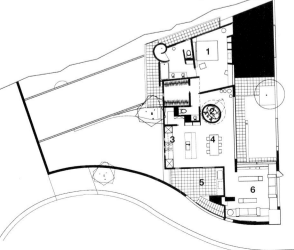

First-floor plan
Key to plan
1 bedroom
2 elevator
3 kitchen
4 dining area
5 barbecue terrace
6 living-room

71

COLOUR & ILLUSION

Architects find colour frivolous; and ever since Modernism unleashed its pure white aesthetic, colour has been slowly bled out of buildings, only creeping back as much-derided decoration. That is the theory. In fact, colour has always been present in architecture. From its very beginnings, applying colour to buildings has been normal, not extraordinary. And Modernism did not decree that all buildings must be white. Le Corbusier is often blamed for giving architects licence to build in grey concrete, but he was one of colour's advocates, if only because it gave "free expression to the joy of white". But in order to avoid looking like styling, colour has to be carefully handled. The best architects think about colour from the outset rather than applying it at the end. Together with light and the manipulation of space, colour can also be used for illusionary effect, giving architecture a sense of deviancy or eccentricity that seems highly appropriate to the urban condition.

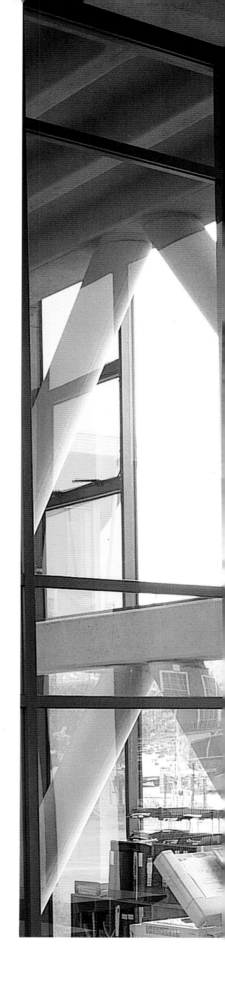

right *The London borough of Southwark needed not simply a library but a focus for the community and a building that would instil a sense of civic pride. Alsop & Störmer's library, with its irreverent design and back wall of glass the colour of boiled sweets, has delighted locals and put Peckham on the architectural map.*

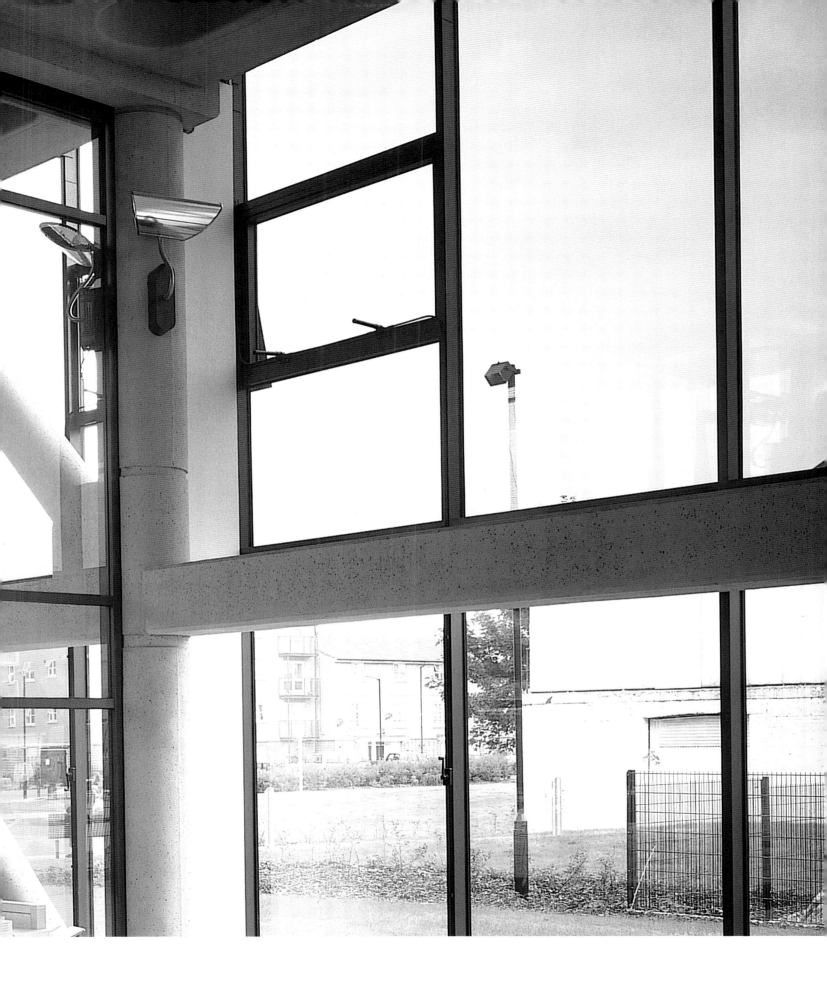

SAUERBRUCH HUTTON
GSW HEADQUARTERS, BERLIN, 2000

In sombre Berlin, the warm hues of the gently curving west façade of the GSW tower are as unexpected as the cheeky Day-Glo hatbox in yellow and lime that tops the new low-rise block under the tower's base. GSW is Berlin's largest housing association and its headquarters on Kochstrasse stands in the historic heart of the city. To respond to this location and to signify the company's social commitment, GSW held a competition in 1995 for an addition or a replacement building. The competition was won by husband-and-wife architects Mathias Sauerbruch and Louisa Hutton, who persuaded the housing association that the 20-storey tower should be retained, while a new building, containing shops and offices, would animate the street with its curving form and bold colours.

This is a building that cannot fail to coax a smile on a grey and chilly morning and it begs the question: why is colour so lacking in modern architecture? Sauerbruch Hutton has certainly done its bit to challenge the norm, first with the peacock-like Photonics Centre on the outskirts of the city. Yet, while colour has become a hallmark of the pair's buildings, they are just as passionate about the need for a sustainable architecture.

Although Germany has some of the strictest energy conservation laws in Europe, many of the office buildings built since reunification are sealed and fully air-conditioned. By contrast, the GSW building has met and even surpassed the tough standards by using both new and tested technologies such as natural ventilation, solar shading, and the exploitation of sun and wind for cooling and heating to limit energy consumption. The building is just as sophisticated as its neighbours but, for those who work there, the joy is in its simplicity – natural instead of electric light, windows that open, and shutters that give protection from the sun.

The high-rise façades are the most important elements of Sauerbruch Hutton's low-energy concept. Fresh air comes through the louvred panels on the east façade and is drawn out through openable windows on the west elevation to a 1m (3ft) wide air space between the insulated glass façade and the single-pane outer skin. Heat rises, drawing in cooler fresh air, and shading is provided by the different-coloured perforated-metal shutters. Just as the GSW staff are encouraged to open their windows to let in a gentle breeze, so the shutters are moved across according to the wishes of those inside, with the result that the pattern formed is always changing.

right Sauerbruch Hutton believes that developing a sustainable architecture is the most pressing, complex, and challenging agenda now faced by architects, and aims to bring this ethical perspective to bear, as much as aesthetic considerations, in all its projects, including the GSW building.

Third-floor plan

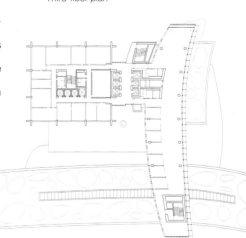

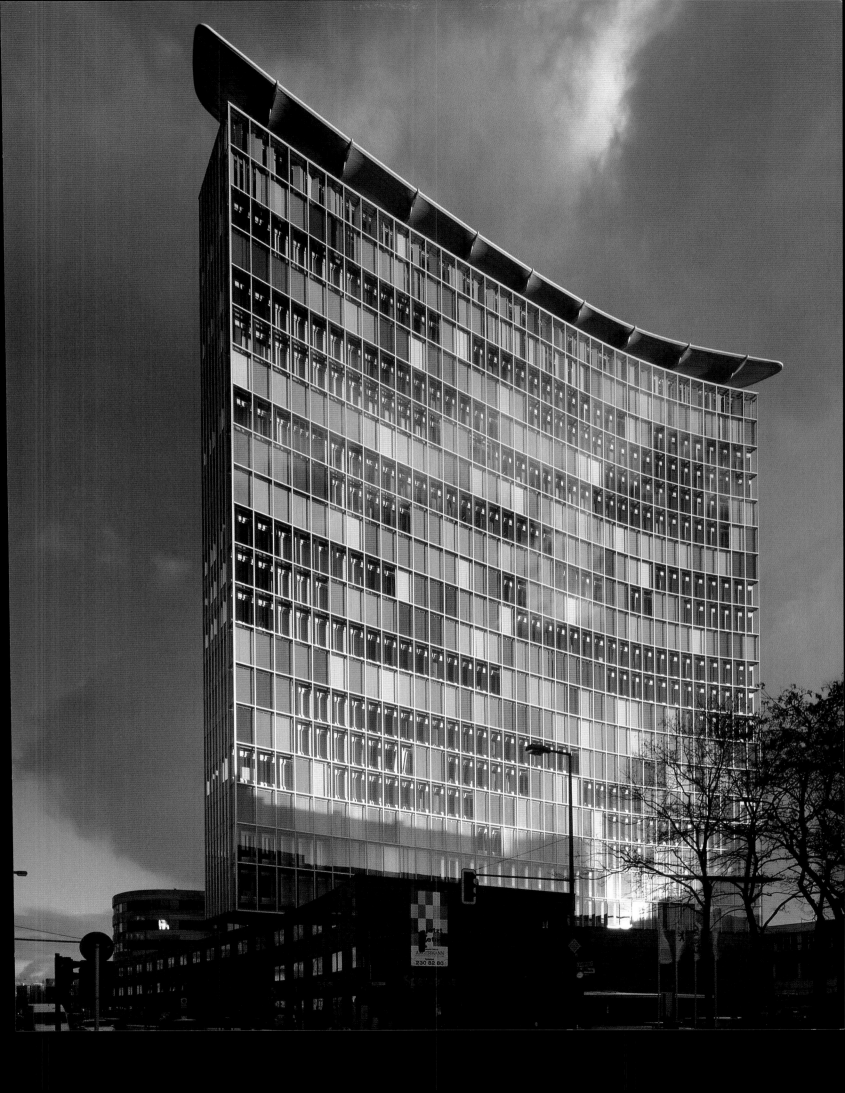

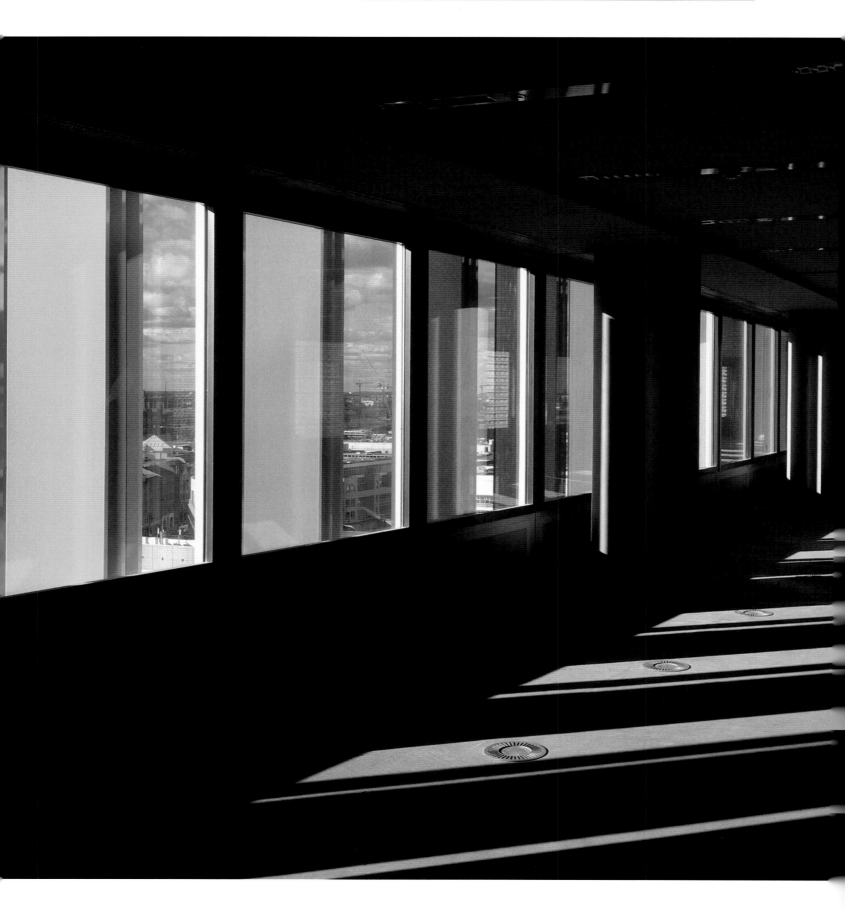

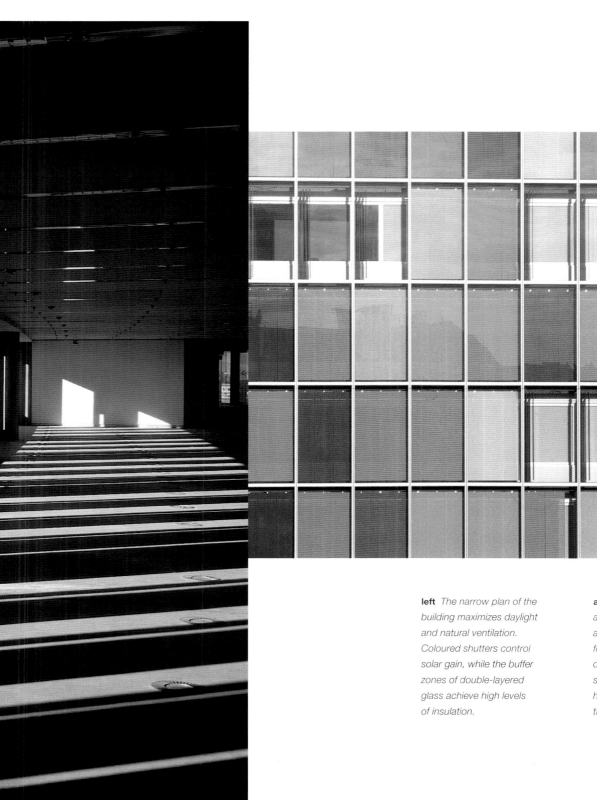

left *The narrow plan of the building maximizes daylight and natural ventilation. Coloured shutters control solar gain, while the buffer zones of double-layered glass achieve high levels of insulation.*

above *The west face is always changing in appearance: the pattern formed by the opening and closing of the coloured shutters depends on the habits and preferences of the occupants.*

TAKASHI YAMAGUCHI
WHITE TEMPLE, KYOTO, 2000

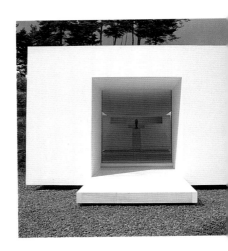

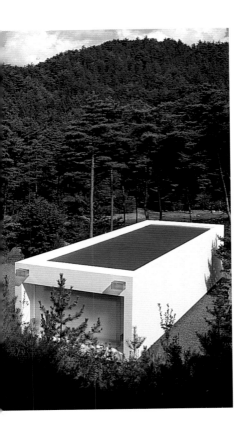

Takashi Yamaguchi occupies an unusual position in Japanese architecture. Although well-versed in contemporary theory and practice he has spent much of his career researching Japan's spiritual spaces, the ancient temples and shrines that are an important part of Japanese life. The 1998 Glass Temple, Yamaguchi's first built project, was an addition to the ancient Reigenko-ji Temple in the hills north of Kyoto. In order to maintain the integrity of the original temple, the new structure is buried with only a slim glass box appearing above ground.

The Glass Temple is a precursor to the White Temple, also set outside Kyoto, but the two projects are quite different. In the former, the architect makes clear his intentions to revive Zen architectural traditions using contemporary materials; in the White Temple, the building's strong geometric form and complete absence of colour or decoration make it almost shocking.

This tiny concrete box set amid timber post-and-beam structures has to express a complex proposition, the progression from this world to the next, as mourners come to say goodbye to the deceased in a ceremony conducted by Buddhist monks. The temple is divided into two halves: one for the living and one for the dead. The first half is for mourners, who watch proceedings from a seating area (*gaijin*) of tatami mats. Just beyond this is the ceremonial area where monks conduct the service, a stepped platform designed to draw the eye up to the light, which is filtered through a large frosted-glass window. Although the window is obscured, it comprises the entire rear elevation and mirrors that of the generous front opening. Narrow frosted-glass skylights span either side of the two openings. The light is never revealed completely, becoming a halo of gold around the Buddha figure that stands at the top of the altar.

Yamaguchi said he wanted to design a building "that exists in our awareness as a membrane so that it dematerializes retaining only an impression of weight". In fact the building only "dematerializes" outside daylight hours: by night, robbed of form, it subsides into darkness and only its luminous interior is visible.

above *Although the temple is severe-looking, the white marble step that projects out from the building encourages mourners to enter.*

far left *In daylight, the temple is a volume that absorbs light and announces its presence. Its startling simplicity and lack of adornment are a marked contrast to the traditional Buddhist temple.*

right *A ceremonial flight of steps on which the monks place memorial tablets draws the eye up to the light. The strict axis signifies the progression from this world to the next, while the light is symbolic of the sadness of death transformed into peace and silence.*

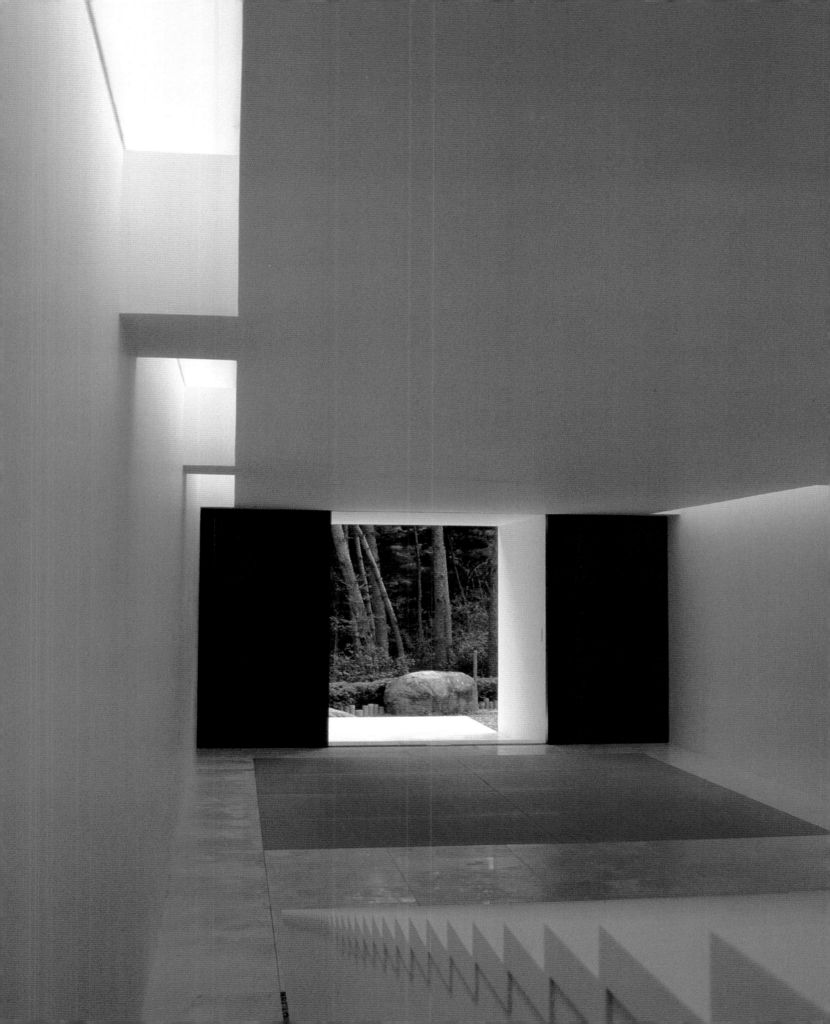

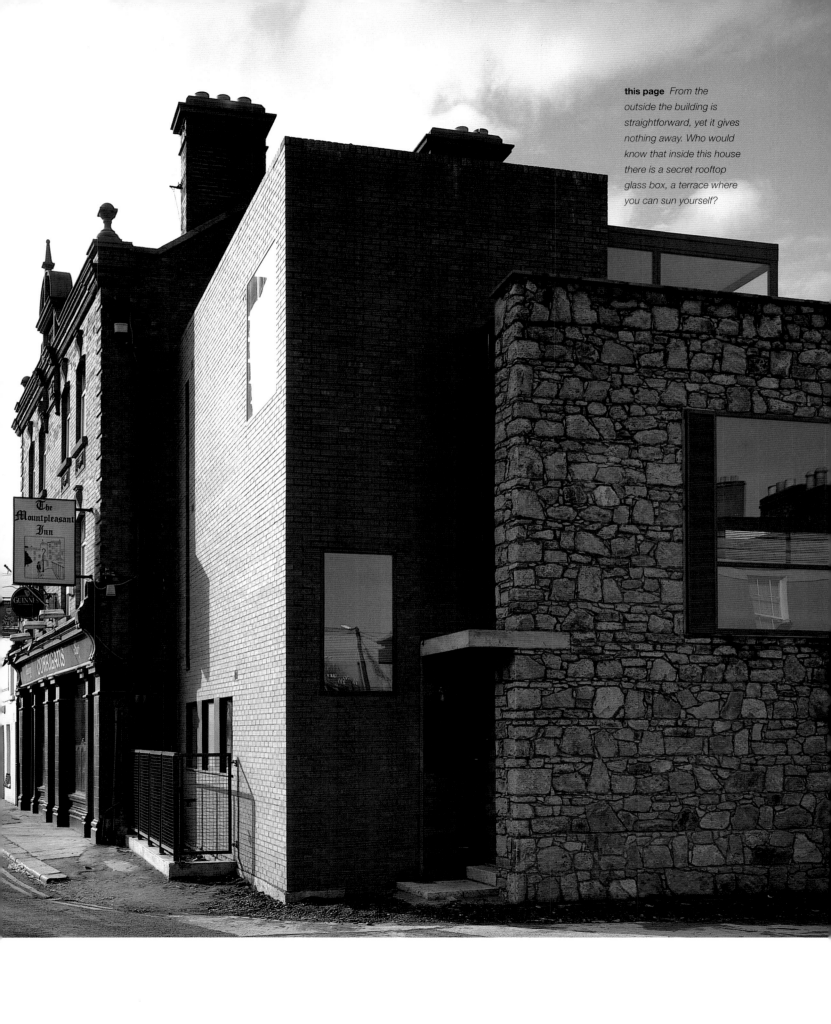

this page *From the outside the building is straightforward, yet it gives nothing away. Who would know that inside this house there is a secret rooftop glass box, a terrace where you can sun yourself?*

GRAFTON ARCHITECTS
HALL HOUSE, DUBLIN, 1999

From outside, it looks as if the owners of Grafton Architects' Hall House want to keep prying eyes out. Apart from the front door, which slides between the stone and the brick wall, the building seems impenetrable. This, of course, only makes you wonder who lives there and what they are doing.

The house sits on a corner site in a tangle of streets between the 19th-century Dublin suburbs of Ranelagh and Rathmines. From the outside the house seems straightforward, reading as two clearly differentiated volumes: a smooth three-storey brick box with a lower stone-fronted piece overlapping it at right angles. But once over the threshold, what appears private and closed becomes the opposite. From the hall – a tiny double-height space lit by the window above – the visitor is encouraged up the stairs to the living areas. The more private spaces – bedroom, bathroom, and study – are on the ground floor.

The house is organized around a pair of simple concrete frames overlapping at right angles. These are clearly expressed at first-floor level where they demarcate the L-shaped space. The dining-room and living-room open onto a timber-decked courtyard divided from the interior by sliding glazed walls. Open, these allow the space to be read as a single volume so that, at times, the house appears to have been turned inside out. Above is a conservatory leading to a roof terrace, a bedroom, and a bathroom. The arrangement is a further clue to the informality of this house and its occupants.

The windows are central to Grafton Architects' fascination with the interface between the lives of the house's inhabitants inside, and the outside world. The rotating windows that light the stairs reflect the sky and give no clue to the activities within; the slit window allows the inhabitants a chance glimpse of passing buses or car lights but is impossible to look through from outside. The big window opening in the stone wall, which the architect describes as the "weather eye" of the house, is the only chance to look in, yet even this gives little away; what you mainly see are shadows. This is a house of contradictions. Step inside and the plate glass suddenly seems remarkably revealing, connecting the inhabitants not just with the street but also with the city beyond.

Section through house

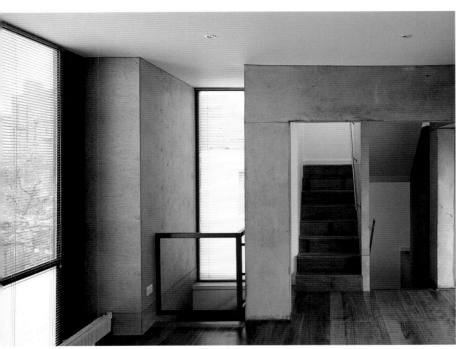

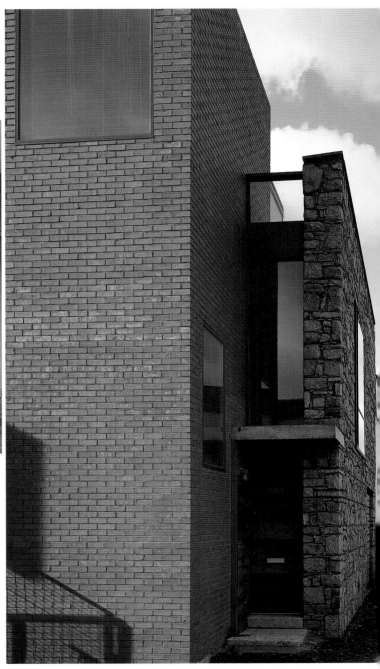

above *A tall, narrow window lights the double-height entrance hall as well as helping to bring natural light to the first-floor living area.*

right *For passers-by the house looks impervious and closed – even the front door is partially hidden, sliding as it does between the main brick box and the stone-fronted façade.*

right *Sliding glazed walls divide the dining-room and living-room from the timber-decked courtyard, meaning that at times the interior and the exterior seem hardly differentiated. At the top is a conservatory leading to a small roof terrace.*

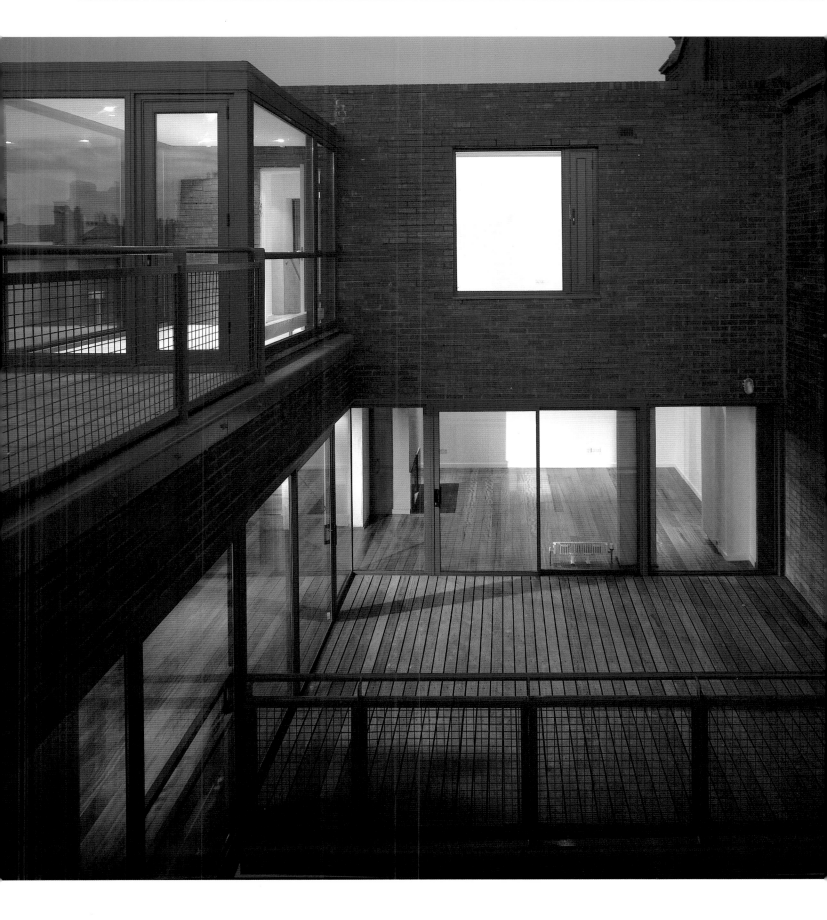

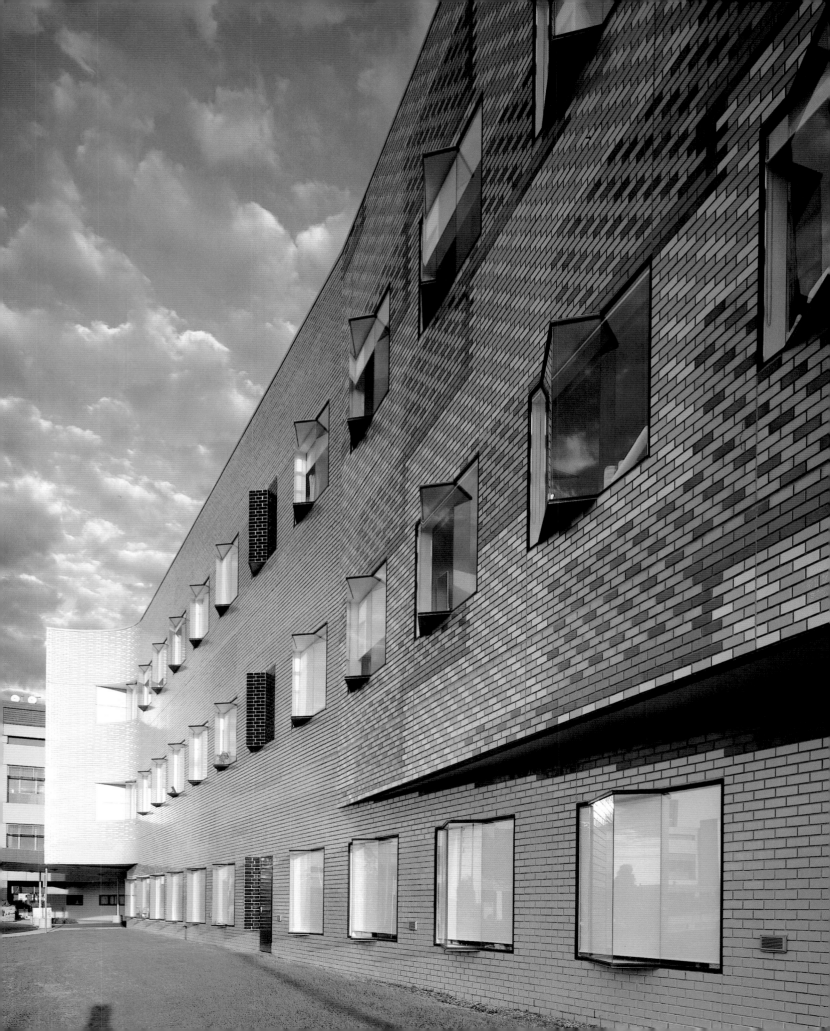

LYONS
SUNSHINE HOSPITAL, MELBOURNE, 2002

Health buildings are rarely able to transcend the limitations of type; they have become places that lack either civil or social significance. This is partly because hospital design has become such a specialized sector that it has been unable to encompass new talent or individual thinking – but there are exceptions. Melbourne architect Lyons believes that hospitals should engage with the outside world, so it turned a fairly standard list of requirements for an extension to the city's Sunshine Hospital on its head. The extension includes a suite of surgical theatres, a new building to house the hospital's hydrotherapy facility, and a three-storey ward block.

The brazen exterior is partly achieved by the glazed bricks, which create a surface pattern in a combination of grey, white, orange, yellow, and blue. A line of black bricks marks the shadow that is caused by the upper two storeys cantilevering out at the middle of the block, while more black bricks denote another shadow on the short eastern wall under a canopy over a secondary entrance.

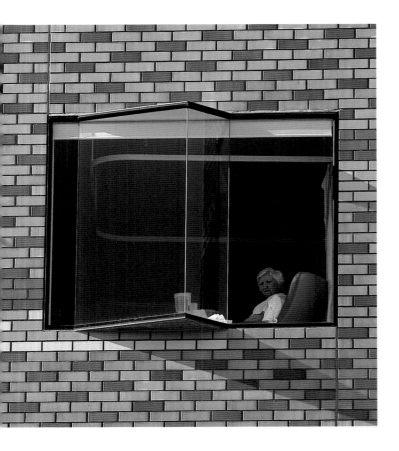

above *Few hospitals consider the patient's relationship with the outside world to be important; wards are often inward-looking. But at Sunshine each room has its own generous window so that although patients are temporarily confined they do not have to feel cut off from the world.*

left *Architects continue to reinterpret the bay window. Here the bay is formed from two narrow panes joined at an angle, set within a large sheet of plate glass that is flush with the façade.*

If colour is the first impression, it is the windows that challenge passers-by to take another look. On the north elevation they are private with awnings whose shadow creates another layer of pattern over the coloured bricks. The hydrotherapy block is given a slightly different treatment. The bricks are different shades of brown and beige and left unglazed, but the building refers closely to the main ward block, with black brick picking out the shadows, while the windows are set high for privacy. The most unusual are the windows on the ward building's south elevation, which project as a bay with a base low enough to sit on and wide enough to serve as a generous shelf for flowers and cards.

From here patients can watch the comings and goings in the car park and on the freeway beyond. It is not a beautiful view in the conventional sense but it gives the patient a sense of connection with the world beyond the institution. And for passers-by, the views into the wards give the hospital a more human and welcoming face. This is especially true in the evenings, when the façade becomes a grid of poignant scenes.

85

above The eye-catching façade of the ward block is composed of coloured glazed bricks. The shadows have been "coloured in" and are in fact black bricks where a real shadow would fall.

above right The ward block is to the left, the hydrotherapy unit to the right. The buildings have an obvious relationship but the windows on the hydrotherapy building are smaller and higher for privacy.

Ward building, south elevation

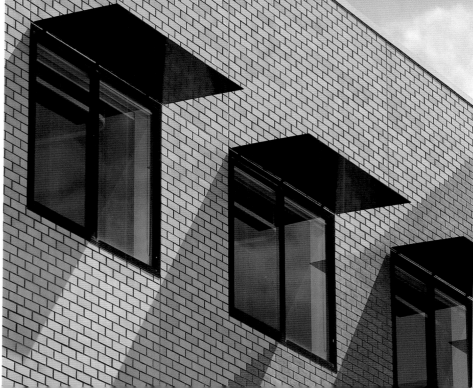

left *The windows on the north façade that look across to the hydrotherapy block are more private than those on the south. Metal awnings give shade and their shadow is delineated in black brick.*

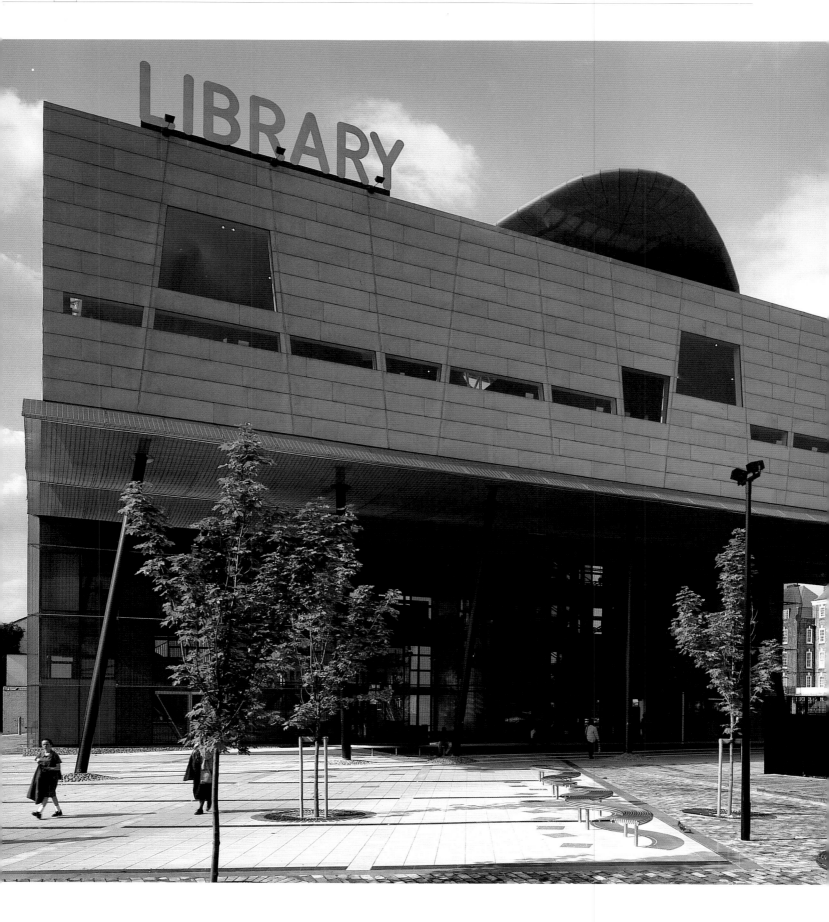

ALSOP & STÖRMER
PECKHAM LIBRARY, LONDON, 1999

Alsop & Störmer's Peckham Library punches above its weight in more ways than one. Built in one of London's most deprived inner-city districts, it is a modest building yet one that is changing ideas of what public libraries should be – and how they should look. Will Alsop's building heralded a new type of library, one that still houses books and information but is as far removed from the sombre brick affairs of the 19th century as it is possible to be.

Looked at sideways the building is in the shape of an inverted L; its underbelly is a stainless-steel mesh and on the rooftop sits what appears to be a giant orange tongue. The building is blue on three sides while the fourth is a variegated pattern of large panels of yellow, magenta, and turquoise glass. A large illuminated sign spells out the word LIBRARY, and the entire building appears to be supported on spidery columns leaning at strange angles. The windows may appear to be one of the more conventional features in this highly unconventional work, but do not be fooled. This is an architect who likes to flout architectural convention whenever possible.

On two sides, the patinated copper skin is punctured by tiny windows set flush with the façade, giving no clue to the activities inside. The main, south-facing elevation gives a little more away – bigger openings and different shapes, like a row of not-quite-perfect front teeth. These windows offer glimpses of the three extraordinary plywood pods – raised free-standing spaces – in the double-height lending library and, at night when the building is floodlit, the view in through them gives the impression that the pods might at any minute burst through the roof.

But it is the five-storey north façade where the boldest move is made. Although there are conventional window openings, the entire façade is a window wall, a patchwork of transparent coloured glass that allows daylight to flood through and past the muscular concrete frame, creating a pattern of colours across the library wall.

left *The library stands on seven gravity-defying stilts. Above the roofline is a vermilion-coloured flying-saucer-shaped lid. Dubbed the "beret" by the architect, this acts as a shade for the ventilation shafts.*

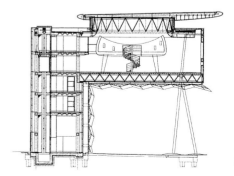

Cross section through library

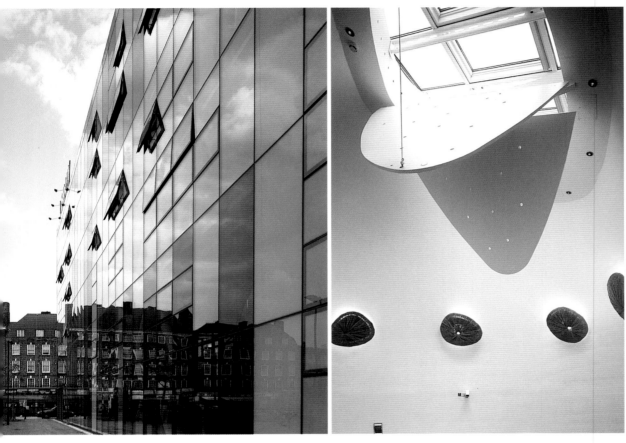

above *The patchwork of coloured-glass panels reflects the surrounding buildings and streets and, from inside, provides an unusual filter through which to see the London skyline.*

above right *Electrically operated butterfly-wing shutters monitor levels of light and ventilation in the timber pods, which are free-standing spaces in the main library hall.*

right *The north face is a window wall of transparent coloured glass that allows daylight to be distributed evenly throughout the building. The actual library element of the building (the top two floors) is deliberately raised above the hubbub below, allowing readers the opportunity for quiet reflection as they browse the books or admire the views.*

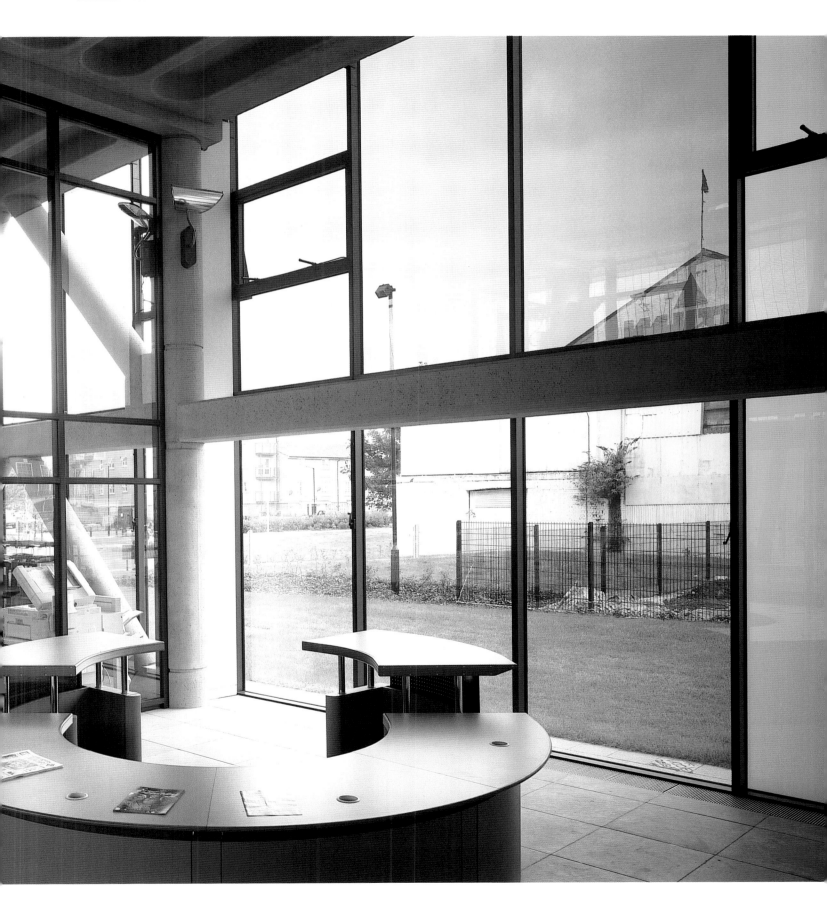

GIGON/GUYER
SIGNAL BOX, ZURICH, 1999

"Building is actually a kind of transformation of the earth's materials," says Annette Gigon, one half of the partnership Gigon/Guyer. While the firm is best known for three major art museums in its native Switzerland, it is the signal box in Zurich where its fascination with weathering and colour has been most thoroughly explored. Gigon/Guyer are not the first avant-garde architects to be commissioned by the Swiss Federal Railway as it gradually replaces about 50 signal boxes around the country. Herzog & de Meuron's signal box next to the tracks at Zurich, and Morger & Degelo's at Basle are also part of this programme, which not only shows the railway as an enlightened patron, but also demonstrates that purely functional buildings can have a distinctive image.

For the signal box, the architects were inspired by the patina of iron dust released by train brakes, which covers everything along the tracks. By incorporating iron oxide pigment in the concrete mix, the static dull grey material of concrete is replaced by a rich, evolving mix of hues from yellow and orange to deep purple. This is a process that Gigon/Guyer likes to call "alchemy"; the flat surface of the concrete appears to be deepened and, as the iron pigment rusts, the building changes from day to day and in response to weather and light conditions.

The three-storey signal box stands next to the railway tracks on the industrial outskirts of Zurich and houses the computerized switching station that services a large portion of the network. The building is close to the Gottlieb Duttweiler Bridge, at the point in the city where housing gives way to industrial districts. The top floor is used for offices and workspaces. The lower floors contain technical equipment such as relays, computers, rotary converters, power equipment for the rail system, and ventilation facilities.

Only the control room and workspace have windows, described by the architects as "like shiny eyes watching over the tracks". They consist of a sealed inner leaf that can be opened from inside and a floating outer sheet of glass that serves as a sunscreen. Horizontal blinds regulate the light reaching computer monitors in the control room. The glazed sunscreen is coated with a reflective vaporized metal that is reddish-gold in colour.

above *The five large windows on the top floor, two of which can be seen on the south façade, function as an ever-present reminder of the building's function – to monitor the tracks. By day highly reflective, at night, lit from inside, they appear to glow.*

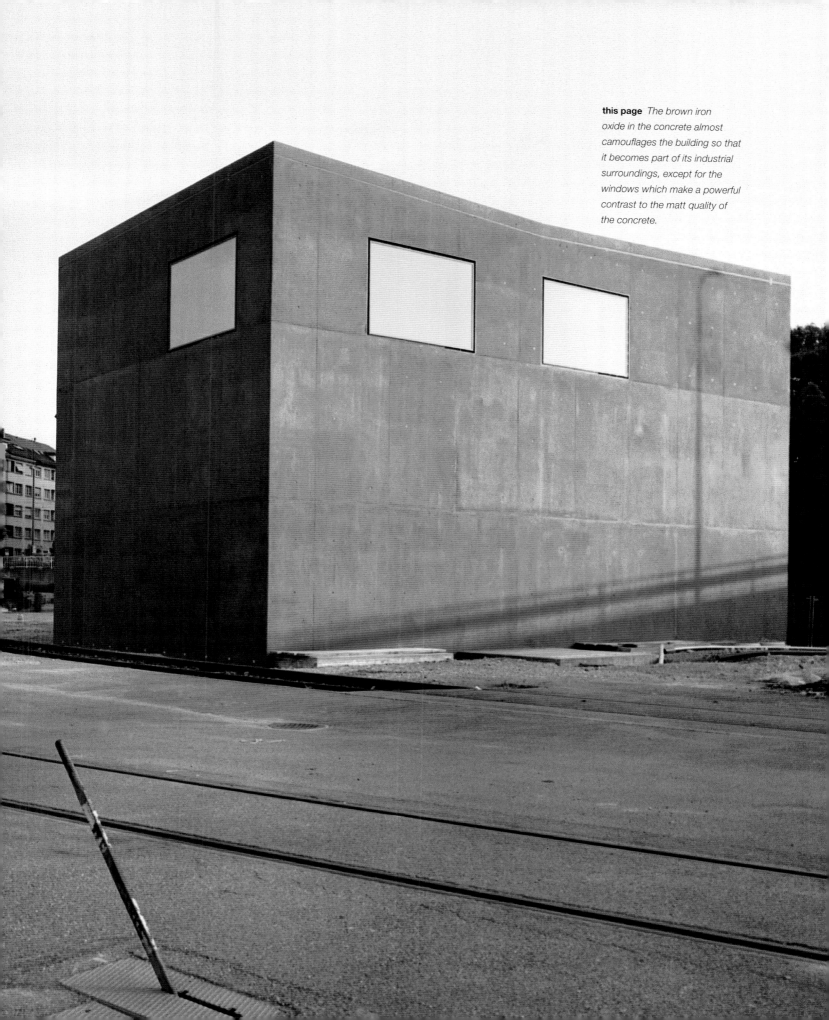

this page *The brown iron oxide in the concrete almost camouflages the building so that it becomes part of its industrial surroundings, except for the windows which make a powerful contrast to the matt quality of the concrete.*

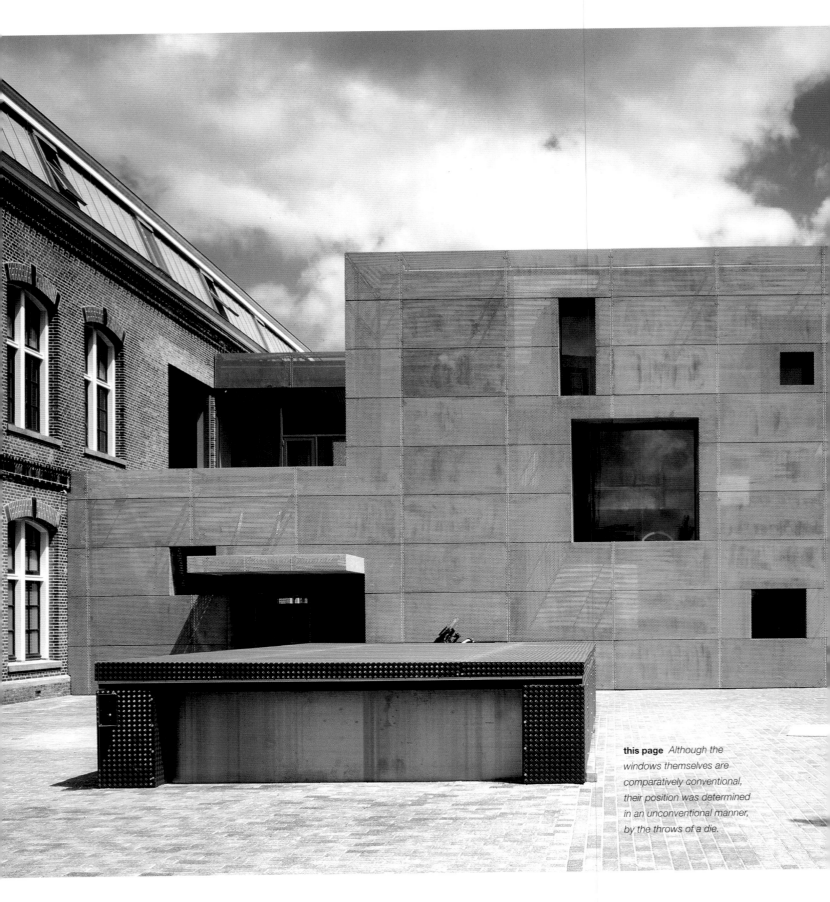

this page *Although the windows themselves are comparatively conventional, their position was determined in an unconventional manner, by the throws of a die.*

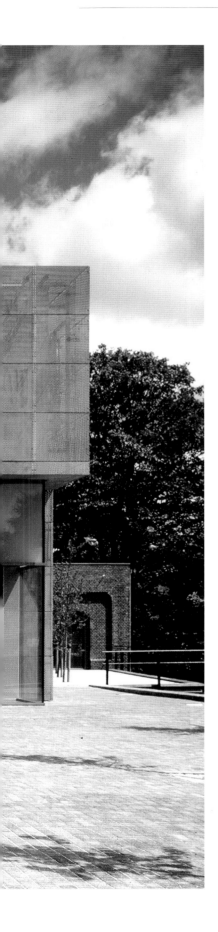

STEVEN HOLL
HET OSTEN HEADQUARTERS, AMSTERDAM, 2000

This enigmatic little pavilion, an extension to a converted warehouse, stands on Amsterdam's Singel Canal. Its luminous texture, mysterious voids, and blurred edges belie its function as part of the headquarters of the housing company Het Osten. As a work of architecture it attempts to address the balance between thought and feeling: Holl's scheme leavened concepts from mathematics and music with patterns generated by throws of a die, so it is not surprising that all is not what it seems. What is solid or void, window or wall, is ambiguous.

The basic form derived from a complex mathematical construction called a Menger Sponge, in which each face of a cube is divided into nine squares and certain squares are removed. Holl used throws of a die to decide which squares to remove, so that the positions of the windows became random. At this stage the voids were an obvious visual feature even if their positioning was random, but Holl

Section through façade

introduced further devices that generated more layers of ambiguity. The pavilion's outer skin is made of pre-patinated, perforated copper panels, about 50cm (20in) outside the stuccoed wall. Inside the wall is a layer of perforated plywood panels, back-painted with fluorescent colours whose random application also came from throws of a die. Between these skins are the windows, relatively conventional assemblies of glass and frame. As both skins of perforated panels overlap the openings, light is filtered, refracted, coloured, and reflected with almost infinite variety, although its possible configurations come from a fixed numerical system. The effect is constantly changing with the movement of the sun.

Part of Holl's inspiration came from the site, specifically the way light bounced off the canal. He was familiar with the tradition of Dutch painting in which domestic interiors are transfigured by mysterious openings. In the pavilion he intensified that tradition with his interest in the action of chance within predetermined parameters, partly inspired by the music and ideas of composer Morton Feldman. Holl's approach enriches the expressive possibilities of openings: to make the windows simple sheets of glass to let in light, but to use the inner and outer skins to transform that light with glorious variety and invention.

95

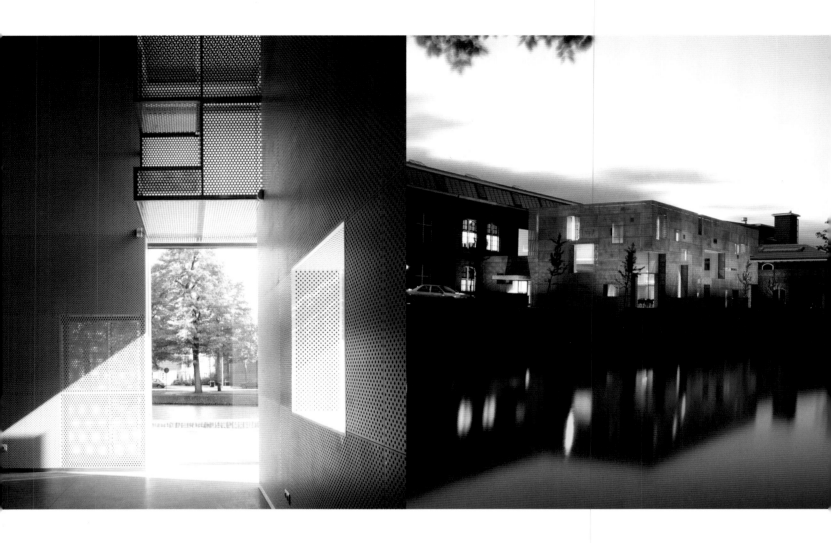

above The decision to build
walls in perforated layers –
the outside metal, the inside
plywood – was made not
only for compositional
reasons but also for technical
ones, to hide the services.

above right The window
pattern that perforates
the outer shell in carefully
achieved arrangements
and colouring reveals the
architect's interest in
music and art.

right The main space, which
is used for conferences and
as a restaurant, is pierced by
a mezzanine, adding to the
play of solids and voids and
the careful gradations of light.

*Section showing connection between
new extension and existing library*

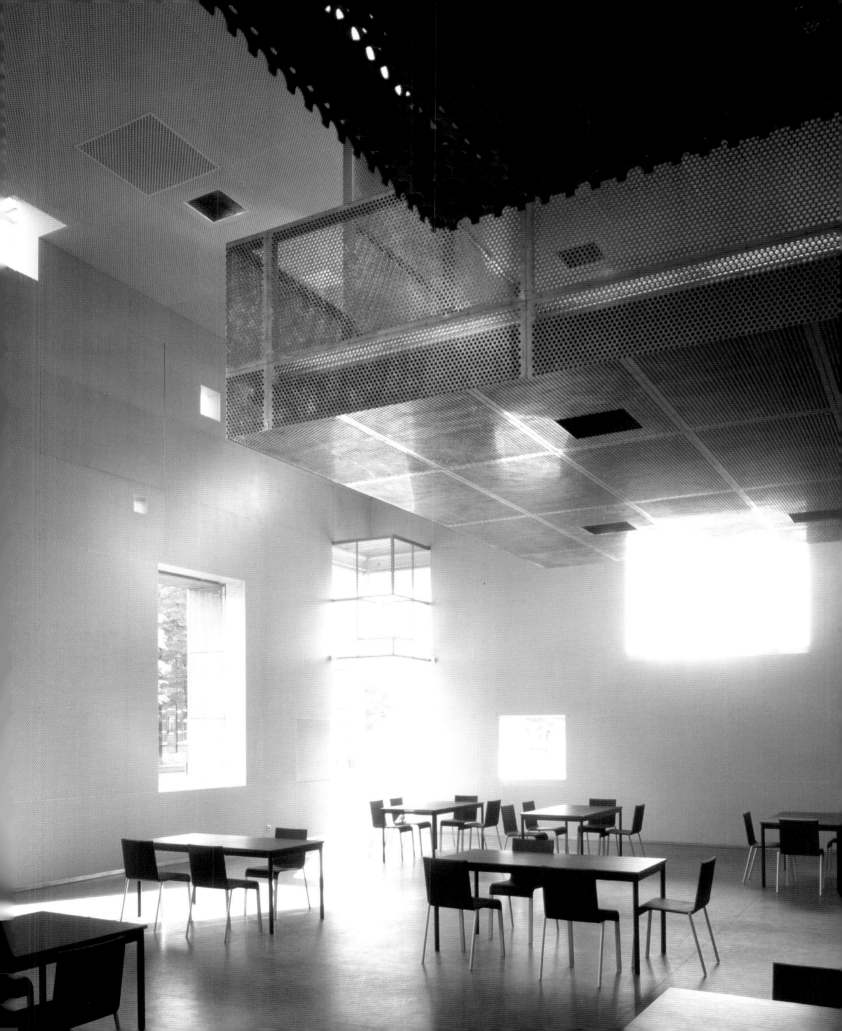

CHRISTOPH MACKLER
EXTENSION TO HOUSE ON LAKE CONSTANCE, 1996

Christoph Mackler's extension on the banks of Lake Constance, Germany, is an annexe to a 16th-century winery that is now a family home. Since the winery is a listed historic structure, the Frankfurt architect's addition had to respect certain planning restrictions.

Linked to the winery by a glazed bridge, the new building comprises a square raw-concrete podium embedded in the ground, over which is lifted, on single piloti (supporting columns) and four roller bearings, a two-storey block. Only the narrow end of the addition is visible from the lake so the winery remains the prominent structure. This gave Mackler the freedom to make the new building distinct in form and materials. The bunker-like block over which the main structure sits serves as communal space, while the long thin building contains four bedrooms, with kitchen and bathroom treated as protruding concrete boxes.

At the western end, projecting over the lake, a two-storey window wraps around the corner of the building. Mackler has taken one of the oldest of window features, the oriel, and given it a new twist. The oriel is a pragmatic way of opening rooms to light – especially here, where all three sides are glazed – and a means for the architect to investigate ways in which internal space can be projected into the exterior beyond the façade.

From a distance, the brightly painted wood box frames are suggestive of Gerrit Rietveld and de Stijl architecture. A clear composition comprising opening windows inserted into fixed glass walls is set off to striking effect against the white rendered walls. Elsewhere in the building, the windows are more private and deeply set into the façade, as if to compensate for the large glass expanse at the lakeside corner. The two protruding boxes each have a small rectangular window and a small balcony, while the half-buried living-room is illuminated by skylights embedded in playful forms on its rooftop.

Ground-floor plan

right *The extension appears to be designed in two pieces – a thin addition that floats on top of a partly buried structure, which contains the living area. The bathroom repeats the floating motif in the form of a concrete box projecting through the façade.*

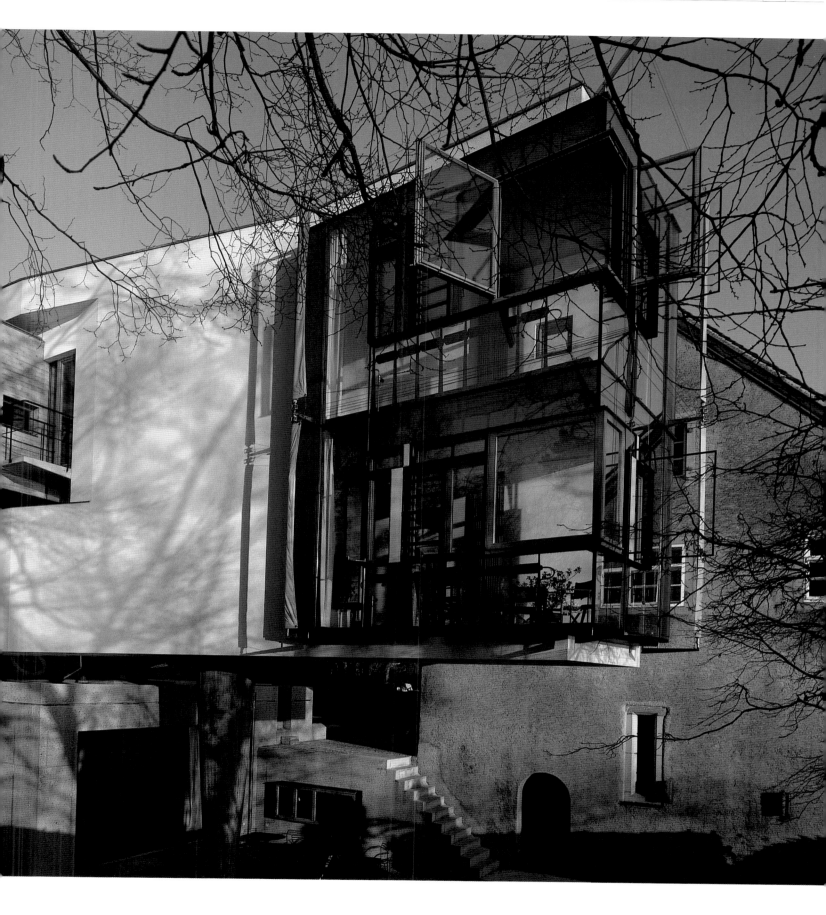

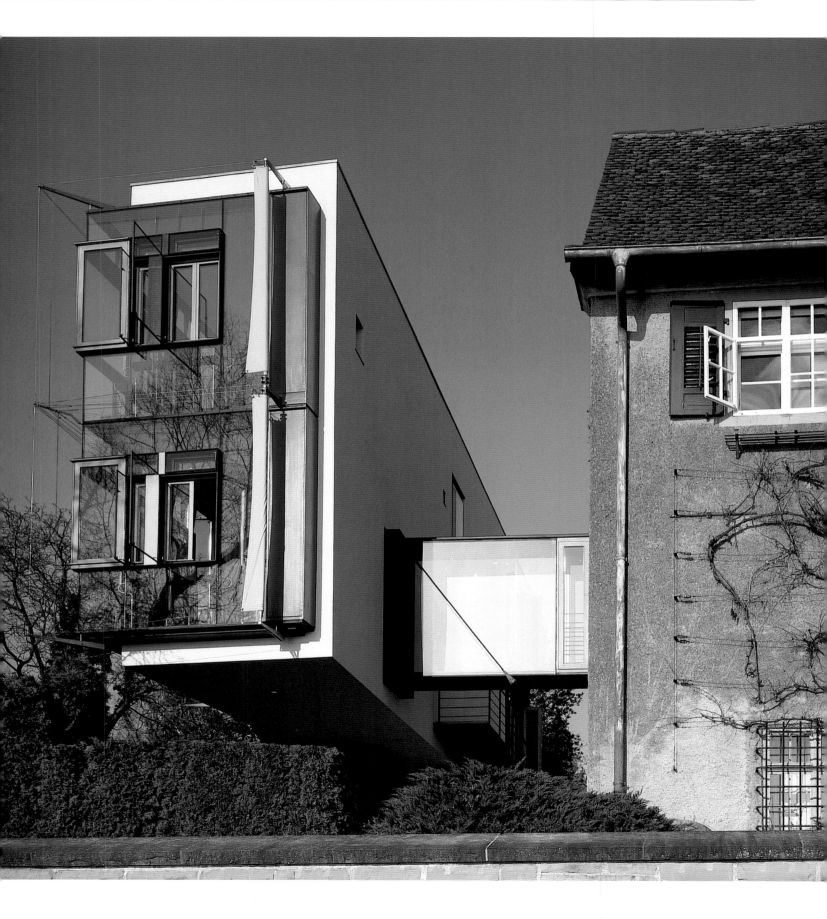

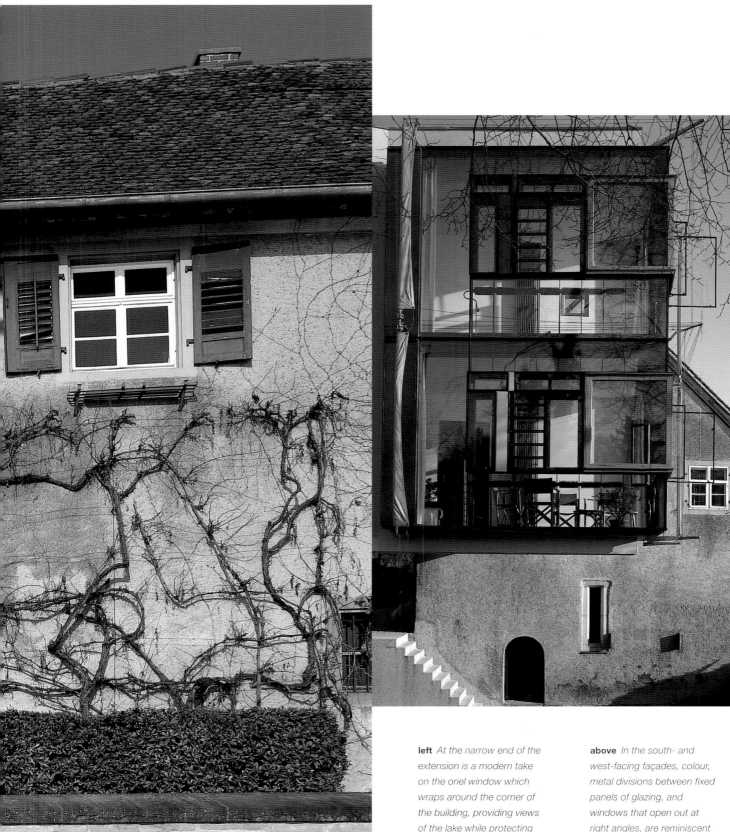

left *At the narrow end of the extension is a modern take on the oriel window which wraps around the corner of the building, providing views of the lake while protecting from the elements.*

above *In the south- and west-facing façades, colour, metal divisions between fixed panels of glazing, and windows that open out at right angles, are reminiscent of de Stijl architecture.*

101

RICHARD ROGERS PARTNERSHIP
LLOYD'S REGISTER OF SHIPPING, LONDON, 2001

Lloyd's Register of Shipping has been part of the City of London for more than 230 years. In the late 19th century it moved to its current location in Fenchurch Street, into an Arts and Crafts building designed by T E Colcutt. In the 1990s LRS asked Richard Rogers Partnership to look at a site in the south of England. In the end LRS decided to stay in the City, yet the issues that had made it consider moving out of London remained: there was little obvious room for expansion and the site lay in a conservation area. Richard Rogers may have struck some as an unusual choice, for the firm's most famous building, Lloyd's of London, is patently not one that pays lip service to its historical context.

The planners were clear that the building should have only a limited street presence. In other words a huge building – up to 14 storeys – should be hidden from view, and all in a confined space. The architect describes the solution as the "Alice through the Looking Glass experience", meaning that although you can see the building from the narrow Fenchurch Place it really does seem to be invisible from more sensitive views.

All-glass offices usually suffer from being too hot in summer and rely on air conditioning to maintain an even temperature. Lloyd's Register overcomes this in two ways, first via the overall design concept: atria separate the two office towers, allowing daylight deep into the offices but at the same time acting as a thermal buffer between the offices and the exterior. Staff can sit at a window, feeling its benefits, without direct exposure to the outside. The second element is the use of motorized louvres on the east and west façades, which rotate according to the angle of the sun, and the use of "chilled beams" centred in each ceiling vault which bring cool air into the offices.

Colour emphasizes the towers' verticality: blue for the main structure, yellow for the stairs, and red for the lifts. Although this building has had to partly hide itself it is also like a giant window, allowing the colour to be instantly legible while the people inside provide the animation.

Section through offices and atria

right *The steel structure is painted in primary colours, a trademark of Richard Rogers, whose red, yellow, and blue was also used on his Lloyd's of London building.*

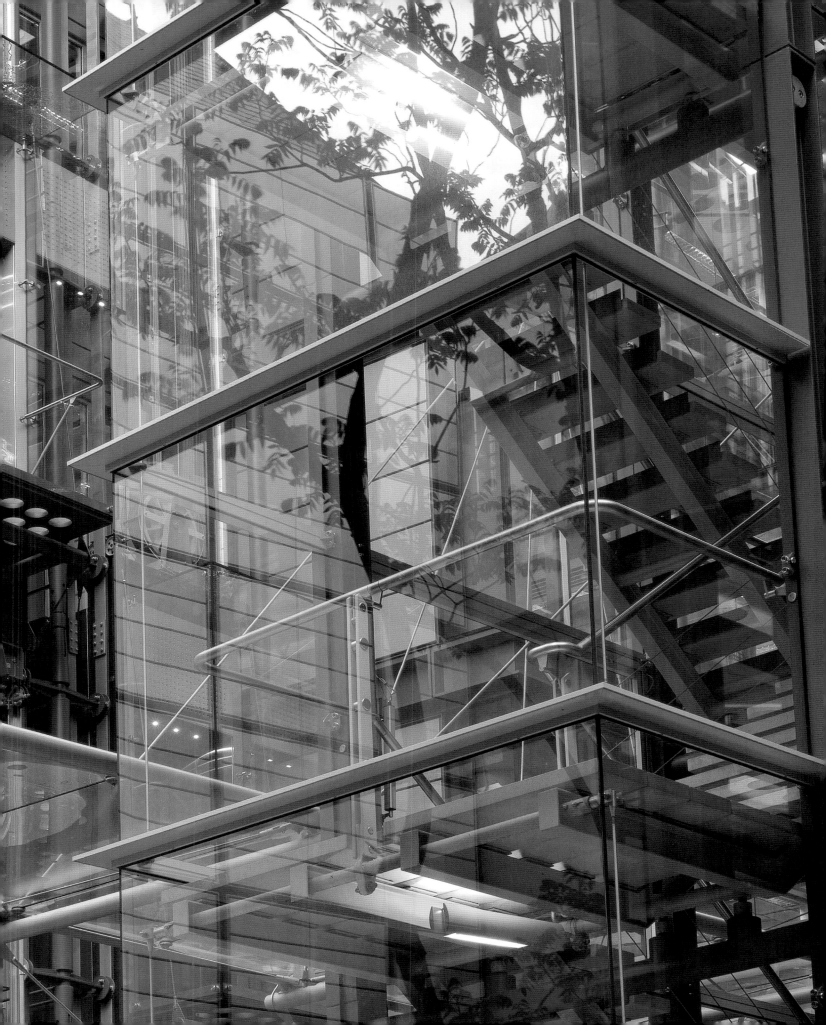

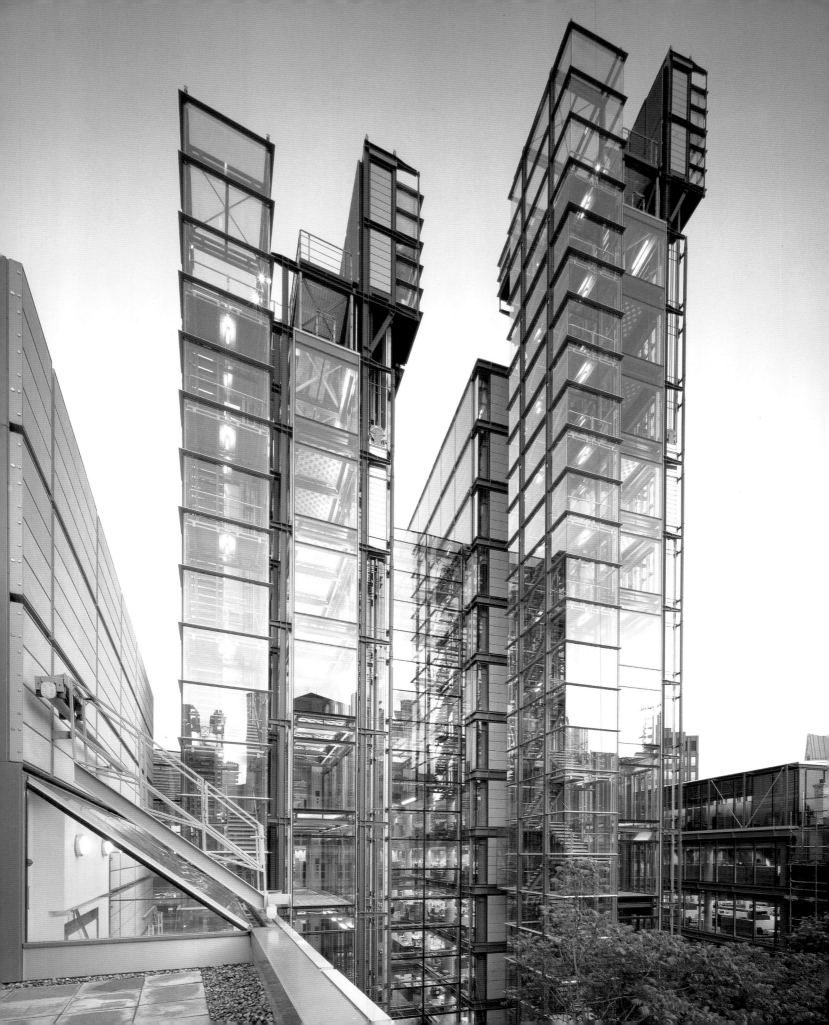

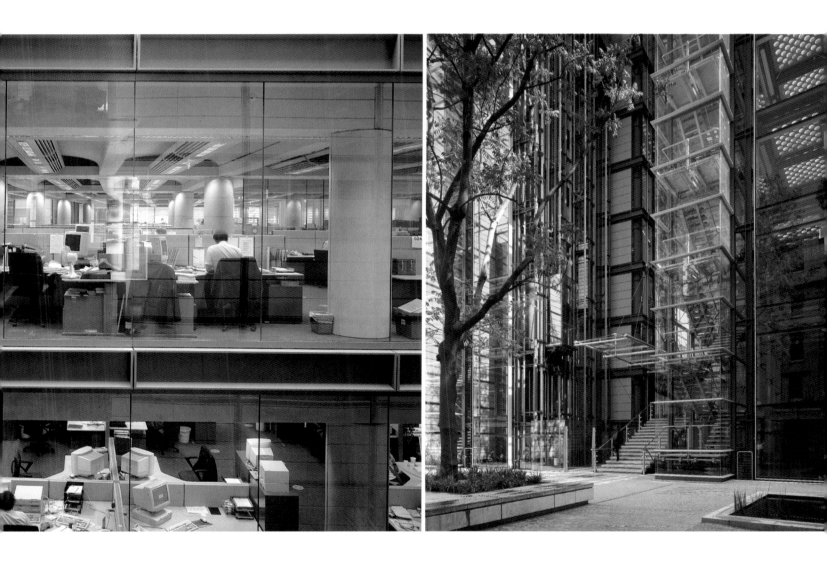

left *To achieve such a dense building on a historic site in the City of London took years of negotiation with the planners. The result is a tour de force in glass and steel where colour plays a key role in making the building's constituent parts legible.*

above *The large floorplates can either be used open plan or be divided into cellular offices. Open plan brings the obvious benefit of ensuring that everyone benefits from the daylight that floods the building through the main glazed façade.*

above right *The upgrading and re-landscaping of the St Katherine Coleman churchyard was one major benefit brought to the City by the redevelopment, offering a protected area of calm. Seating areas and water features combine to make it a popular lunch spot.*

PUBLIC EXPRESSION

The civic realm is constantly under pressure; old city centres fall into disrepair as their economic basis changes. In some places the private sector is involved with large-scale urban renewal, not always with satisfactory results owing to conflicting demands for profit and public space. But there has been a resurgence of civic pride in cities such as Vienna and Berlin that – be it for political, economic, or social reasons – are trying to forge a new identity. While it is the landmark projects, such as Berlin's Reichstag by Foster and Partners, that grab the headlines, these cities are also having to find an appropriate architectural language for a range of buildings, from embassies to churches, that play a role in moulding perceptions of that town, region, or nation. In the last decade, the boom in cultural buildings has added a new dimension to cities that were previously off the map. Most famous perhaps is the Guggenheim Museum in Bilbao by Frank Gehry, which transformed the Basque city from a post-industrial wasteland into an international tourist destination. Other cities have seized on this heady mix of architecture and art as a way of reinventing their cultural image and civic pride.

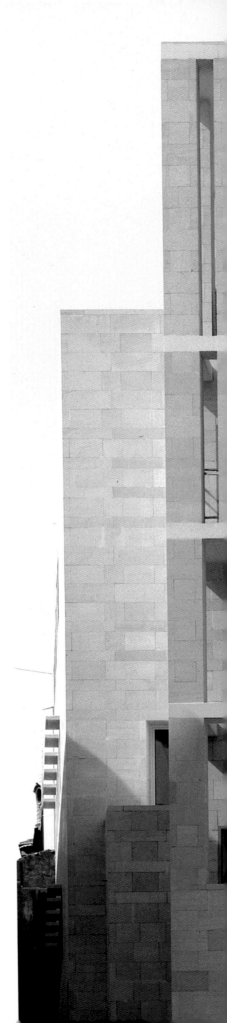

right *Fronting Murcia's main square and positioned opposite an imposing 18th-century cathedral, Rafael Moneo's city hall is an expression of the democratic pride of modern Spain.*

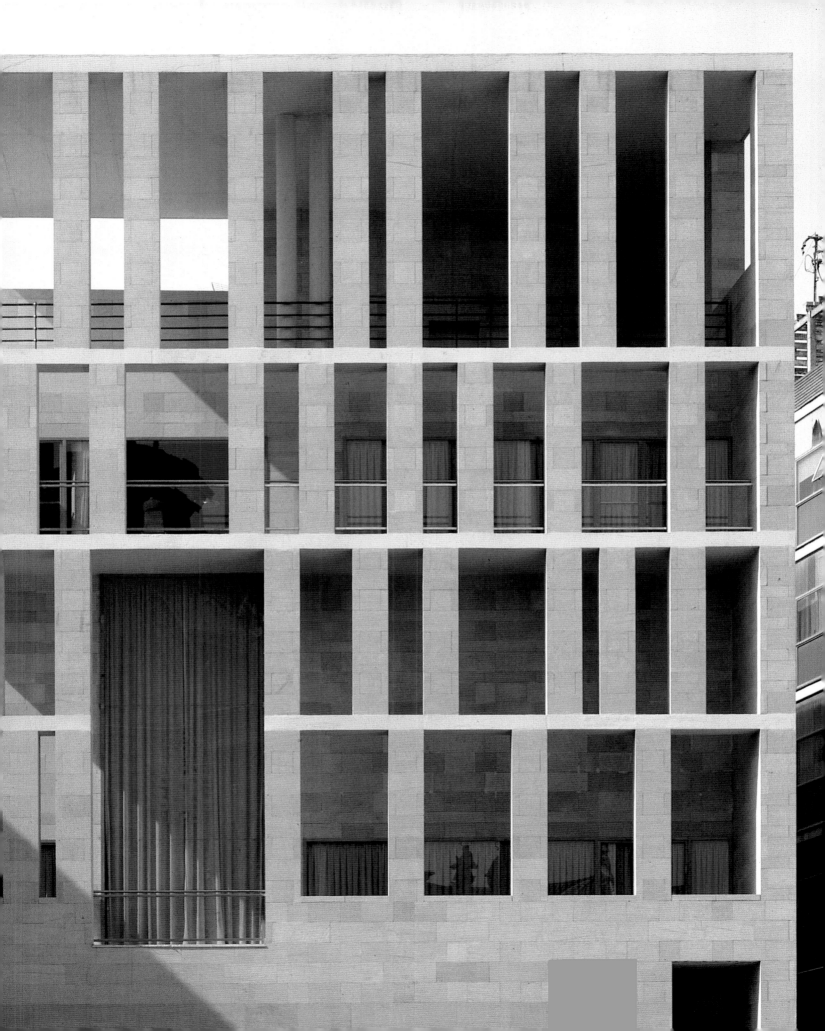

ORTNER & ORTNER

LEOPOLD MUSEUM AND MUSEUM OF MODERN ART, VIENNA, 2001

Once the imperial stables, Vienna's new museums quarter is one of the largest cultural complexes in the world. But the project has not had an easy ride. Early designs by Ortner & Ortner, the Austrian firm founded by brothers Laudris and Manfred Ortner, had to be dropped after criticism led by a popular newspaper, which struck a raw nerve in a city struggling with the idea that nostalgic charm is its defining character. In some ways what was finally built was a compromise. The project was reduced in size, and the three new buildings were concealed behind the Baroque façade of the stables. The result is that the new museums are only partly visible from the Ringstrasse; as one approaches, they disappear entirely.

Entering the central portal, a visitor faces the 19th-century riding school. Set off at axes from this are two of the new buildings, the black Museum of Modern Art and the pristine white Leopold Museum. The third new building, the Kunsthalle, is hidden behind the riding school with only its flat overhanging roof visible.

Yet the results are far from what one might expect in such a historic location. The Museum of Modern Art looks as if it has erupted onto the earth's surface. This is partly because of the choice of basalt – a volcanic rock – for the cladding but also because the lack of conventional windows is strangely dislocating. Without windows there is no sense of scale; what windows there are read as horizontal slits complementing the precisely arranged slabs of basalt. All the galleries are artificially lit. For views of the city one has to go to the Leopold Museum, where the windows are handled rather differently.

In this white cube of smooth limestone, windows help visitors to read the building. Picture windows offer views out over the city and denote the position of the main single-flight staircase running the length of the atrium. Other windows act as a guide to the museum: full-height glazed slots mark the location of galleries, while bronze-faced internal windows offer glimpses into other rooms arranged around the courtyard.

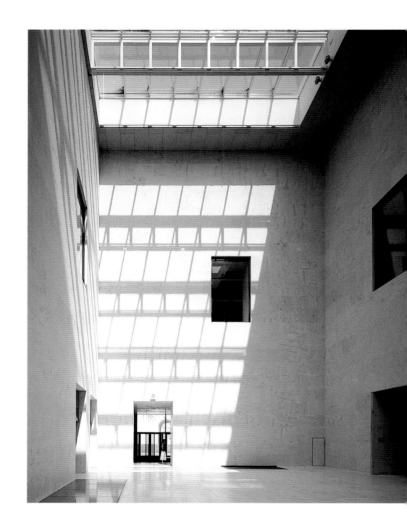

above *Large openings in the above-ground galleries look into the Leopold's top-lit central atrium. From here visitors can take the stairs to the right or enter the Klimt gallery on the left.*

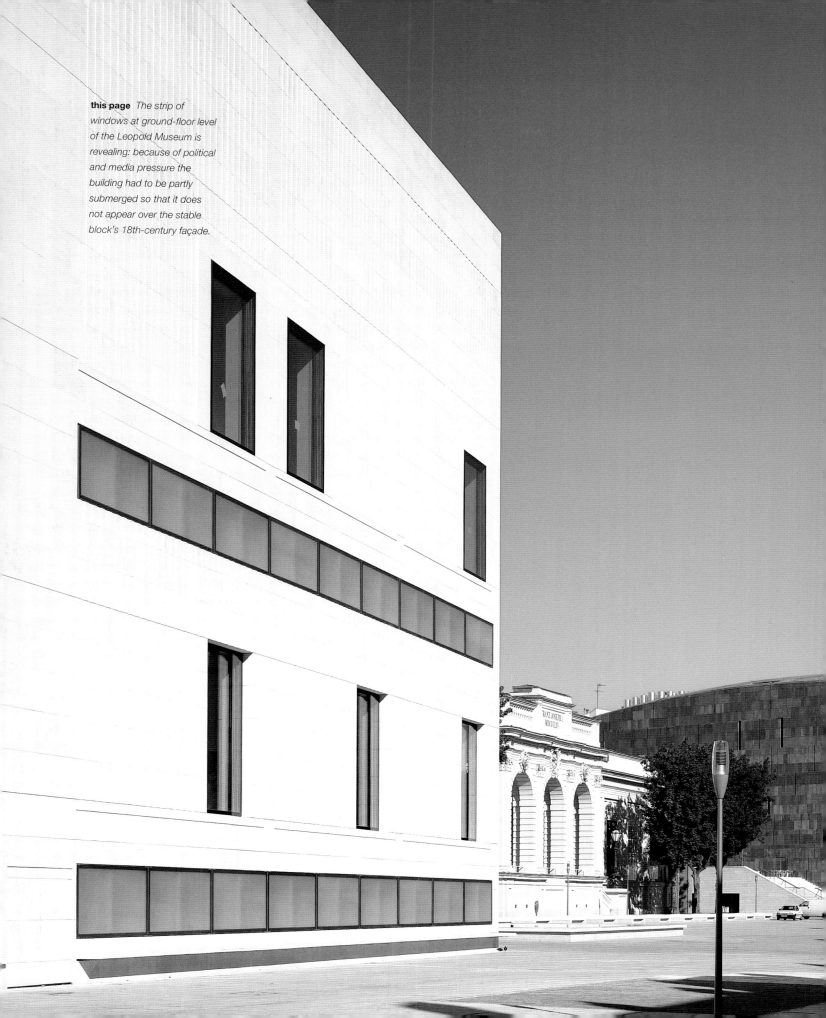

this page *The strip of windows at ground-floor level of the Leopold Museum is revealing: because of political and media pressure the building had to be partly submerged so that it does not appear over the stable block's 18th-century façade.*

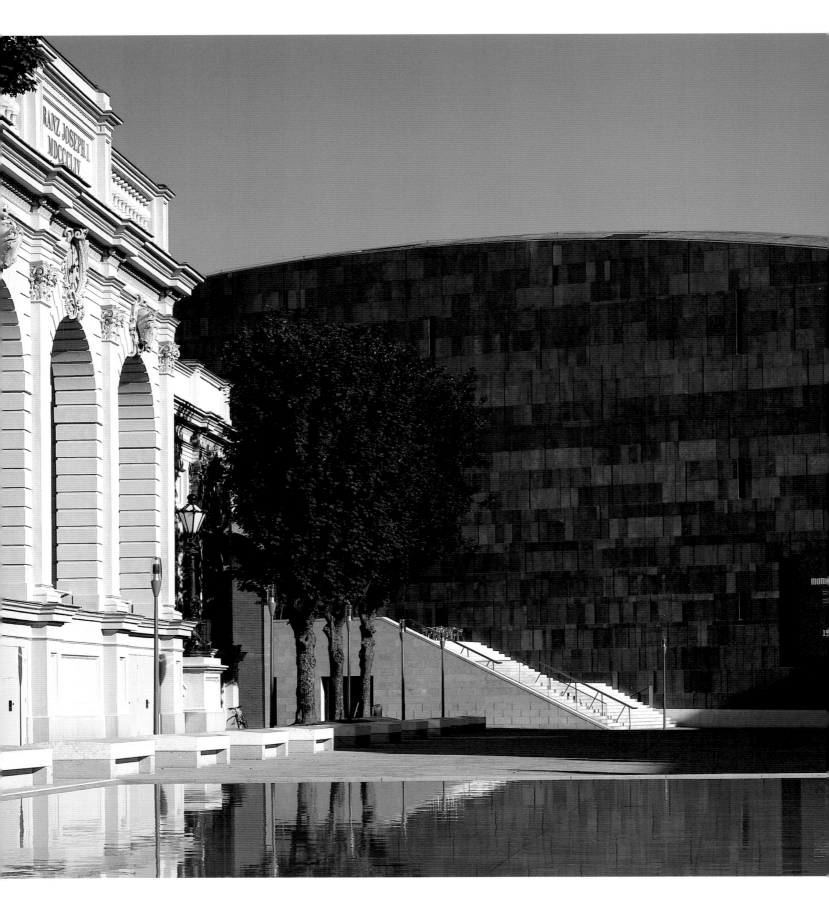

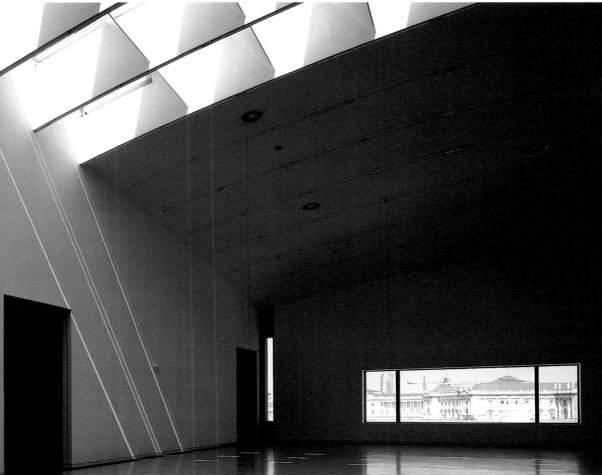

above The only view out of the introverted building is from the upper exhibition space, where a long panoramic window looks out over the city.

left Looking at the Museum of Modern Art, the senses are confused: there are no windows to lend the building a sense of scale, no obvious entrance, and no distinction between walls and roof.

Site plan showing the museums quarter built discreetly behind the 350m (1150ft) long imperial stable block.
Key to plan
1 Museum of Modern Art
2 Leopold Museum

111

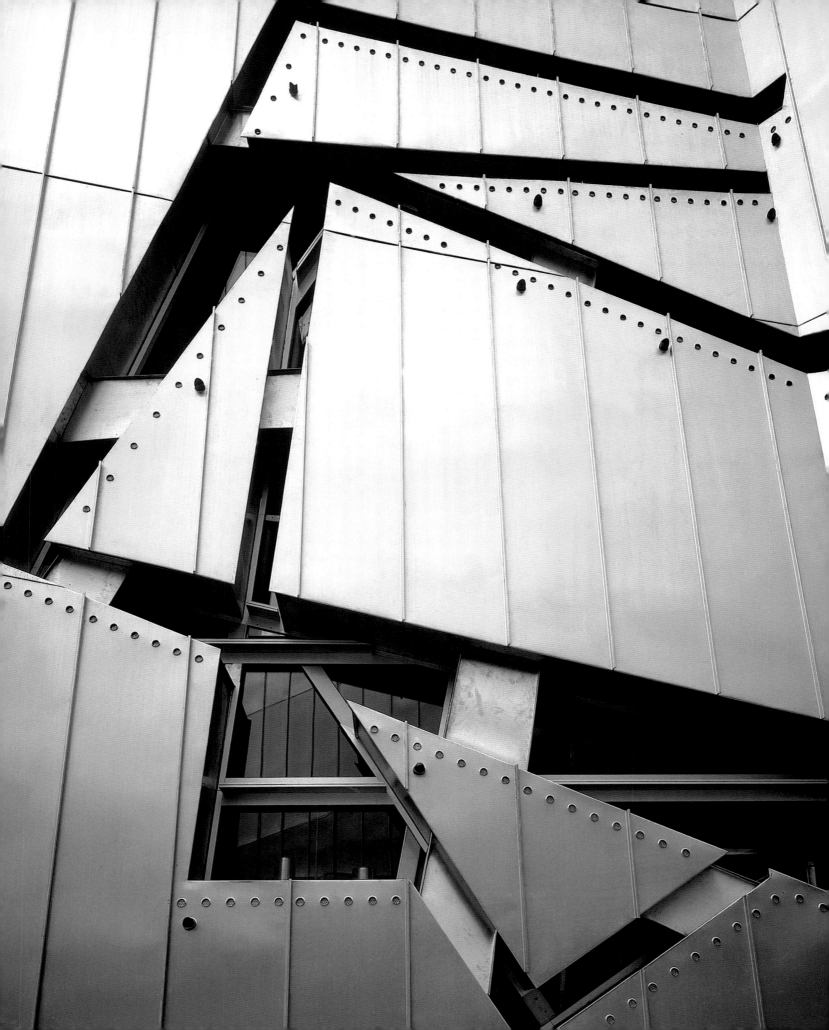

DANIEL LIBESKIND
JEWISH MUSEUM, BERLIN, 1999

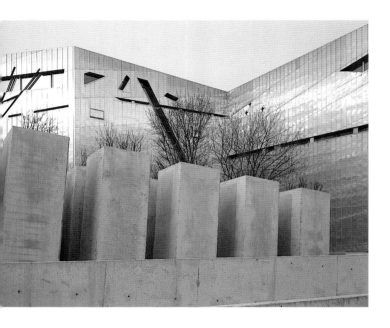

above *Forty-nine earth-filled columns make up the Hoffmann Garden, also known as the garden of exile and immigration. The columns have been planted with willow oak which will, when fully grown, form a green canopy over the concrete.*

left *Incisions in the façade correspond with the museum's fragmented plan and overlay the windows, which also seem to be placed randomly, although they actually increase towards the upper storeys where the museum's offices are located.*

Daniel Libeskind's Jewish museum is one of the most discussed buildings in the world. Unlike many of the memorials undertaken by Holocaust organizations, it eschews a chronological approach in favour of an emotionally charged architecture of overscaled spaces, angled walls, and long windows or slots. Libeskind won the competition in 1989. By the time the museum was completed ten years later, Germany was reunified and Berlin once again its capital. With the city's change in status came a new conservatism and vast financial obligations. In this climate, it is remarkable that the architect's original scheme emerged virtually intact.

The design is loosely based on a distorted Star of David, but the architect has also used lines connecting significant sites in the city to create a basic outline. It zigzags across the site, bearing no resemblance to the existing museum it adjoins. Visitors are taken underground, where they face a choice: straight ahead is the main stair, the route to the galleries; a second corridor leads to the Holocaust tower; a third passage leads to a garden of exile and immigration. Slashing across the galleries is a series of "voids", cold, hard spaces that stretch the full height of the building. Indirectly lit by slit-like windows, they represent the inexpressible absence of lives lost in the Holocaust. The most disconcerting area is the Holocaust tower, an eerie space that is sealed by a heavy metal door. Anyone stuck inside is left to focus on the tiny shaft of light coming in from high on one wall. The single window is not only hopelessly beyond reach, it also lets in street sounds distorted into wails.

Technically the windows were a huge challenge, having to meet Libeskind's demands that they should not only fly off at every angle but also be hermetically sealed, as well as being set on the inner wall rather than flush on the external wall. This is a building that can be read on many different levels but the visitor does not need to understand its complex and at times confusing intellectual origins to be unsettled. The glistening zinc skin scarred with windows is the starting point of an experience that is deeply moving. Simply looking out at jaggedly cropped city views is a reminder that some of the events depicted in the museum occurred very close by.

113

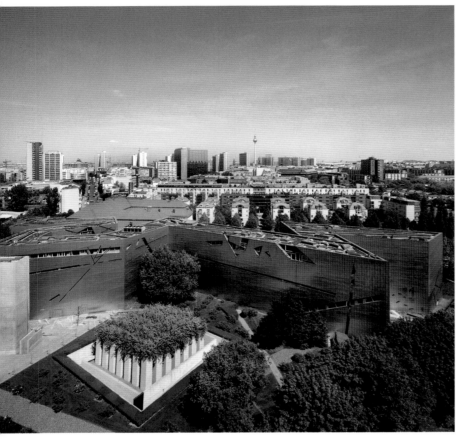

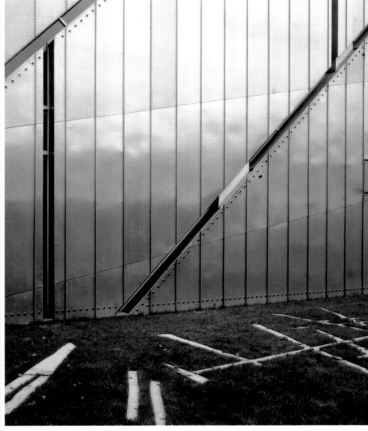

above *The design is loosely based on a Star of David. The architect also used connecting lines between locations of historic events and Jewish culture in Berlin to create the basic outline.*

above right *Zinc is a much-used material in Berlin and in time the perfectly detailed cladding will dull down to a blue-grey. The incisions in the façade are carried through to the landscaping.*

right *The voids are not all accessible but their point is clear. Left empty and lit by windows that resemble gun slits, they express the gap in European history and culture left by the Holocaust.*

Elevation of south façade

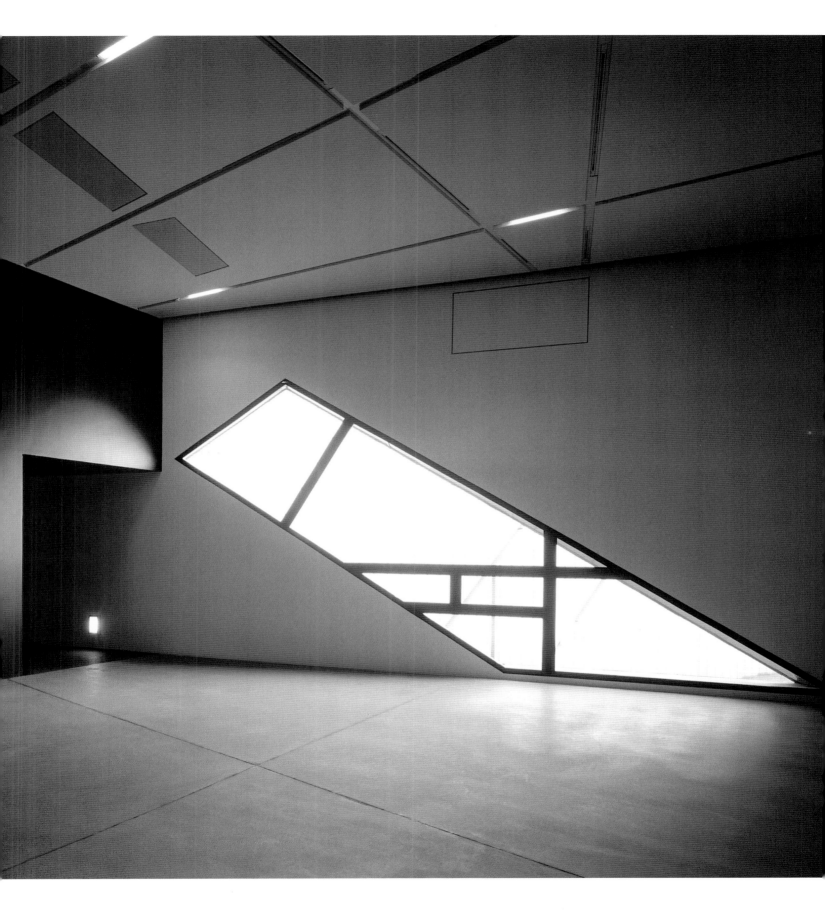

FRANK GEHRY
DG BANK, BERLIN, 2001

DG Bank sees its Frank Gehry-designed building on Pariser Platz as "an emblem of reunification, the new aspirations of Berlin embodied by art and architecture". To the north the building recalls the work of Rationalist architects such as O M Ungers and Aldo Rossi, and its stone cladding and carefully controlled proportion of solid to void hint at a stripped classicism. At night, the plain openings punched in the stone wall reveal as much about the interior as they help to make a congenial working environment by day. The enormous sheets of glass slide open automatically and on the upper levels incline outward to the top.

On the less formal south façade, the slightly projecting oriel windows are similar in form and scale to those on numerous northern European buildings where a need for daylight has to be balanced with energy-saving strictures. This part of the complex contains residential apartments. Only its undulations, barely perceptible at low level and gently more insistent at the top, suggest there is anything extraordinary behind the façade.

Faced with rigorous planning regulations and the client's requirement that every office have a window, Gehry saved his trademark amorphous forms for the interior. His design revolves around a central atrium, an extraordinary amalgam of sculpture and construction. Its centrepiece is a conference room, one of Gehry's most sculptural forms and derived from the folds of hanging drapery. Above it is the soaring, geometrically curved glass atrium roof. Gehry saw the two sets of curves as a homogenous composition, with the conference room acting as a fulcrum between the roof and the glass canopy over a second meeting room below. Looking into the atrium on all four sides are cellular offices.

Here the transparency afforded by the layers of glass and the light streaming through the roof brings out the dynamism of the contrasting forms. If the expressiveness is reserved for the interior rather than the exterior, it also gains by each layer of enclosure.

North–south section

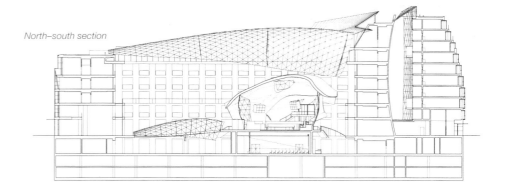

this page *The main façade is relatively conservative, yet there is something disquieting about the oversized windows undivided by mullions, which seem to suggest blankness and render the highly charged interior all the more unexpected.*

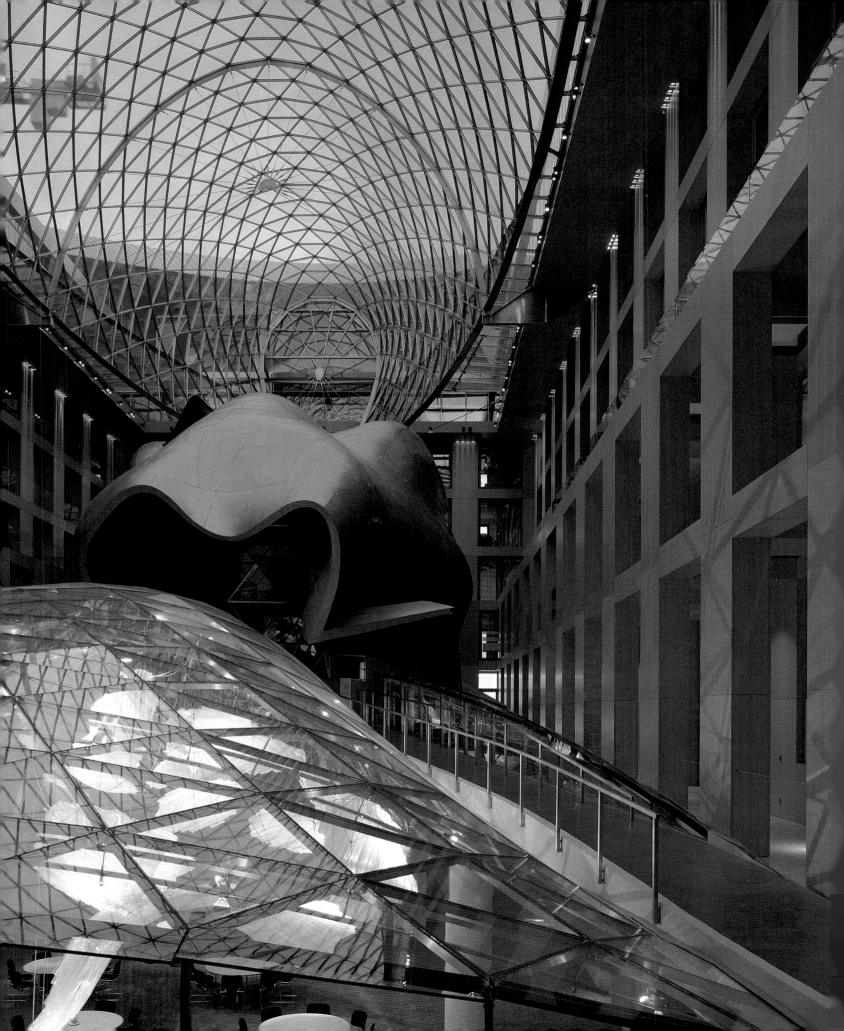

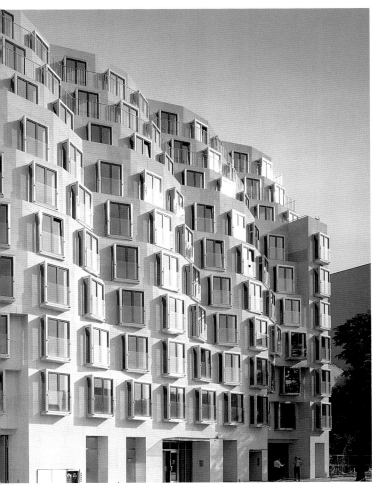

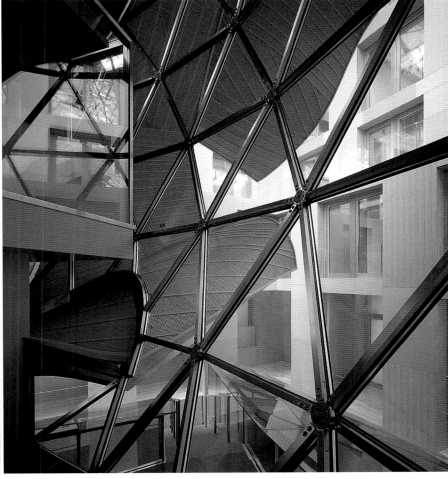

left The drama of the building is really on the inside. Pine-clad offices wrap around the atrium and look into it, where an extraordinary sculptural form seems to take up most of the space. In fact it is very pragmatic, for under the curvaceous roof is a state-of-the-art conference room linked to a reception and dining area under the glass bubble.

above Although Berlin's planning regulations have strict rules about height and materials the architect had more freedom on the rear south façade, which is apartments. The façade undulates and is stepped back on its upper floors, giving the whole a pleasing rhythm.

above right Detailed view from inside the reception area – a good vantage point from which to appreciate the building's extraordinary combination of geometries.

MICHAEL WILFORD & PARTNERS
BRITISH EMBASSY, BERLIN, 2000

The guardians of Berlin's architectural heritage had no reason to complain about the designs for the new British Embassy. Although the German capital is a notoriously difficult place in which to build owing to stringent planning regulations, Michael Wilford's embassy design appears to follow all the rules. It has a stone façade with a proper base and a mansard roof. The building's height of 22m (72ft) complies exactly with city building regulations. Yet all is not quite what it seems.

The windows also appear to be conventional, with a regular pattern of openings for the offices on the upper level. But what is below is more puzzling. A slit has been left on either side of the façade, and the stairways in the corners, with their windows facing diagonally out onto the street, act as a joint. This reinforces the impression that you are looking at a piece of scenery placed in front of the building. These windows seem to dance to a different tune, folding and bending behind the scenes.

The two striking objects that reach out into the road have two functions. The light-blue trapezoid with a window onto the street is an information centre. Its positioning just above the entrance gateway makes it a symbolic interface between the two countries. The lilac-coloured cylinder houses a closed-off conference and meeting room.

If the architect had to bend the rules to achieve the striking façade, no such compromises had to be made inside. The interior is unashamedly modern, celebrating its freedom from constraint. The entire structure is grouped around two courtyards on different levels. The lower courtyard is open with an English oak tree in its middle. The winter garden is on the level above, connected by a ceremonial staircase and covered with a glass roof. Staff offices overlook either the street, the courtyard, or the winter garden, so there is always a connection with the exterior. Playing with convention, or bending the rules, is a fitting analogy for a modern embassy that is more like an office block with different departments. The only reminder of the old embassy is the original wrought-iron gate, which has been inserted into one of the windows in the wall.

right The street façade is perforated on the upper levels by a regular pattern of office windows while below an abstract assemblage of coloured metallic forms marks the entrance.

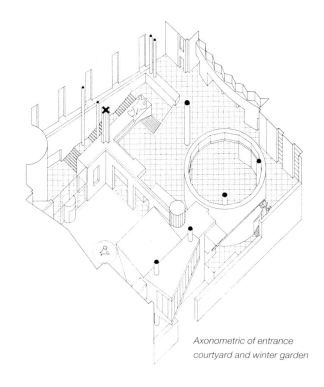

Axonometric of entrance courtyard and winter garden

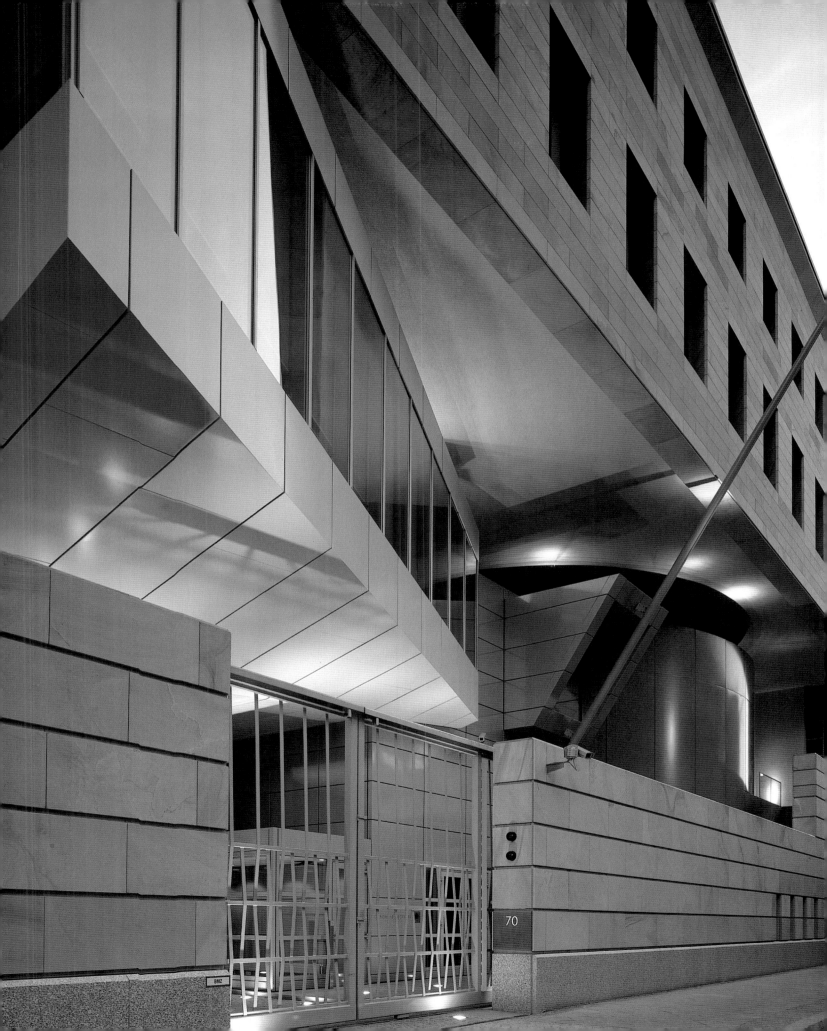

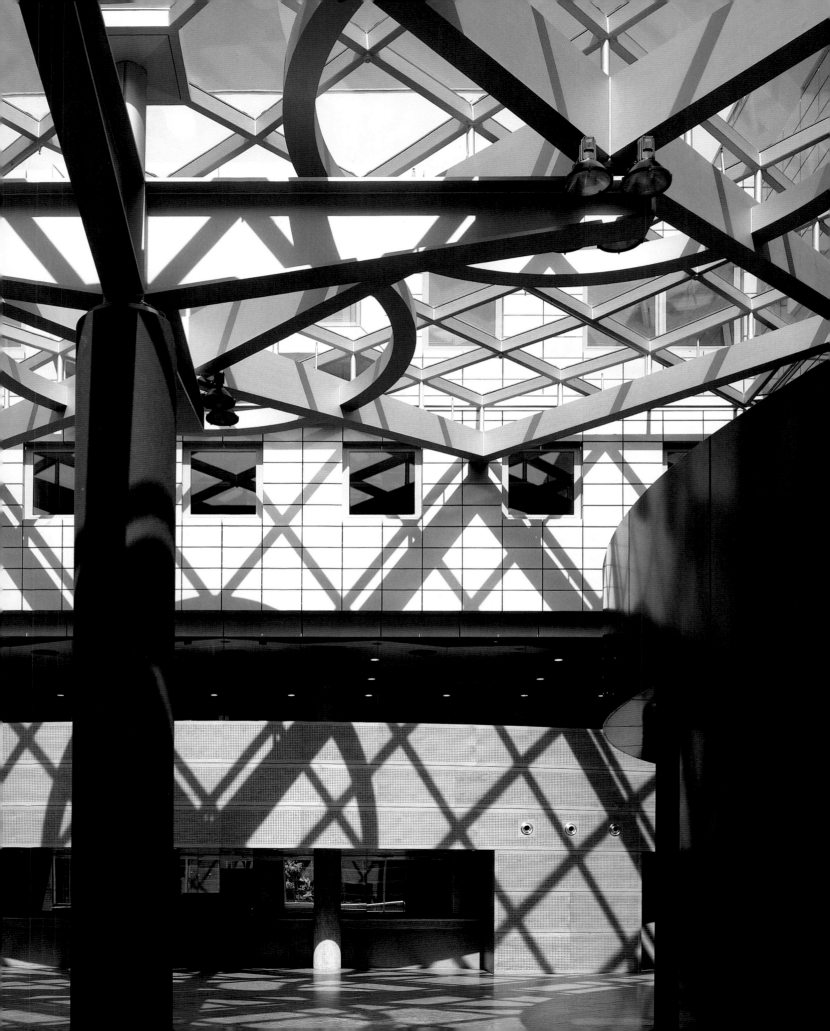

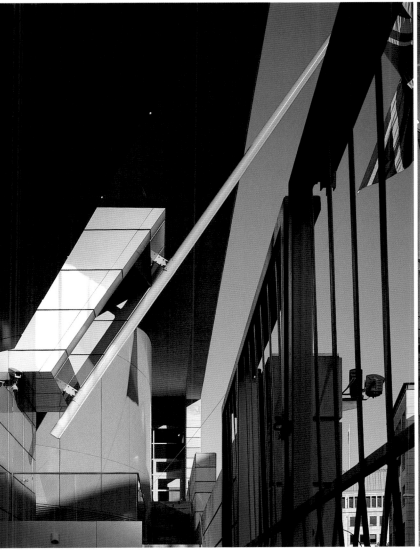

left The embassy's first floor is a generous glass-roofed hall known as the winter garden, which contains a wood-lined bar and a purple-coloured lecture hall and meeting room.

above The Union Jack flies from the flagpole on Wilhelm-strasse. Having entered the courtyard, visitors pass by an oak tree – a symbol of British endurance – before reaching the reception area.

above The entrance courtyard, dominated by an English oak in the centre, is designed with security in mind. Large enough to accommodate a Rolls-Royce, it allows high-ranking officials and diplomats to emerge from their cars straight into the inner entrance.

HÖGER HARE
CATHOLIC CENTRE, BERLIN, 2000

above *Like the chapel, the pews in St Thomas Aquinas are deliberately simple.*

far right *The church sits on the main courtyard behind a concrete colonnade. Interspersed with the granite are pieces of cast green glass, producing a solid stone wall that changes into a diaphanous wall of light.*

Shortly after the fall of the Berlin Wall, the Roman Catholic Church found itself in possession of a piece of land on Oranienburgerstrasse in the former east of the city. The Church decided to celebrate its revival in eastern Germany with a major new Catholic Centre. Höger Hare won the resultant competition, which demanded offices for the Bishops' Synod, moved from Bonn, accommodation for the recently established Catholic Academy of East German dioceses, a church, a chapel, a 40-room conference centre, and lettable offices.

The church, dedicated to St Thomas Aquinas, is the single most important part of this varied and tightly planned complex. Conceived as a local amenity where people of any faith might drop in, it avoids overt Catholic references. It is a powerful cuboid form, surrounded by a stone wall flecked by glass blocks. The blocks' frequency increases towards the top, where they make up almost 60 per cent of the wall. At night these wide, dense blocks glow with light from within, but this inscrutable volume becomes most animated by day, when sunlight casts sharp shadows from the skylights that run around the perimeter. The smooth glass blocks contrast with the bush-hammered stone walls, and the crescendo of glass draws the eye irresistibly upward.

Hardly windows in the conventional sense, the glass blocks are an integral part of the wall: 4.5cm (1¾in) high, 50cm (19½in) deep and 63cm (24¾in) long, they are the same size as the stone pieces and apparently identical to them – they might have been transformed to glass by the touch of an invisible angel. Cost dictated that the walls had to have a concrete core for the first 4m (13ft) above ground and a brick core above that, with a ring beam to support the rooflight. But with the glass blocks stretching the full thickness of the wall, they reinforce the sense of its solidity and integrity.

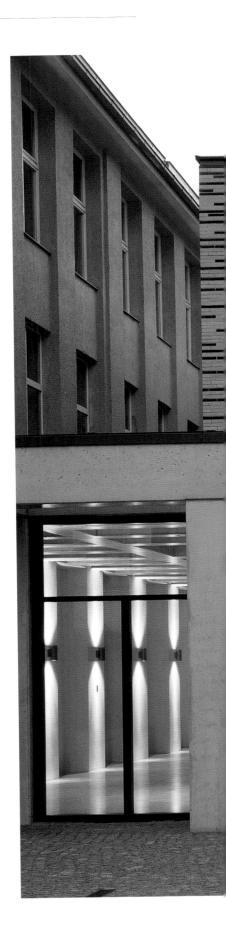

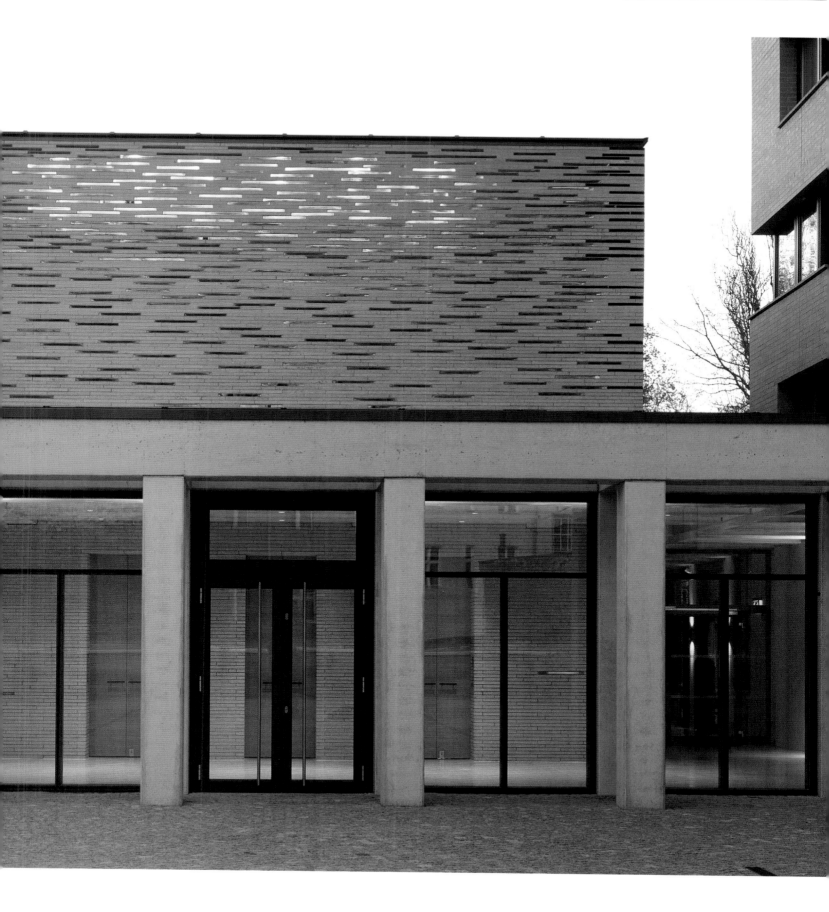

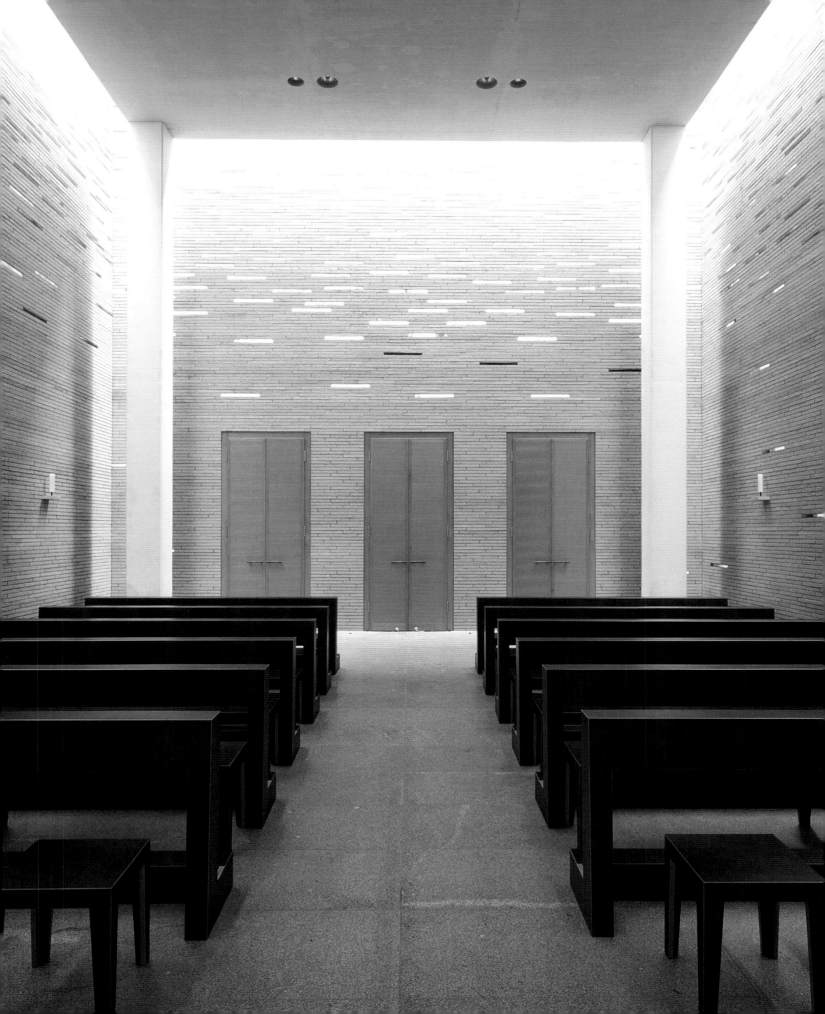

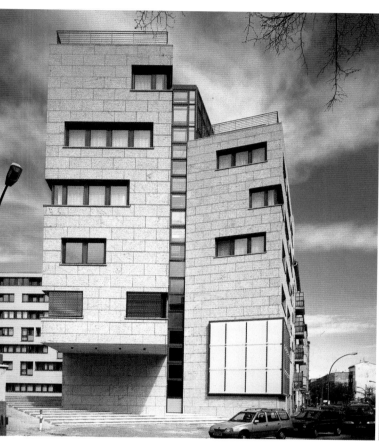

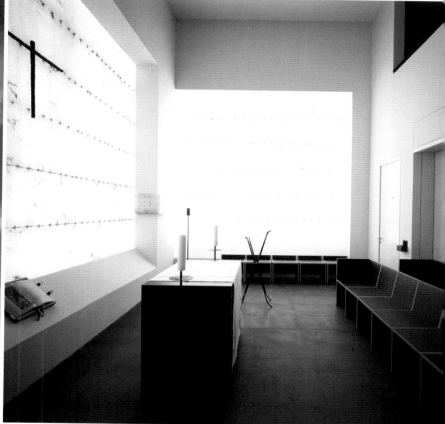

above The various functions of the complex generated a number of distinctly separate structures. The seven-storey office of the secretariat was designed as a highly sculptural form marking the entrance.

left The church consists of two elements – the solid stone and glass walls, and the roof structure in the form of a baldacchino (canopy) on four corner columns.

above right The chapel in the Bishop's Synod is a more intimate space than the church of St Thomas Aquinas. Light seeps in through an inner layer of white alabaster panels.

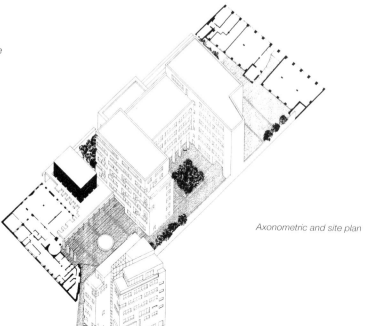

Axonometric and site plan

127

BENSON & FORSYTH
MILLENNIUM WING, NATIONAL GALLERY OF IRELAND, DUBLIN, 2002

Windows inevitably take on an air of ambiguity when architects indulge in that old game of blurring distinctions between inside and outside. But Benson & Forsyth's Millennium Wing extension to the National Gallery of Ireland transcends easy clichés.

Tucked into an interstitial space between the original Italianate gallery on Merrion Square and its neighbours, the new wing has only a narrow frontage onto Clare Street. Yet it is densely worked, with numerous planes recessed or standing forward from the main building line and each rebate offering scope for a slit window or a hidden lamp to spray light across the stone façade after dark. The "orientation space" that lies just behind the entrance begins to decode the abstractions of the façade. Straight ahead is a flight of stairs leading to the new galleries or the original museum; to the left is a shop; and to the right, on the other side of a deep wall running on a diagonal, is a large top-lit restaurant. With a retained Regency ballroom and two shallow convex bays of a Georgian townhouse, this space has the feel of an external courtyard. Apart from small areas for special collections and research, the new galleries are on two levels above the shop. The upper one is top-lit and the lower dependent on artificial light except for a neat little projection with a narrow rooflight to illuminate works against the side wall.

One of Benson & Forsyth's most potent themes is that windows are not just light sources or patterning, nor a vehicle for clever detailing, but that they reveal information and, ultimately, meaning. Throughout the building is a series of routes, each marked by dramatic but subtle framing of views towards important objects, such as Leinster Lawn, the Wicklow Mountains, or the spot where James Joyce supposedly had his first date with Nora Barnacle. These routes and vistas are integral to Benson & Forsyth's conception of the building within its urban and historical context: just as the physical route turns into an implied vista, so the building helps to bridge the gap between mythical and real histories. The exhibits themselves add layers of interpretation to the historical and cultural location of the building. But the sources of light and what they reveal of the city, the building, and the exhibits, help to establish an interpretative context.

right *Views into the gallery are as carefully controlled as views out, giving glimpses of the exhibits, which include the Jack Yeats collection and a smattering of international 20th-century works.*

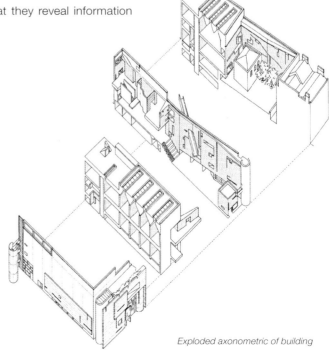

Exploded axonometric of building

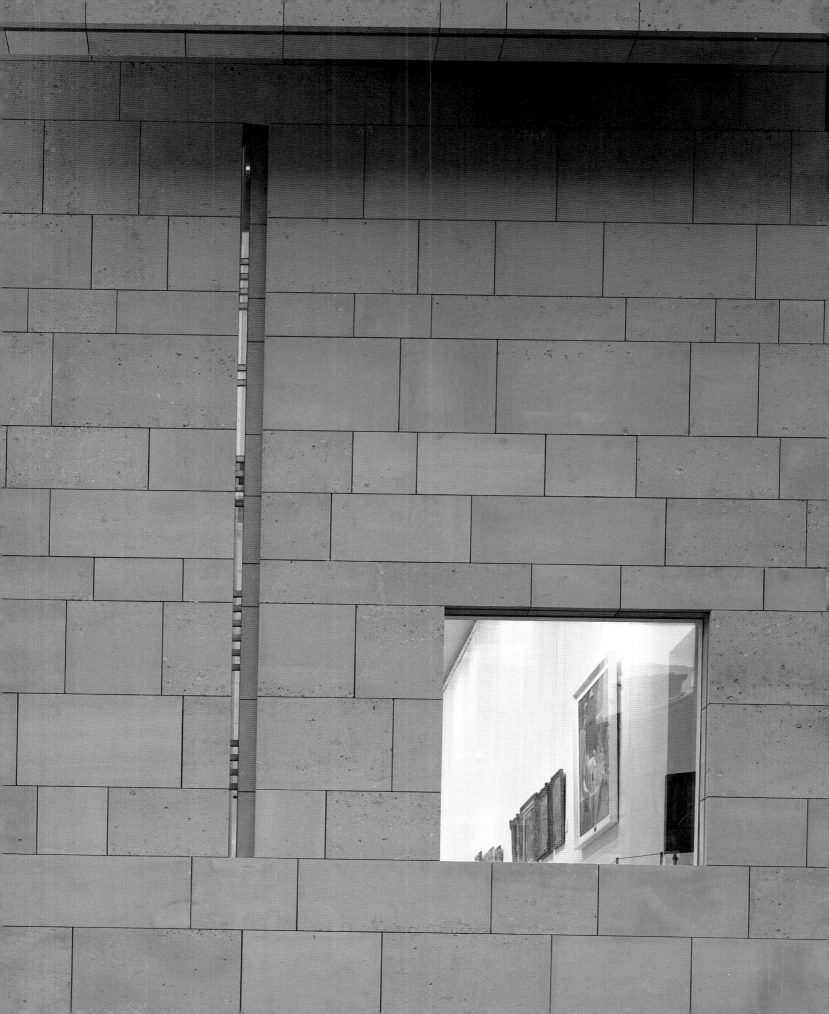

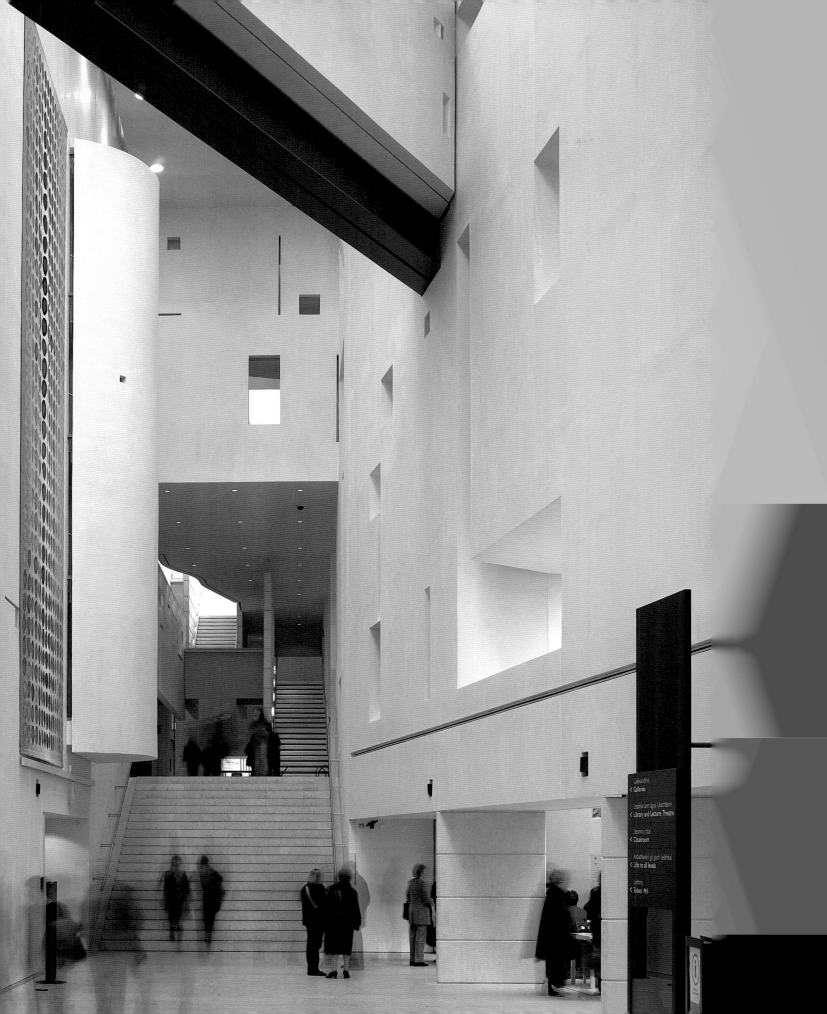

Galearaithe
< Galleries

Leabharlann agus Léachtlann
< Library and Lecture Theatre

Seomra cótaí
< Cloakroom

Ardaitheoiri go gach leibhéal
< Lifts to all levels

Leithris
< Toilets ♿

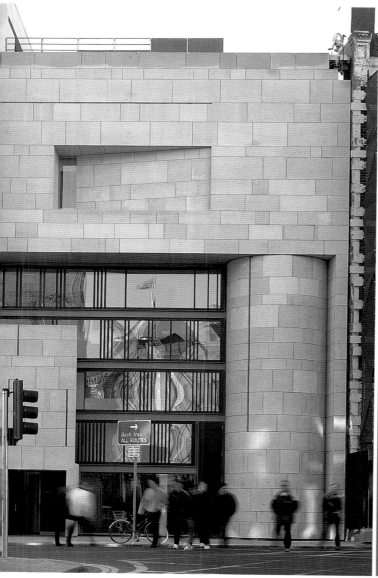

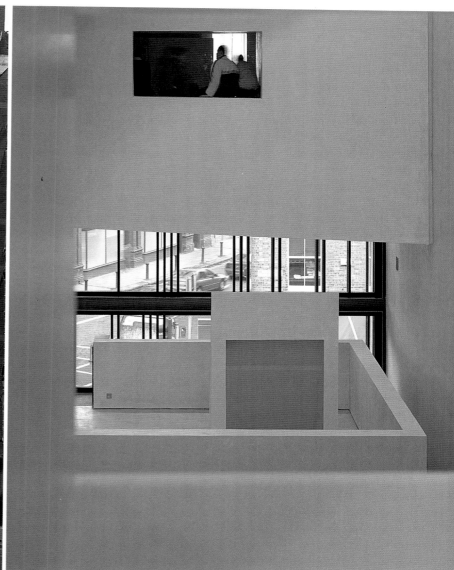

left *The orientation space that the visitor reaches on entering the building has something of the feel of a courtyard to it, a sense that is reinforced by the openings etched into or gouged out of the thick wall.*

above *Like many of Dublin's buildings, the new sculptural façade is clad in Portland stone; it has a presence that cannot help but overpower its Georgian neighbours.*

above right *View of the entrance from the bridge window. Windows are carefully placed to give views across the building as well as out into the city.*

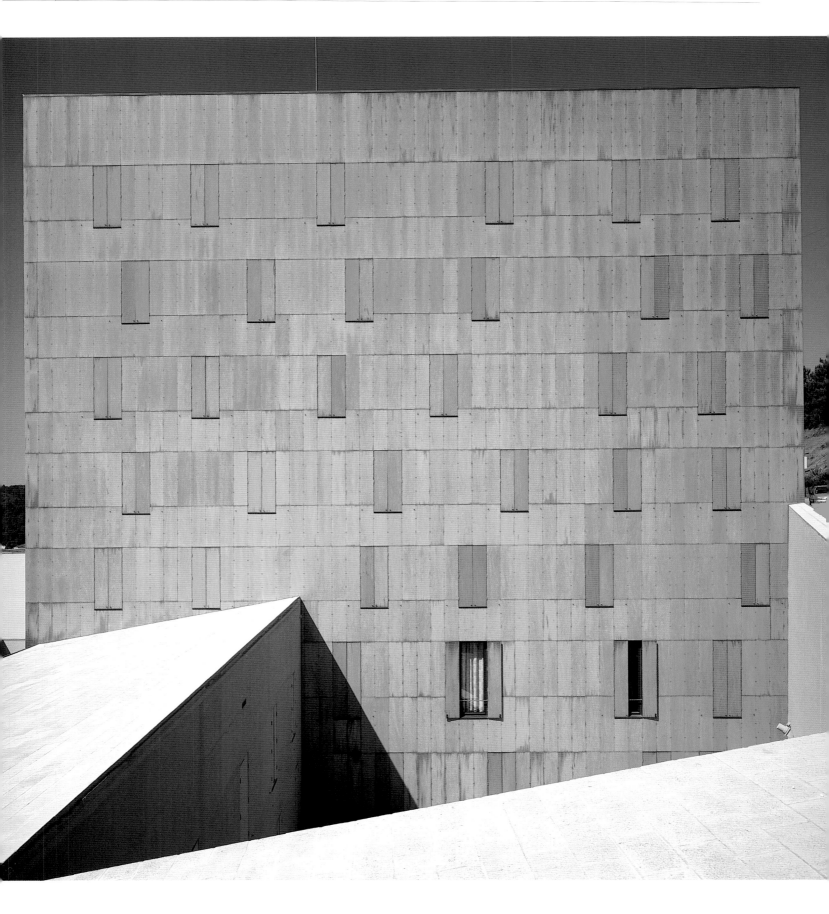

AIRES MATEUS & ASSOCIATES
STUDENT HOSTEL, UNIVERSITY OF COIMBRA, 2000

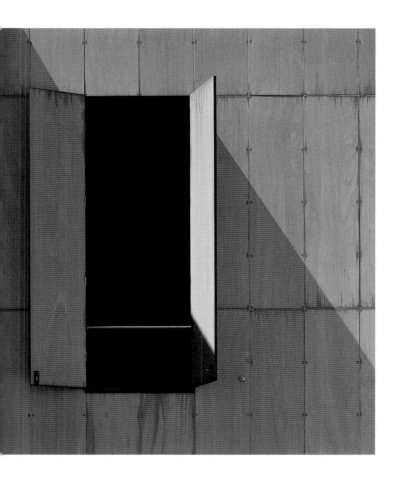

above *The windows are tall and narrow and proportioned rather like doors – perhaps a way of revealing each student's room rather than the more anonymous proper front door accessed off an internal corridor.*

left *This precise, crisply detailed timber window wall is designed to contrast with the white buildings on the rest of the campus and blend with the surrounding pine forest.*

Student hostels are often dreary places, cramped and with little natural light; yet universities can also be enlightened patrons. Portugal's most celebrated architect, Alvaro Siza, has designed an architecture faculty for the University of Oporto and a journalism faculty for the University of Santiago. More recently, the University of Coimbra in the west of the country commissioned Aires Mateus, a young practice based in Lisbon, to design a new student hostel. The brief demanded a large amount of accommodation on a tricky triangular site formed by the junction of two routes. The architect responded with two buildings: a seven-storey tower and a low-rise triangular building. Between the two is a small gravelled courtyard.

The students each have a bedsitting room, arranged in pairs, with a shower and lavatory shared by each couple of rooms. The common rooms are in the south-west corner of each floor of the tower, with another large common room to the east of the triangle.

Walls are of two kinds. Three – the north, west, and south walls – are clad in off-white concrete blocks, split to provide a slightly rough but sparkly surface that relates to and contrasts with the concrete of the other university buildings. Window walls are quite different. Windows on the lowest floor look over the court. At entrance level they face south past the university refectory. In the tower they look east over the best views of the forest and the distant river. Almost all the windows in the bedsits are set in walls clad in wood panelling. The windows themselves are tall and narrow, humanly proportioned, rather like doors. Each has two wooden shutters, made in exactly the same module as the timber panels that surround them.

Like three of the other projects in this book, the Finnish Embassy in Berlin (pp.24–7), Sean Godsell's house (pp.36–7), and Sauerbruch Hutton's GSW building (pp.74–7), the changing façade tells a story of the lives of the building's inhabitants. Here the façade is animated by the simple yet revealing opening and closing of shutters.

133

RAFAEL MONEO
TOWN HALL, MURCIA, 1998

Facing the cathedral on Plaza Cardinal Belluga in Murcia, Spain, stands an enigmatic wall. It follows the historical building line on the narrower end of the wedge-shaped space, but its openings mimic neither the solemn regularity of the flanking buildings nor the florid treatment of the cathedral's 18th-century façade opposite. Although evidently modern, it seems also to refer to the square's long history, an impression reinforced by the approach through a sunken court, as if it were rising from an archeological excavation.

This strange wall belongs to the town hall extension designed by Rafael Moneo. The extension contains a public foyer, a council chamber that doubles as a lecture theatre, offices, and reception space. Replacing an 18th-century house, the project offered a chance to design a façade on the city's main public space that would express the tension between Church and State at the same time as representing democracy and civic identity.

Built in local sandstone, its character comes from irregular openings that increase in frequency towards the top, giving it, like the cathedral, a solid base and a lighter, almost playful roofline. The irregularity of these openings may be simply to give the new building a distinct identity, but it might also refer to the plurality of political views or the richness of the city's history – created by the Moors in the 9th century, Murcia was an important trading centre. But in much of this façade the openings are not actually windows. From second-floor level upward, the stone wall acts as an arcade, creating shaded colonnades and shielding the internal spaces from the morning sun. Although the composition is rational and even severe, the architect took his cue from the Baroque portal opposite and the glazed loggias of the city's townhouses. But there is a further reason why Moneo wanted to have these blank openings in the wall, for together with the large expanses of glass they frame views of the cathedral and its tower, thus expressing the uneasy relationship between the two institutions.

Conventionally a façade facing a public square takes precedence over those facing streets: Moneo respects that tradition. Although the shape of the site means the two side elevations are much longer than the façade on the plaza, they are treated far more simply. Here the openings retreat with conventional regularity, helping the new extension to meld back into the urban fabric.

Section through building

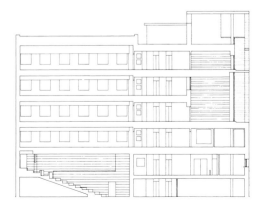

above *Clad in local calcite stone, the façade has as its compositional focus the two-storey opening that looks not unlike a large door. In fact, the building does not have its own entrance, and is connected to the 19th-century town hall by a glass-enclosed bridge.*

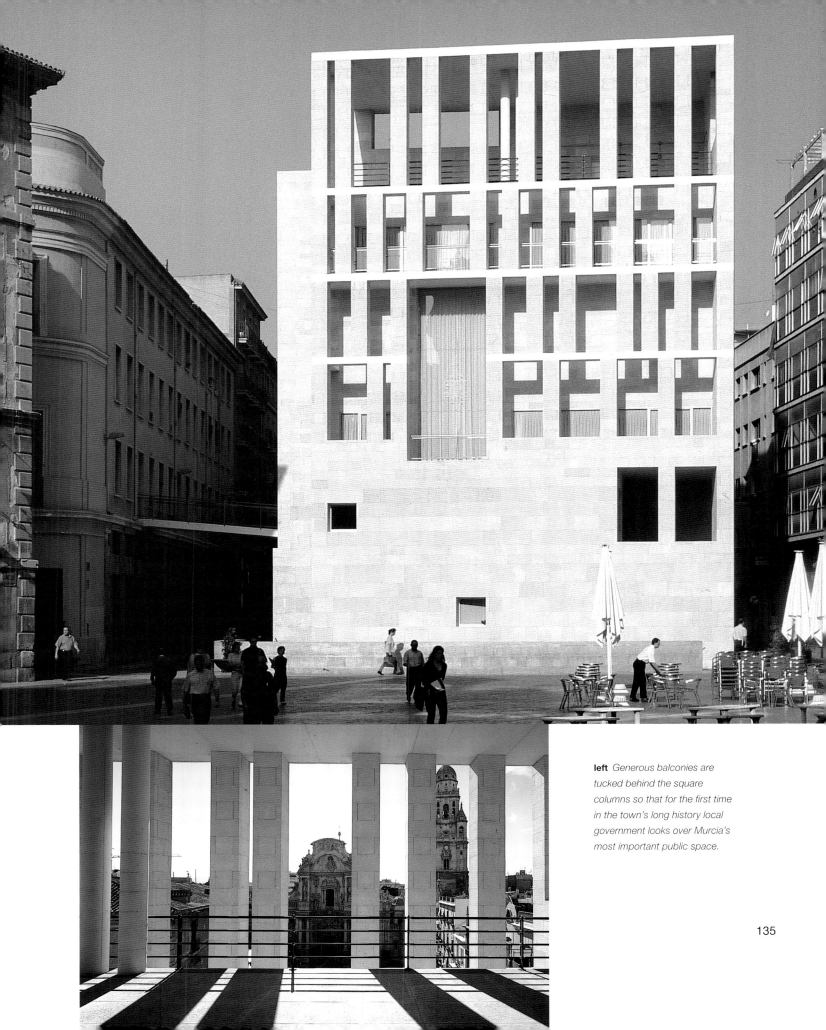

left *Generous balconies are tucked behind the square columns so that for the first time in the town's long history local government looks over Murcia's most important public space.*

135

ENRIC MIRALLES
TOWN HALL, UTRECHT, 2001

Not all owners of historic buildings want a facsimile of the past; architects working in a contemporary vein can bring a freshness to historic buildings that more traditional solutions sometimes lack. This was the feeling in Utrecht, in the Netherlands, which held a competition to extend and restore its town hall. Begun in the 16th century, the town hall had been randomly added to over the centuries forming a series of labyrinthine spaces that were hard to convert to modern, efficient offices. The competition was won by Catalan architect Enric Miralles: it was to be the last building he completed before he died of a brain tumour in 2000. Although he had built up a reputation for buildings that broke with the understated tone of Spanish architecture, it was his first project outside Spain.

Miralles was able to demolish a swath of ramshackle medieval structures, which freed up enough space to slot in a new four-storey office wing and lay a modest new public square. He also turned the building around 180 degrees by switching the entrance from the southern canal so that it now faces the new piazza to the north.

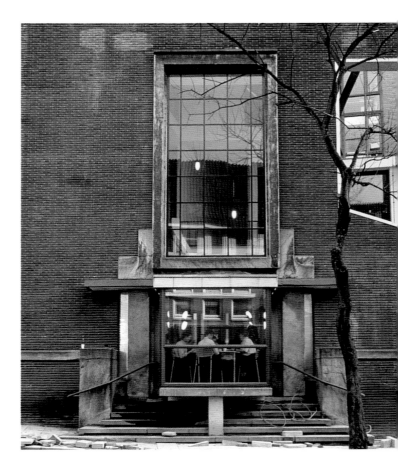

Although the history of the original building is still visible in what remains of the original design, it has been enriched by the architect's personal and complex formal vocabulary. The result is bizarre but unforgettable. The windows are one of the most intriguing elements; Miralles has insisted on making far more openings than are strictly necessary, even for light and views. But more than this, instead of conforming to the strict neo-classical rhythm of the town hall's original façade, the new windows are just where he wants them to be – side by side; one on top of the other – and any shape. Strangest of all was the decision to frame some windows in red, and to finish others in off-cuts of salvaged stone that do not join up. The collage effect of old and new materials is dislocating, as if the building cannot make up its mind if it is a ruin or a botched attempt at a facelift. Of course it is neither and, although it is not to everyone's taste, Miralles has restored the building's relationship with the city while allowing its history to remain legible.

above *Although some critics have accused Miralles of failing to respect the building's remaining neo-classical façades, he has preserved them but failed to resist reworking the corner to take in a new staff café.*

right *A new square has been created by turning the building around and away from the canal. Different types of paving refer to walls that have now been demolished, while in front of the façade is an elaborate fountain, designed by Miralles.*

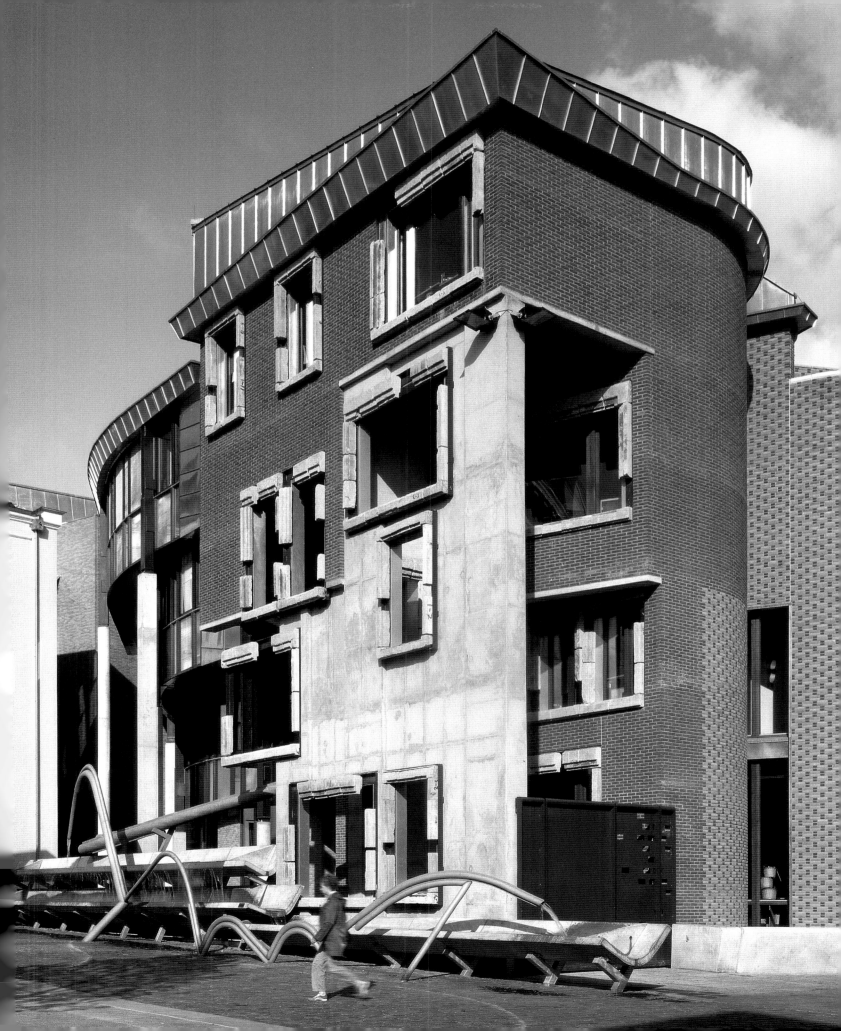

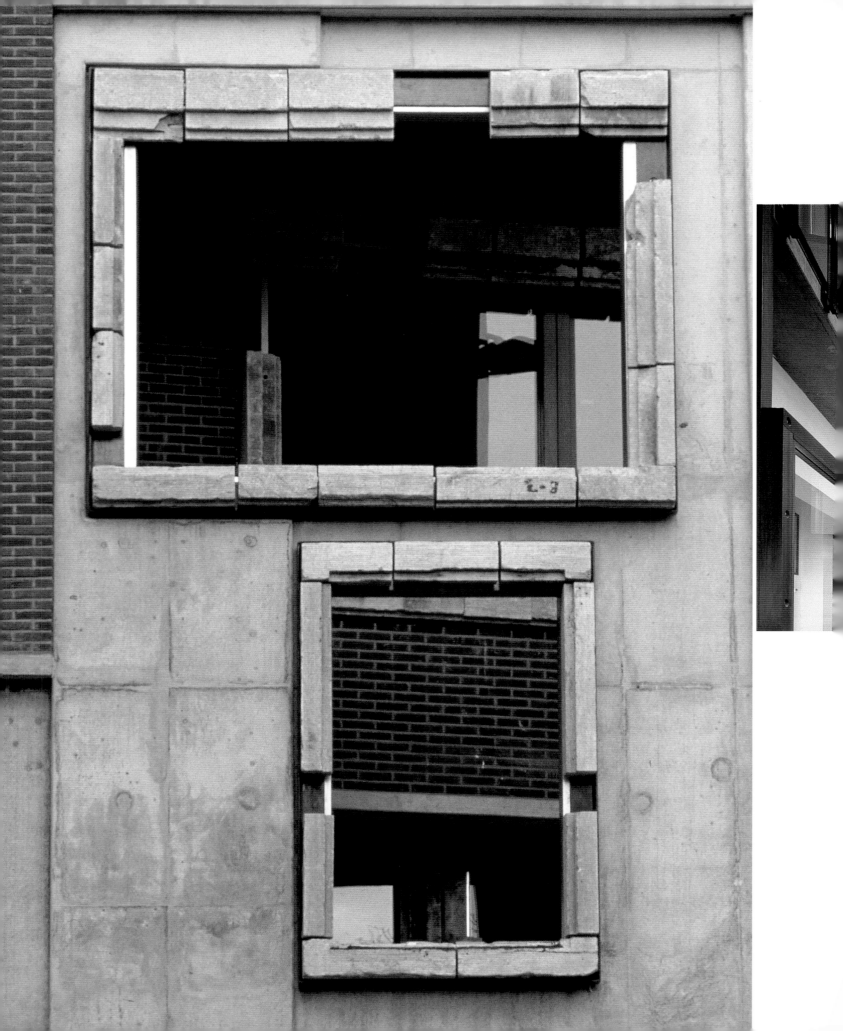

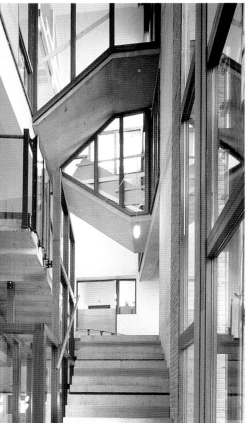

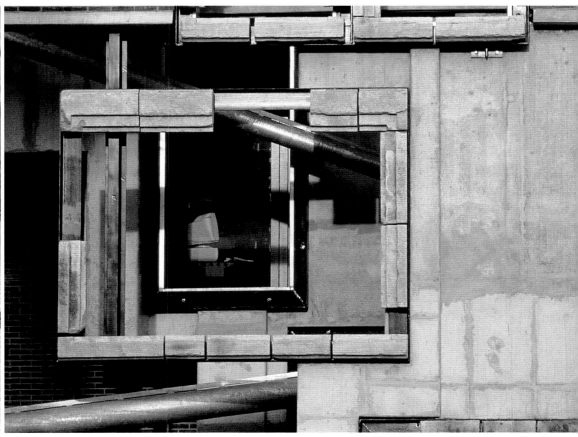

above *A new stair through the offices mixes materials in a controlled way. More important is the quality of light in these new spaces. Numerous windows bring light deep into the building.*

left *By combining fragments of earlier buildings, including window frames, the façade becomes a kind of collage and acts as a reminder that the complex of buildings is steeped in history.*

above right *The building is layered like a stage set. This window is part of a new façade, but behind it is the building proper and another window that belongs to a new block of council offices.*

Ground-floor plan
Key to plan
1 main entrance
2 great hall
3 wedding room
4 conference room

139

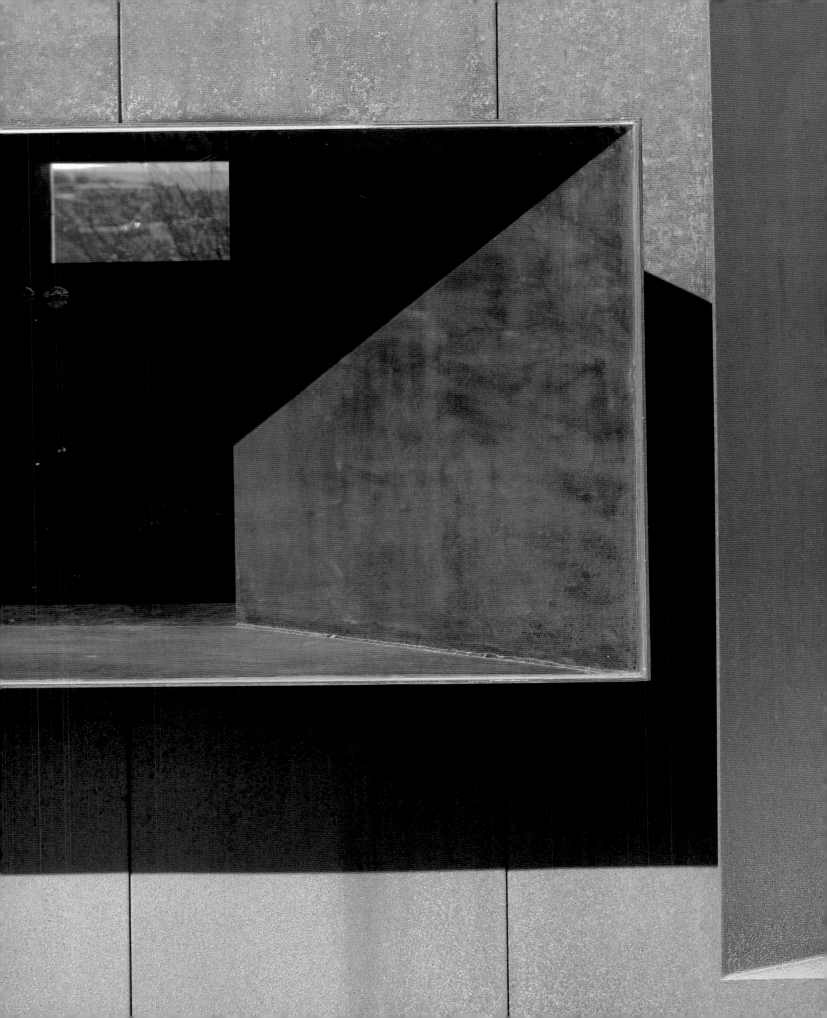

A NEW AGENDA

Low-energy buildings have been on the agenda for some time, but sustainable design is about much more than simply choosing building materials according to how little they deplete the world's resources. It also encompasses lifestyle and workplace issues. For some time Dutch architects have led the way by designing dense but highly desirable developments on reclaimed land. In other parts of the world the agenda is rather different. In South Africa, for example, the issue for architects is how to express the future while being sensitive to the country's traumatic past. In many countries, lack of space has persuaded some architects that the only way to avoid urbanization is to build upward. The counterpoint to this is a growing interest in an architecture that is attuned to the landscape and climate, and seeks to minimize the impact of architecture on the environment. The need for architects constantly to innovate is also explored in this chapter and, while individual architects have diverse preoccupations, the new agenda is to look to the future through buildings that are thoughtfully conceived and executed.

left *Architect Rick Joy chose ordinary steel for this house in Arizona but because of the intensely dry heat the steel quickly weathered to a rich red, blending with the colours of the Sonora Desert.*

GLENN MURCUTT
ARTHUR & YVONNE BOYD EDUCATION CENTRE, RIVERSDALE, 1999

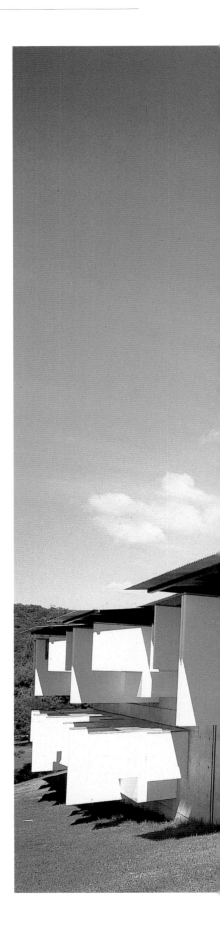

Many Australians rank Arthur Boyd as their country's greatest painter, but his most significant legacy may prove to be the art centre designed by Glenn Murcutt on the late artist's ranch in the bush of New South Wales. Boyd bequeathed the property to the Australian government to be developed as an art centre for children to experience nature through sketching, music, and drama. Murcutt, with his wife Wendy Lewis and a former student, Reg Lark, was asked to provide an outdoor amphitheatre, a multi-purpose hall, and a dormitory. A response to the mountainous landscape, the centre marked a break with Murcutt's usual disciplined and orthogonal plan. It has a distinctive geometry that is closer to Alvar Aalto than Mies van der Rohe – whom Murcutt calls "my conscience".

The approach to the complex is uphill, so the buildings are revealed bit by bit. It is only after the visitor has passed under the low east veranda of Boyd's studio that the new hall comes into view. The immediate impact is made by the large soaring wing-like roof. In fact there are two roofs – one covering the meeting room and the other the residential block – with rainwater captured in the "valley" between them for later use.

Although the hall has a monumental feel, the sleeping quarters are more intimate. This is partly due to the warm wood tones of the fenestration – windows within windows – that give the residential wing a monastic character, while a long low window at bed height frames views of the river. As in all Murcutt buildings, expression and function coincide. The arrangement of the cell-like windows gives a rhythmic beat to the façade, with white-painted concrete sun-shading blades separating each alcove. The building has neither heating nor air-conditioning. The location and orientation of glazing, sun breakers, and canopies, combined with natural ventilation, are designed to allow the building to breathe and to create comfortable conditions adapted to the climate.

Site plan

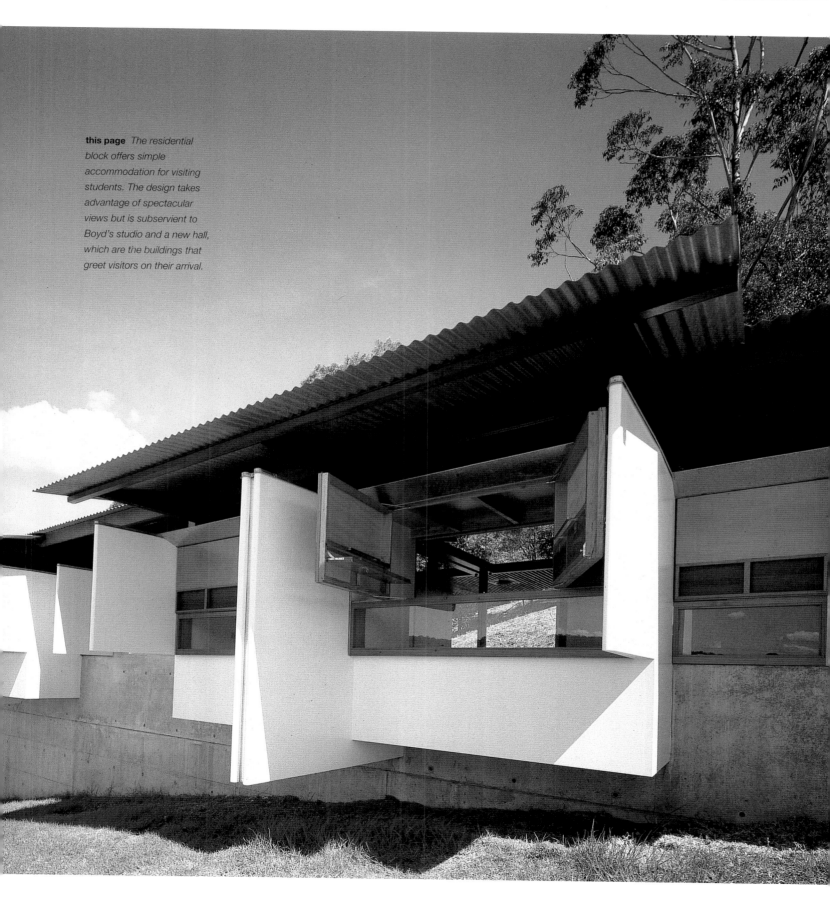

this page *The residential block offers simple accommodation for visiting students. The design takes advantage of spectacular views but is subservient to Boyd's studio and a new hall, which are the buildings that greet visitors on their arrival.*

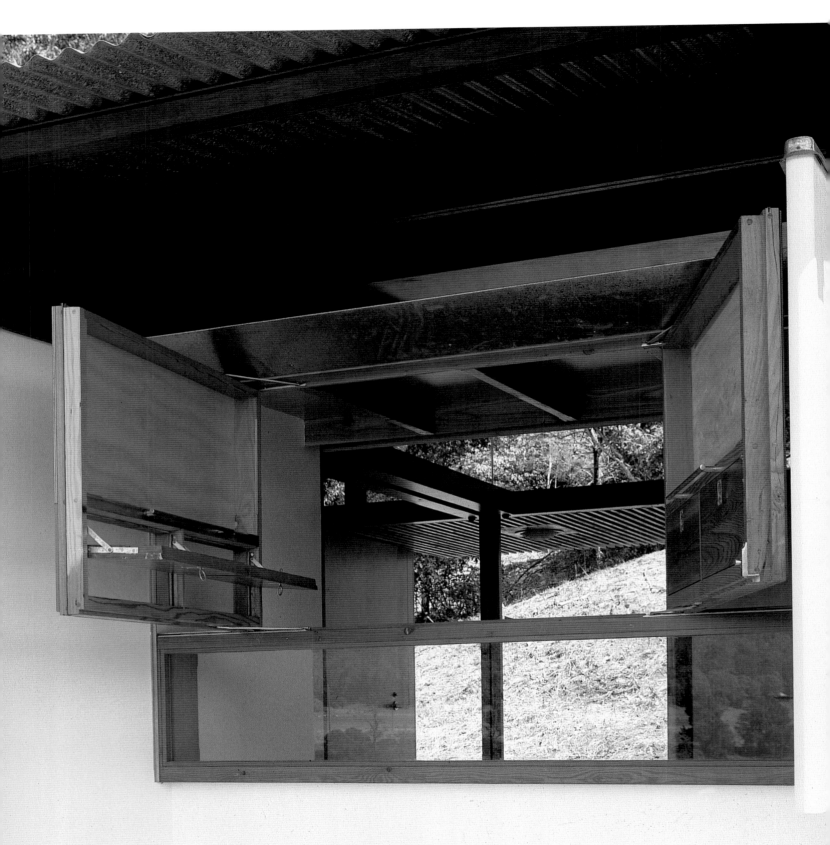

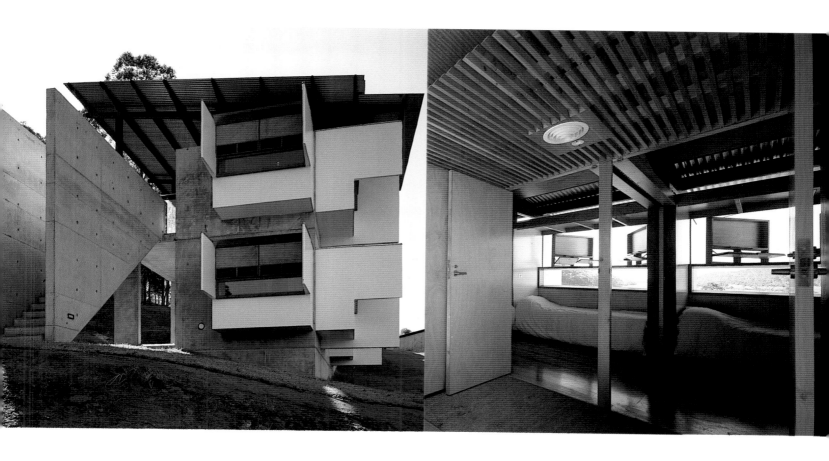

left *From a distance the white outer blades and inner wooden shutters look like windows within windows. The blades are in fact fixed and are there simply to give protection from the harsh Australian sun, while the shutters can be opened and closed depending on the season.*

above *The building combines the architect's favourite materials – metals, concrete, timber, masonry, and stone – in his muted palette of white and black and what he calls "nature material" colours.*

above right *Each block sleeps eight children in rooms of four beds each. Although the dormitories are utilitarian, with neither heating nor air conditioning, the rooms' wood lining gives them a warmth and richness.*

REM KOOLHAAS
HOUSE NEAR BORDEAUX, 1998

A new home outside Bordeaux was the dream of one young family, but the dream had to be put on hold when the father was involved in an accident that left him in a wheelchair. Some years later, the parents went back to the architect, Dutch maverick Rem Koolhaas. The father told him: "I do not want a simple house. I want a complex house because the house will define my world."

Designed as three houses one on top of the other, this extraordinary home can be entered by three doors, each leading to a different internal experience. One leads to the ground-floor kitchen, the other to the stair up to the living room, and the third is a castellar staircase that unexpectedly ejects you into the external terrace. Such variation is part of Koolhaas' idea that the house must contain the richness of a much bigger space. So it is with the three levels. The lowest is cave-like, while the highest is divided into bedrooms for the children and the parents. The most important room is the middle-level living-room, an archetypal glass box half inside and half outside so that the floor plane appears to shoot out, hovering over the view of the river and the city.

Moving between the three levels is a lift that transforms the floors: on the top floor it functions as an office for the husband; on the mezzanine it completes the aluminium flooring; on the bottom level it becomes part of the kitchen. The big window that erases the distinction between outside and inside is actually a massive double-glazed motorized sliding glass door 8.5m (28ft) long. Although the middle portion of the house is open, the architect wanted the upper level to be very closed, with the circular windows planned according to the height of each bedroom's occupant. The single universal eye of Le Corbusier is replaced by a multiplicity of eyes; the children will feel the room in constant change as they grow. The first of the different heights is at eye level to provide glimpses of the horizon, the second frames views of the landscape, and the third is what the architect describes as "anti-claustrophobic holes framing the nearest piece of ground" – the antithesis of the panoramic vista available from the glass house below.

far left *Windows in the building are different shapes and sizes. The big, pivoting window in one of the children's bedrooms is replicated in the courtyard below (seen in main picture).*

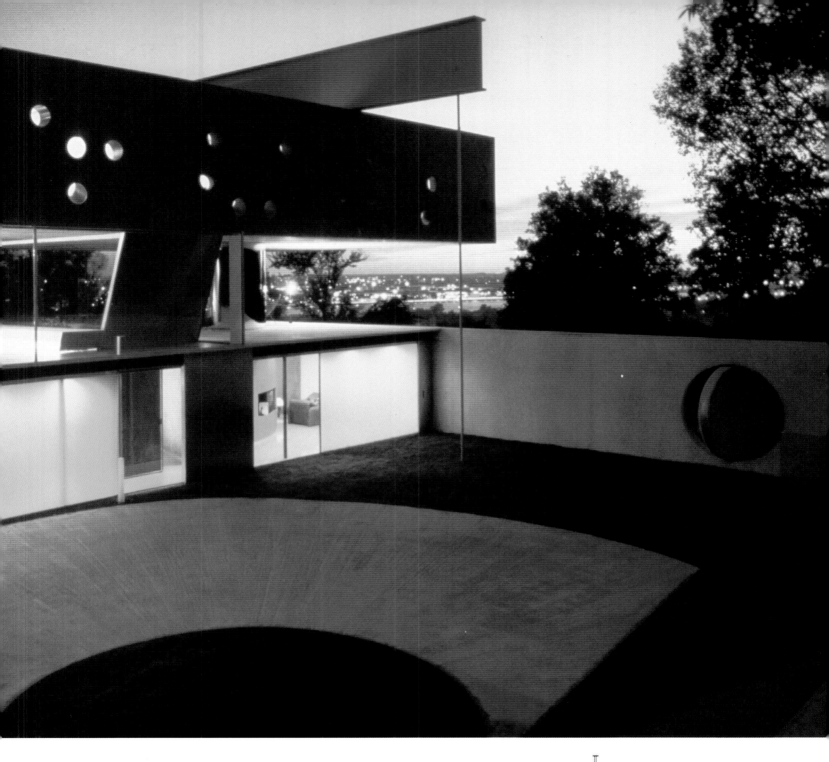

above *A night view of the principal façade of the house from the courtyard, showing the "Swiss cheese" windows that are set at varying heights in the walls.*

Longitudinal section through house

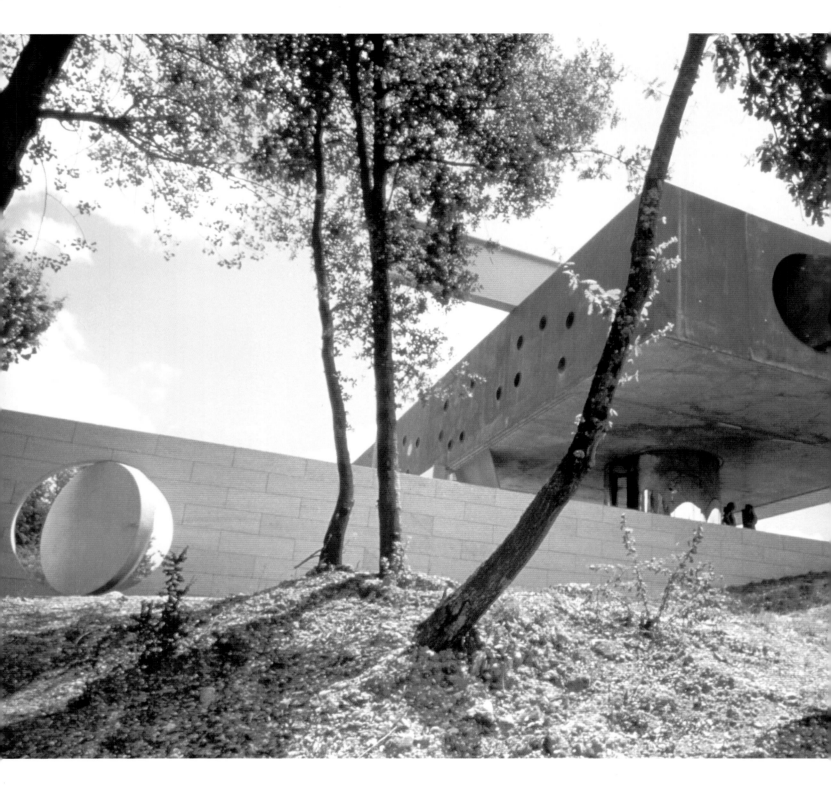

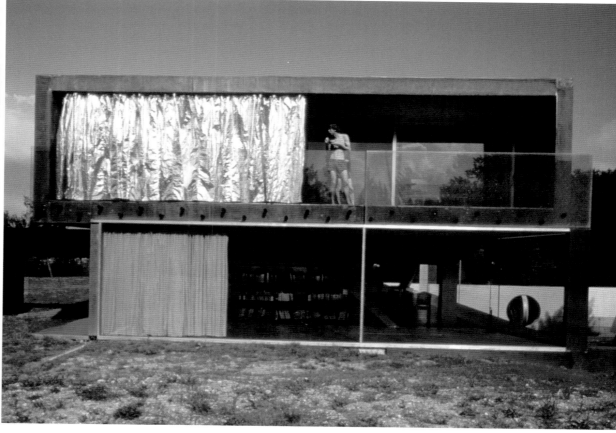

left The scale of the house looks and feels non-domestic. The top floor is a concrete box that hangs implausibly over the column-free middle floor, itself supported by a huge spiral-stair-filled column and a vestigial-looking tendon that plunges into the ground.

above A huge external metallic curtain provides shade and privacy to the master bedroom facing south. On the middle storey floor-to-ceiling windows slide away on hidden tracks to make the room almost disappear. Just visible is the three-storey high bookcase.

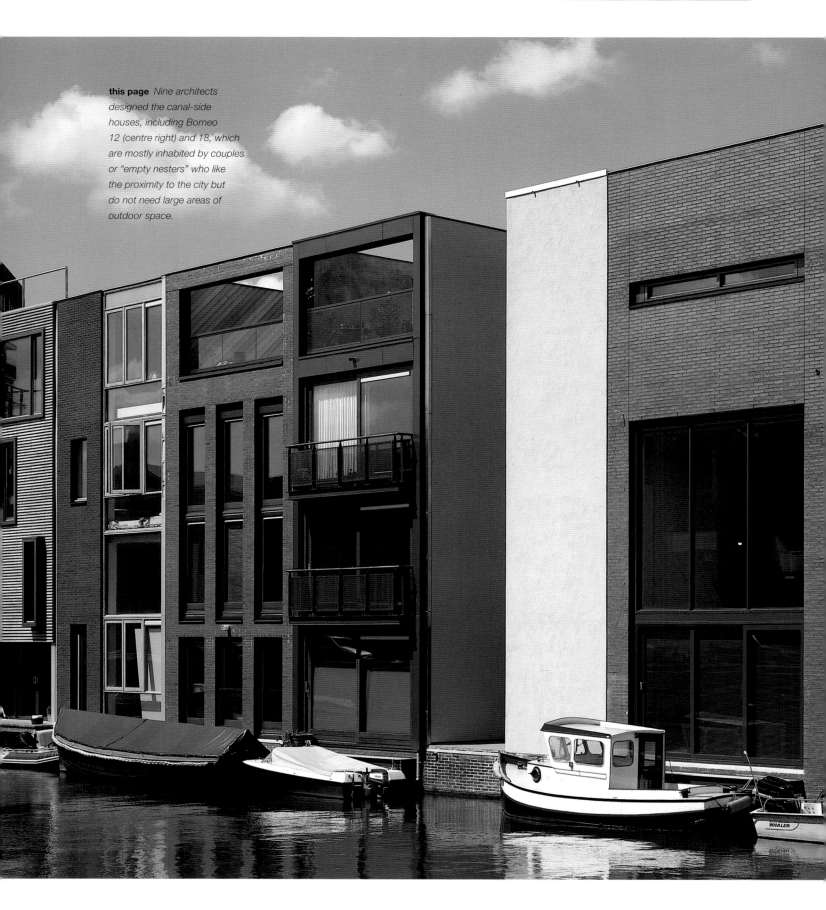

this page *Nine architects designed the canal-side houses, including Borneo 12 (centre right) and 18, which are mostly inhabited by couples or "empty nesters" who like the proximity to the city but do not need large areas of outdoor space.*

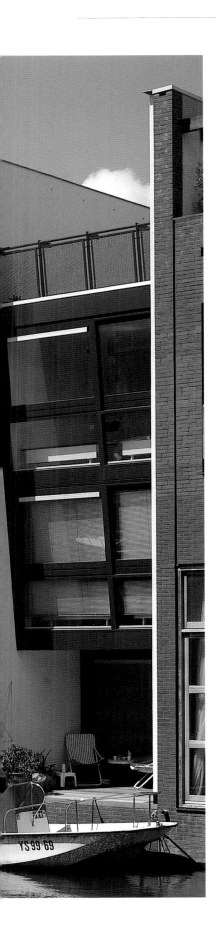

MVRDV
BORNEO HOUSING, AMSTERDAM, 2000

Borneo Sporenburg forms about one third of an enormous redevelopment of Amsterdam's eastern docklands area – a once-abandoned landscape of warehouses, rail sidings, and cargo cranes. The urban design firm West 8 laid out the two fingers of the island with 2500 townhouses and apartments and then charged nine architects with reinterpreting the traditional canal house. The government had already laid down a density of about 100 units per hectare – the highest density of any site in the Netherlands – and in response West 8 placed most of the tiny lots back to back. It asked the architects to find ways of creating light courts and outdoor spaces to drive daylight deep into the houses.

Whereas most of the housing has been designed as rows of identical units, family houses, or interlocking flats and maisonettes, the properties on Scheeptimmerstraat are individual designs for private clients. The clients of Borneo 12 and 18 selected MVRDV, a Rotterdam-based firm set up in 1991 by Winy Maas, Jacob van Rijs, and Nathalie de Vries. Both in its built and in its unbuilt projects, MVRDV has been fascinated with density and with stretching spatial possibilities.

Borneo 12 is the smaller of the two houses – 2.5m (8ft) wide. The architect decided to divide the site in half, using the remainder for an alley running from street to canal. The full length and height of the half built along the alley has a glass wall that brings daylight into the length of the narrowest rooms. Full-height sliding doors connect the house to the alley. These are used for ventilation and function as entrance door, garden entrance, and a way to the roof terrace.

At Borneo 18 MVRDV took a different tack. Here it has enclosed the full width of the plot and managed to create four levels by pulling out the bathroom and bedroom to the water boundary. The result is a series of rooms differing in height and privacy and connected to the exterior by large expanses of glazing. In fact, there were other reasons for having what look almost like shop windows in this new district of Amsterdam. In the original master plan the architect suggested that by having higher than normal ground-floor levels and open glazed fronts the houses could easily be converted to cafés or small businesses, if demand and regulations permitted.

Axonometrics of Borneo 18

151

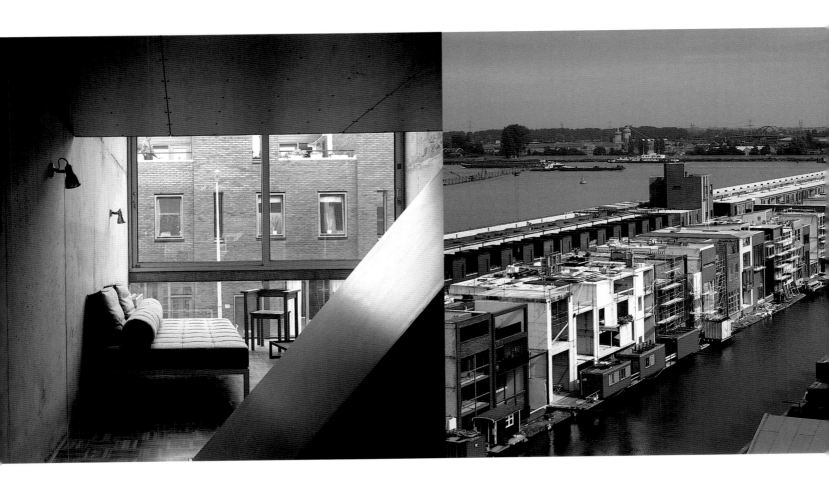

above Borneo 18 is an intricate sequence of spaces of which the main one is the living room facing on to the canal. Although the large areas of window offer little privacy, together with high ceilings they make the spaces seem larger than they really are.

above right Borneo Sporenburg represents only one third of the extensive redevelopment of the city's eastern docklands area.

right Because space is so tight it was crucial that the various designs all took into account the need to drive daylight deep into the volume of the houses. Borneo 12, which faces onto the canal, has the added bonus of the shimmering reflections from the water.

LUCIEN LE GRANGE
NELSON MANDELA GATEWAY, CAPE TOWN, 2002

It would be hard to think of a more highly politically charged project than the Nelson Mandela Gateway in Cape Town. This ferry terminal and museum links the city to Robben Island, a small island first used as a place of incarceration in 1665, when the inmates were political dissidents who opposed Dutch colonial rule. In the early 1960s it became a prison for the political leaders who opposed apartheid.

Architect Lucien le Grange felt that the gateway's design should not imitate the Victorian style of the surrounding buildings. The Victoria and Albert Waterfront is one of Cape Town's urban regeneration successes, a collection of former harbour warehouses transformed into a thriving retail complex. The most recent addition is the Clock Tower precinct, into which the gateway had to fit. The architect attempted to invest the building with its own symbolism, making it transparent like a giant window opening South Africa's recent past to public reflection. With its floating jetty, restaurant, auditorium, information centre, and exhibition space, the building has to combine utilitarian functions with the issue of how to prepare visitors for the trip to the island. Le Grange says of the building: "We thought it had to be transparent for both symbolic and practical reasons – it has to be a building which could be looked into, from which the harbour and the harbour mouth could be viewed, and a building which could be looked through."

Through the building's main north-west façade, you can see the embarkation point for prisoners shipped to the island from 1959 to 1992. Fritted-glass louvres are used at upper and lower level to control sun penetration. The upper level of the second-floor restaurant has fixed glazing up to a height of 2m (6ft 6in) and top-hung fanlights that open out.

By contrast, the triple-height hall dubbed the "courtyard" (a reference to the prison's Section B Courtyard) is deliberately claustrophobic. Light streams in though skylights above the staircases and through the glazed sun-facing wall, yet the effect is one of unease, compounded by the gangplank-like ramp that takes passengers onto the jetty.

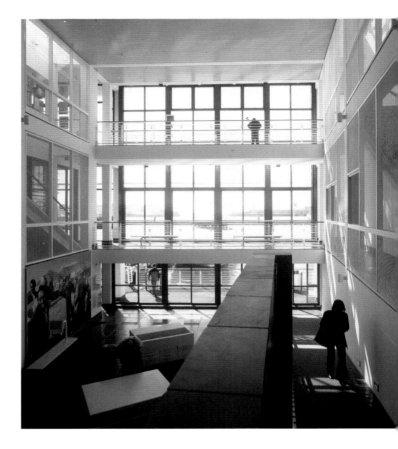

above *The building helps prepare visitors for their trip to Robben Island with a series of exhibitions on the island's history. The exhibits are housed on three floors surrounding the main courtyard and waiting area.*

Section through building

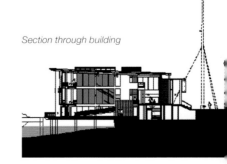

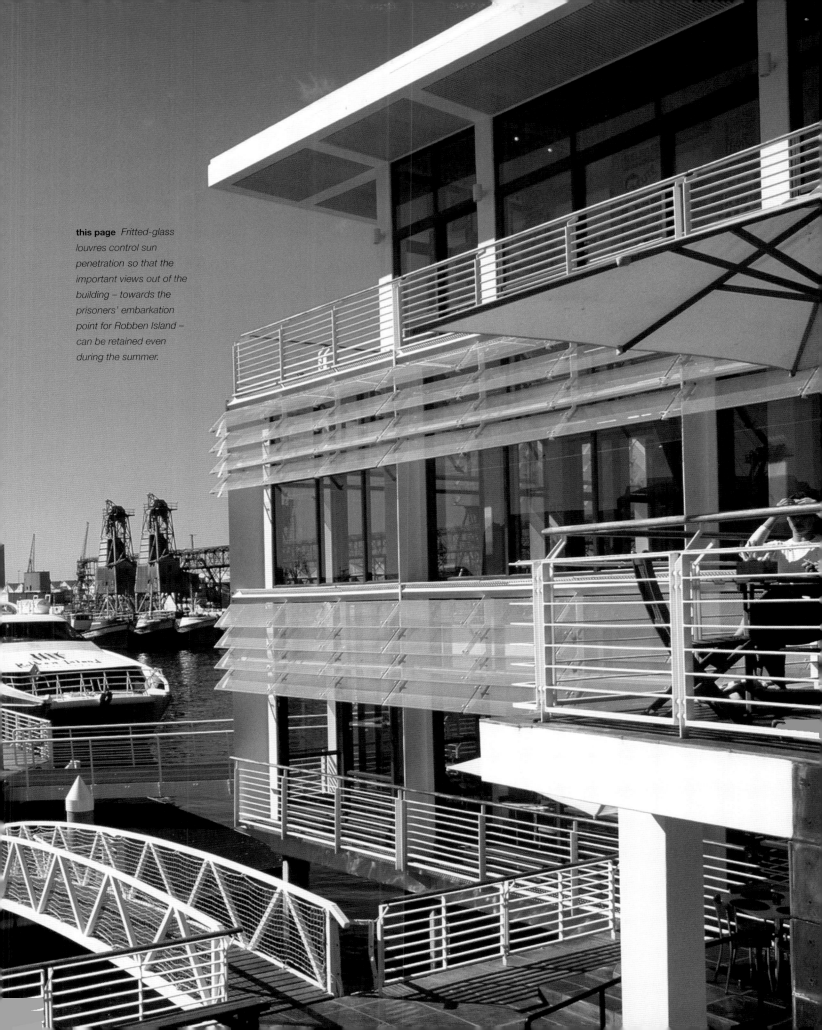

this page *Fritted-glass louvres control sun penetration so that the important views out of the building – towards the prisoners' embarkation point for Robben Island – can be retained even during the summer.*

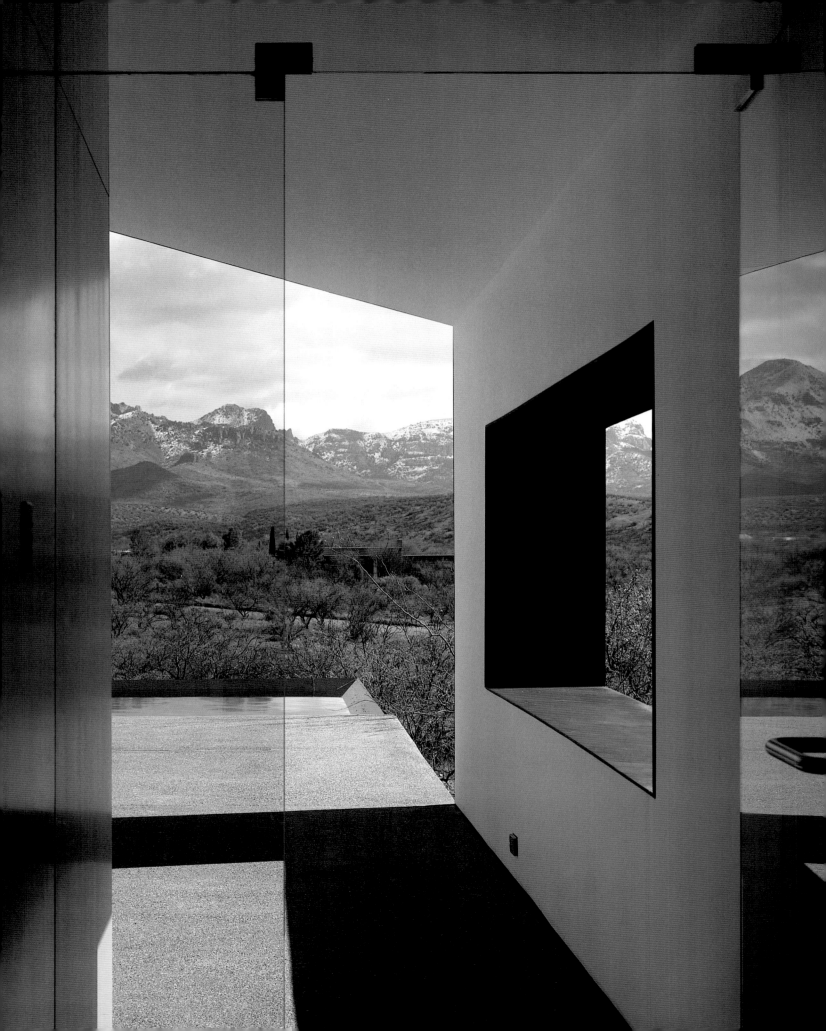

RICK JOY

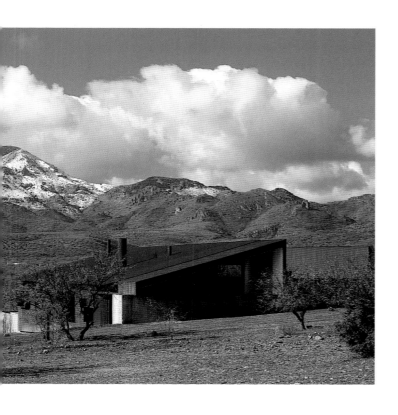

above *As far as possible the architect wanted the house to become part of the dramatic landscape. Low-slung pitched roofs echo the mountain forms while the steel cladding has turned a rusty red in the Arizona climate.*

left *The house is designed as a combination of floor-to-ceiling glass and carefully composed openings – some of which have no glazing but simply frame a vista.*

"I always try to create an architecture rooted in its place," says Rick Joy, an architect best known for a series of elegant rammed-earth buildings that have their roots in the history of the American South-West. The Tyler House was a departure for Joy. Clients Warren and Rose Tyler wanted a more refined building material than earth so the architect used steel for the exterior. The interior is white walls and pale wood, a backdrop for the Tylers' art collection. In his use of steel, Joy drew on the vernacular of the metal utility sheds and silos put up in the frontier days of the South-West. Having turned a rich rusty red, they now blend in with the terracotta of the Sonora Desert.

The site was in Tubac, Arizona, 24 kilometres (15 miles) from the Mexican border, an area famous for clear starry nights, spectacular lightning storms, and dry cloudless weather. The landscape is also extraordinary: an open expanse of desert scrub and low mesquite bush against a backdrop of three mountain ranges – all visible from the house.

The brief was for a house that had to work on various levels. Although the roughness of the metal exterior was in stark contrast to the finely detailed interiors, the clients wanted a home that blurred the boundaries between inside and out. Sliding glass panels turn rooms into outdoor porches and from inside the house it is the vista beyond that commands attention. The house is actually two buildings, the main house and a smaller guesthouse with workshop and garage. The buildings flank a courtyard and are slightly angled to frame a view of the Tumacacori Peak. The courtyard leads onto the swimming pool deck to the west. Here, an outdoor kitchen is sheltered beneath the roof's deep overhang, and a long rectangular unglazed opening cut out of the side wall frames desert views.

Once inside the house the landscape is presented as a series of compelling panoramas. Occasionally there are oblique glimpses of two or three framed panoramas appearing simultaneously. All the windows are rectangular but in some places the glazing is set deep within a custom box-like steel frame, while in others the glass seals the frame's outer surface or is set almost flush with the façade.

157

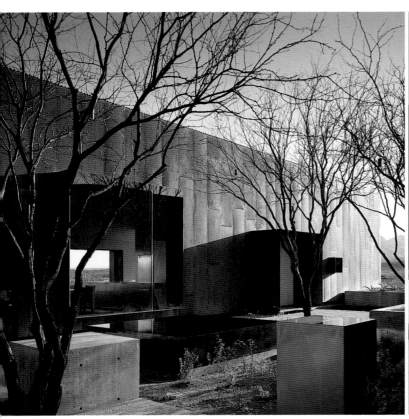

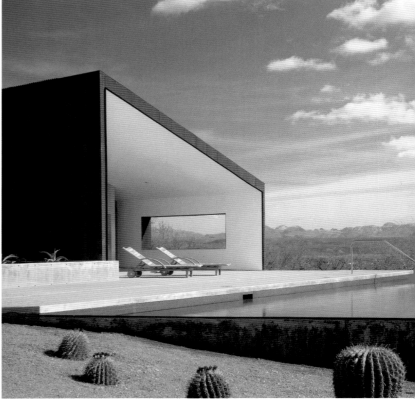

above *Marking the entrance is a hollow rectangular steel box which projects from the front façade, almost like a viewing box, so one can clearly see through the house to the landscape beyond.*

above right *A covered porch, a patio, and a black-granite-edged swimming pool make a dramatic statement and extend the house's boundary towards the distant horizon.*

right *Rick Joy believes that architecture should work with, not against nature, fitting in with the terrain if possible. Here he has carved a level shelf into the hill so that the house appears to lie low on the land – rather like one of the rough-skinned local lizards.*

Section through window detail

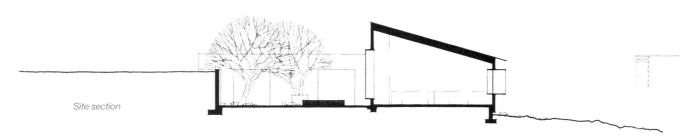

Site section

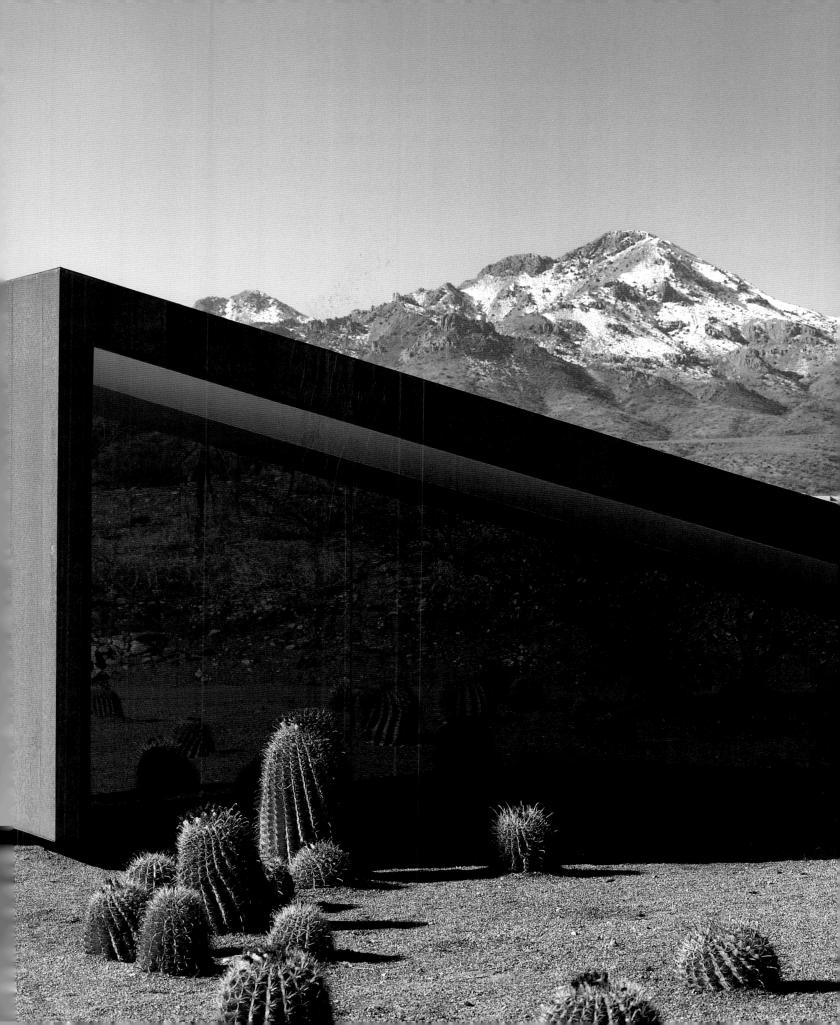

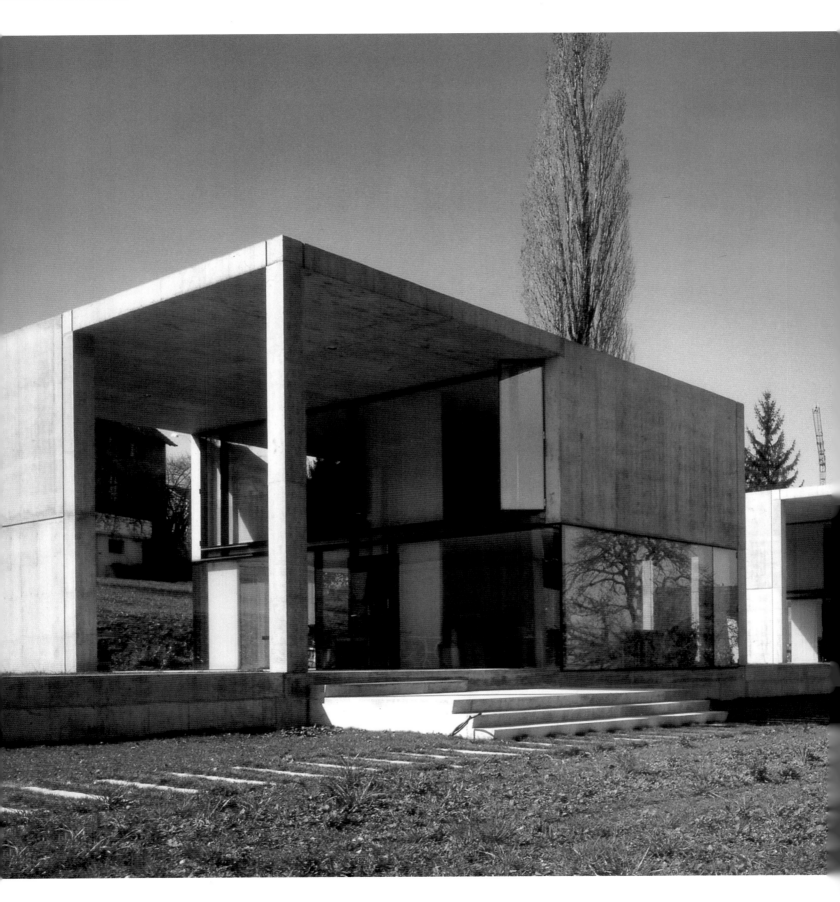

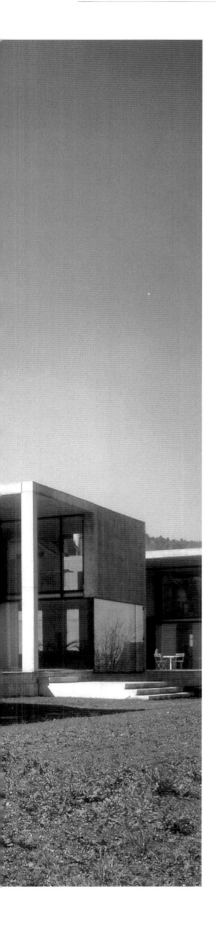

GMÜR & VACCHINI
THREE VILLAS, HALWILLER SEE, 2001

One-parent families, extended families, singles buying and sharing apartments – all types of cohabitation that would have been unthinkable only a generation ago. Yet the reality is that the housing market has not caught up with the changes in society, and living alone, for example, can still be prohibitively expensive. To get around this and to avoid the inconveniences of isolation and high maintenance, three middle-aged women decided to build houses on the same plot on the shores of Halwiller See in Switzerland, halfway between Zurich and Lucerne.

Designed by Silva Gmür and Livio Vacchini, the three villas appear stern, but the architectural game that is played out – between solids and voids, courtyards and buildings, between concrete walls and minimally glazed openings, and between privacy on the one hand and sociability on the other – makes this building a much more intriguing proposition than a simple reworking of the ubiquitous Swiss "box". Each house is comprised of a closed volume, 6m (20ft) in both width and height and 10m (33ft) deep, with an open loggia of equivalent dimensions that contains a semi-private terrace oriented towards the south. The house itself is divided between the living-room and the kitchen on the ground floor and the bedroom and studio on the upper level.

The houses have been built on a platform halfway up the slightly sloping site so that all three can enjoy equal views of the lake. In fact, the architect has set out the individual houses as if they were one long continuous house but the open courtyards between them, where grass is allowed to grow freely, offer a degree of privacy while establishing another order of open-air space. With the three clients living in such close proximity to each other, the main challenge was to define the public and private areas. Rather than using hedges and walls, this has been achieved by a subtle play of solids and voids: one half of the house is open and the other half is closed, one is heated and the other is not. With this theme of opposed elements, the elevations are formed by counterpoising the large exterior frameless windows with exposed concrete panels to conceal the house's interior.

The stark materials and square-based geometry may strike some as a strange choice for houses, especially in so picturesque a location. These homes are neither cosy nor do they offer privacy in the conventional sense, yet they challenge the house-building industry, which for too long has ignored the need to offer an increased number of housing types.

left *Although these are three individual houses, from an architectural point of view they are one single building, 70m (230ft) in length and 10m (33ft) deep.*

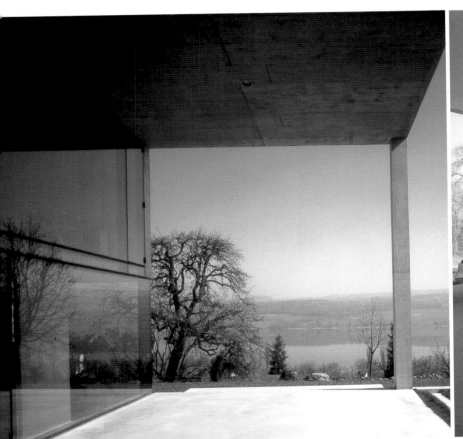

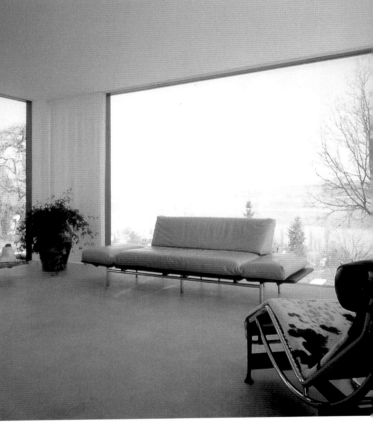

above *Openings are generous and oriented towards the south and views of the lake. The strict geometry and the division of the individual plots into two parts reinforce the sense that each house is really two halves – one closed and one open.*

above right *Although there is only 120sqm (1290sq ft) of living space – shown here is the living-room on the first floor – the glass makes the dimensions feel more generous by opening up the interior to the outside.*

right *Concrete is more respected and better understood in some countries than others. Architects in Switzerland recognize the material's visual qualities, particularly when juxtaposed against other materials such as glass and steel.*

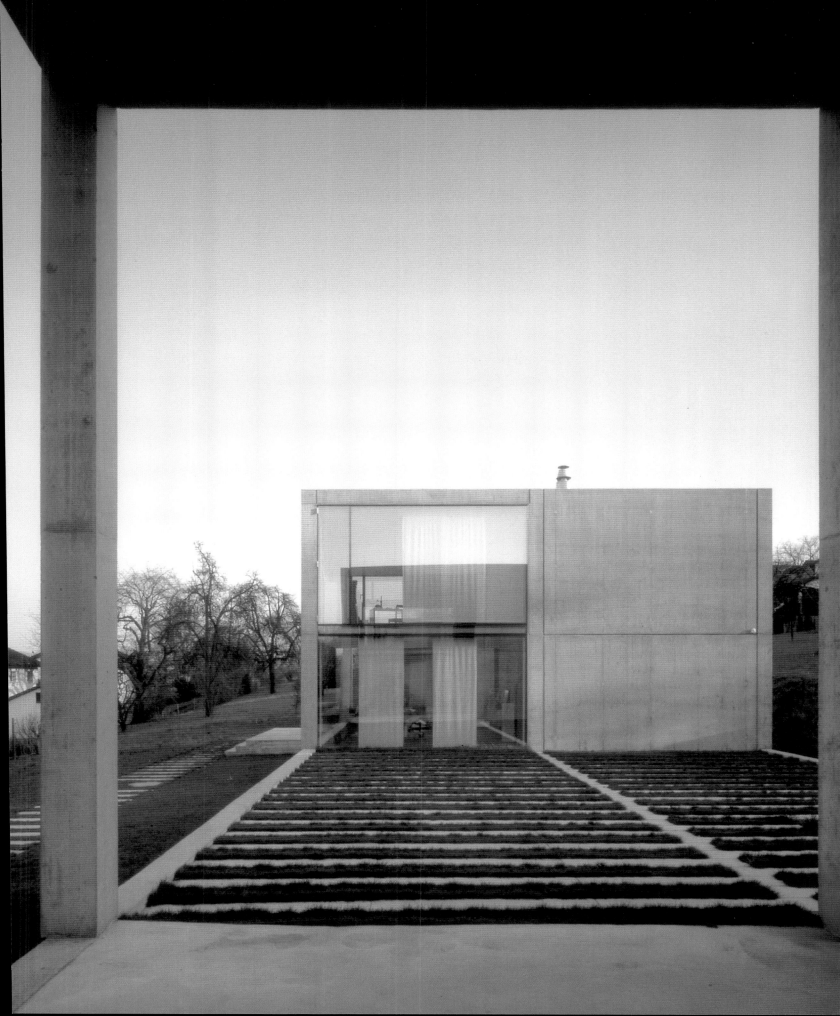

BAUMSCHLAGER & EBERLE
HOUSING, INNSBRUCK, 2000

above *Highly insulated walls and triple-glazed windows minimize heat loss.*

Social housing accounts for more than one third of Austria's construction work, yet it provides limited opportunities for innovation. This is partly because of cost constraints, but also because in Austria Modernism has had to battle against the prevailing style influenced by the local vernacular. Yet Carlo Baumschlager and Dietmar Eberle, based in Bregenz, have concentrated on social housing, taking the view that there is still plenty of scope in exploring the essence of simple materials and forms in a Modernist vein.

The Alpine setting is a vital ingredient of the architects' scheme on the western edge of Innsbruck. Each of the 298 apartments has light, views of the peaks, and generous outdoor spaces. An extension of an existing residential area, the development is spread out in six buildings of five to seven storeys each, with parking underground to allow the spaces around the buildings to be given over to paved paths and public areas.

Unlike so much social housing where the hallways and entrance are poorly lit and mean, here the communal areas are well designed and generous. The entrance, courtyard, and stairs lead onto communal hallways, which in turn lead to individual apartments. The plan allows for the living spaces to face out to views and light while kitchen and bathrooms are arranged around a central light well and service core. Each apartment has floor-to-ceiling French windows, which open onto balconies running round the entire perimeter of the building, giving each apartment access to a generous, semi-private outdoor space.

Full-height movable copper shutters mounted on the translucent glass balconies serve as protection from sun and weather. Eberle calls these shutters "tools to handle the neighbourhood" because they allow tenants to let in as much or as little of their surroundings as they want. They also form a dramatic skin for the building, animating the rather severe façade and giving it an ever-changing rhythm.

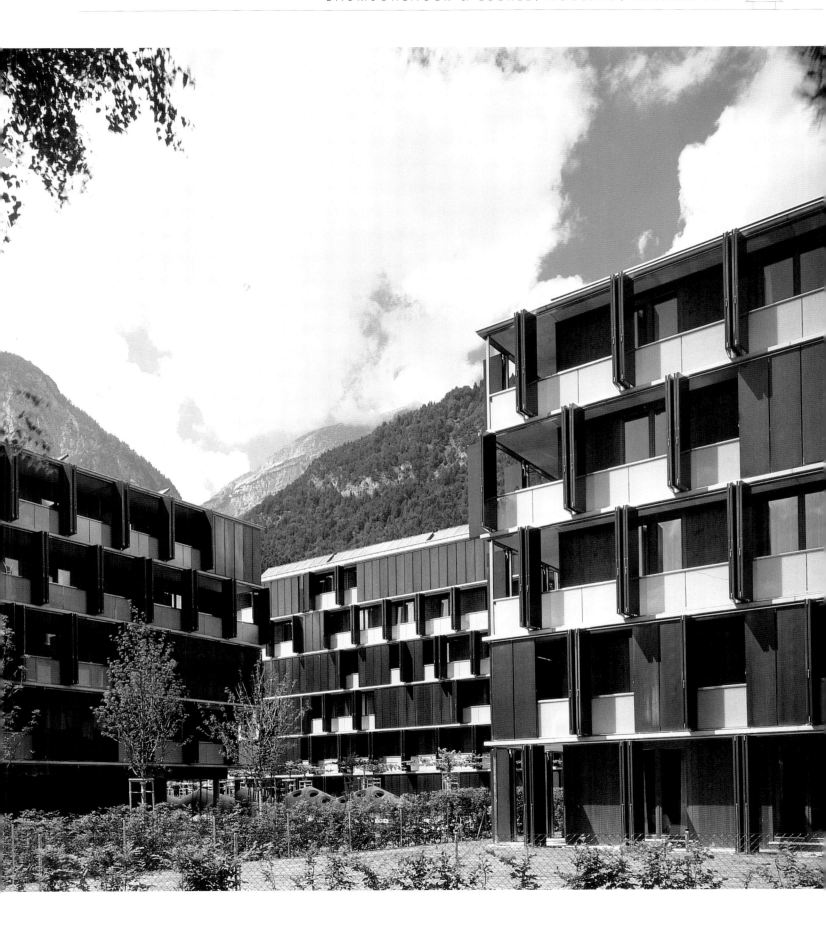

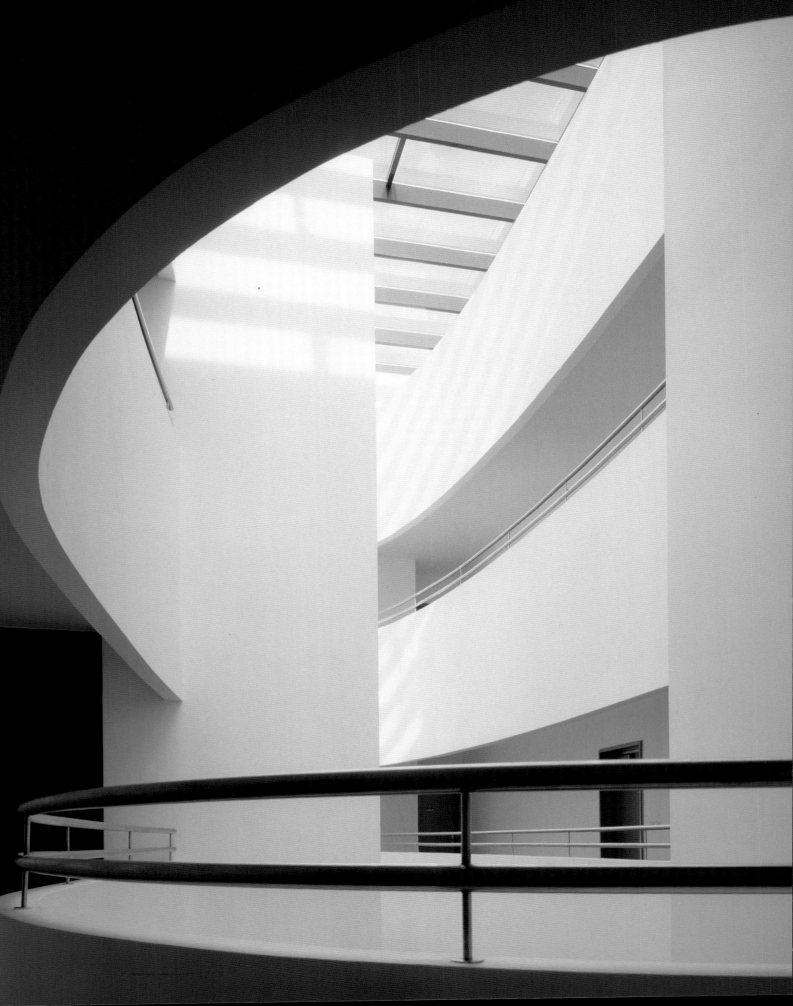

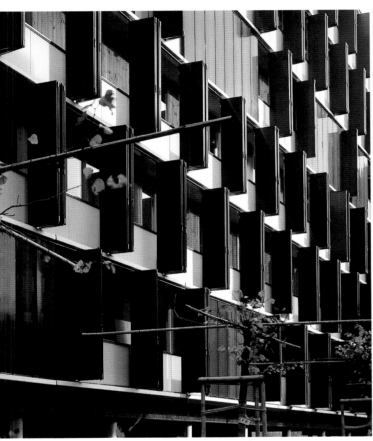

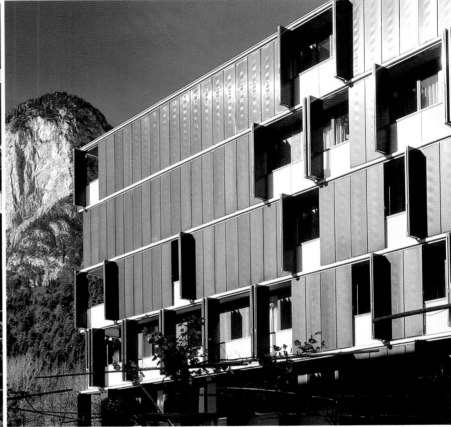

above *The shutters allow tenants to control their own views and privacy, letting in as much or as little of the surrounding neighbourhood as they require.*

above right *Gaps between the buildings were carefully worked out to optimize transparency and the effect of sunlight, shade, and views of the mountains.*

left *Although this is social housing, the public areas feel generous. Stairways are lit from above and the architect has insisted on a high standard of finish despite the tight budget.*

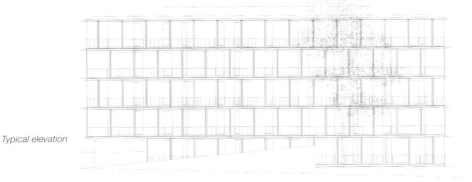

Typical elevation

DAVID ADJAYE
ELEKTRA HOUSE, LONDON, 1999

When young architect David Adjaye designed a house without windows he challenged conventional perceptions of the home. The outcry that followed its completion at the end of 1999 seemed to suggest that however far UK architecture had progressed, to build a family house without windows and a front door was going too far.

The Elektra House was commissioned by an artist and sculptor and is in London's East End, an area popular with artists and designers because of its cultural diversity and lower property prices. The house was built on a tight budget yet the decision to design out the windows was not based on cost. The client asked for a large internal wall on which to show art and video; Adjaye wanted to see if, within this brief, he could experiment. He says: "I wanted to present another possibility of façades to London. There is a tradition to articulate blind façades, mostly seen on Georgian streets as a result of the window tax." His design also asked: why have a window on to the street when the street itself is not that appealing?

Adjaye's office approaches each project as an experiment in materials and techniques, and Adjaye seems to be at his most comfortable transforming cheap industrial materials to create intriguing textures and surfaces. At the Elektra House he has used resin-coated plywood cladding, usually used for shuttering for concrete, for the blank wall of the street facade. The entrance is tucked down a side passage. This, together with the lack of windows, makes the house appear like a remote haven from the street – a feeling that is heightened inside. White walls and a glazed rear elevation flood the living area with light.

It feels deceptively big for such a small house. The ground floor opens onto a small courtyard. Upstairs, Adjaye has kept the ceilings high so that even the smaller bedrooms seem lofty. Many commentators described the house as menacing and antisocial and it is true that it is completely cut off from the street – instead, its occupants are connected to the sky. On the first floor, the glazed elevation is pulled away from the main body of the house so the effect is that of a giant clerestory. Instead of windows Adjaye has devised a series of openable skylights so that the quality of light in each room is always different.

Street elevation

far left *Seen from the street the house is enigmatic, its most striking feature being its unsettling lack of windows. The front façade is clad in panels of phenolic resin-coated plywood – an inexpensive alternative to brick and glass.*

right *The house provoked intense criticism, some people questioning whether a house without windows was the right environment in which to being up children, but what many failed to realize is that the back of the house is almost all glass, filling the living area with light.*

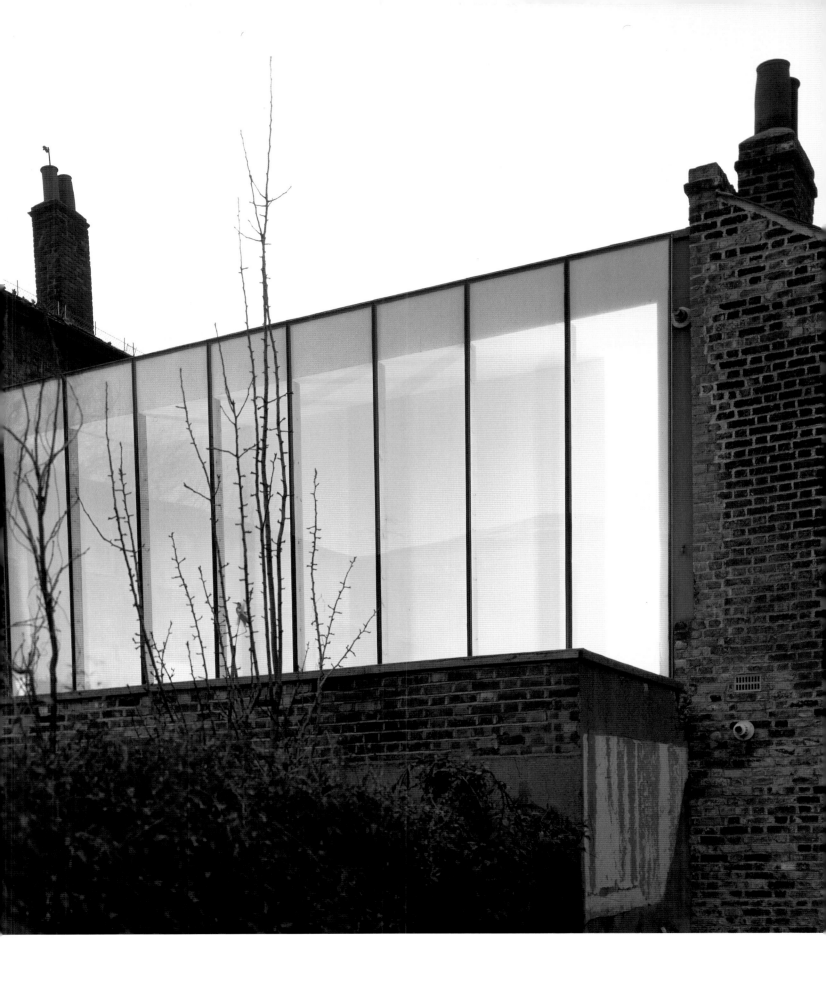

PUGH & SCARPA
ARTISTS' STUDIOS, SANTA MONICA, CALIFORNIA, 2000

The Bergamot Station in Santa Monica is laid out like a small college campus. Numerous galleries and design firms, along with the Santa Monica Museum of Art, occupy the former industrial warehouses built in the 1870s.

Architects Pugh & Scarpa, one of those that moved to Bergamot, have become involved in the ongoing redevelopment of the complex. Their first commission was the conversion of one of the industrial sheds into an animation studio. The architects were then given the more difficult challenge of designing the only new building on the site, an infill of ground-level studio/gallery space with three live/work spaces above, which would occupy the southernmost portion of the site, flanked by the museum.

Although Pugh & Scarpa were determined that the addition should read as modern rather than a film-set copy, its starting point was the surrounding industrial landscape and the existing materials on the site – corrugated steel sheeting, concrete blocks, and glass. Windows became part of this rich collage, with crisply defined sheets of glass positioned to animate the façade rather than for any functional reasons. The south façade is the more abstract of the two: a flat plane of corrugated metal is broken into pristine rectangular volumes of Lexan polycarbonate, concrete blocks, rolled steel, and glass. Together they appear to recede, creating a restrained yet elegant relief and textual complexity.

The north façade is more dynamic. Sheet metal swoops down, like an arm, enfolding and protecting the entrance area and turning an undefined space into one that flourishes as a kind of courtyard or piazza. Again the juxtaposition of materials – cold-rolled steel, polycarbonate, and glass – is made to work as part of a geometric puzzle that gives little away about the spaces inside. "I was interested in surface treatment," says Lawrence Scarpa. "It is a simple façade, broken into a small number of recognizable pieces."

In fact, the interiors are flexible so tenants can create their own space. Each unit is split-level in order to create a double-height space. Living areas are on the primary level, overlooked by the bedrooms above. Each bedroom is awash with light from a continuous band of skylights along one edge of the building.

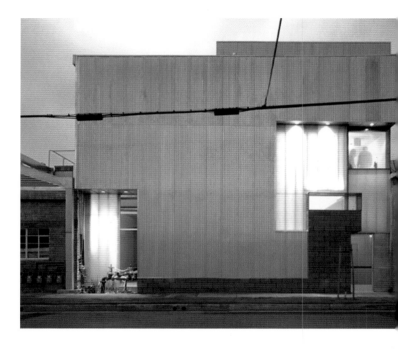

above *The south façade fronts the public street and is a personality foil for its more geometrically complex and dynamic counterpart on the north side.*

3-D perspective

e Set within a primary
of corrugated metal and
windows – both glass
slucent Lexan panels –
material richness that
ome a hallmark of the
's' work.

INDEX

173

ACKNOWLEDGMENTS

Author's Acknowledgments

Thanks to all the architectural practices who contributed information and material for this book. Thanks should also go to the brilliant staff at the RIBA Library, and my colleagues on the *RIBA Journal*, with particular thanks to Concetta Sidoti, and to my family Paul, Ellie, and Clare Charman, for all the lost weekends and evenings.

Photographic Credits

Key: b = bottom; c = centre; l = left; r = right; t = top

Adjaye and Associates: **168**tr

Alsop and Stormer: **89**

Arcaid/Richard Bryant: Architect: Gerrit Rietveld: **15**

Archphoto/Eduard Hueber/Architect: Baumschlager & Eberle: **164–167**

Hiroyuki Arima: **51**b

Artur/Dieter Leistner/Architect: Christoph Mackler: **98–99**, **100–101**, **101**

Shigeru Ban: **31**b

Baumschlager & Eberle: **167**b

Benson and Forsyth: **128**

Hélène Binet/Architect: Caruso St John: **54**l, **55**

Bitter Bredt/Architect: Sauerbruch & Hutton: **75**, **76–77**; Architects: Daniel Libeskind: **112**, **114**tl, **114**tr, **115**

Bridgeman Art Library/British Tourist Authority: **11**; Metropolitan Museum of Art, NY: **8–9**; O'Shea Art Gallery, London: **6–7**,

Wendell Burnett: **71**b

Caruso St John: **54**r

David Chipperfield: **56**

Corbis: **9**, **10**, **12–13**, **17**, **19**, **20–21**, **114**

Daniel Dethier: **32**b

Daniel Dethier/Jean Paul Legros: **22–23**, **32–33**, **33**b

Lyndon Douglas/Architect: Adjaye & Associates: **168**tl, **169**

Esto Photographic/Peter Aaron: Architect: Carlos Zapata: **46–47**, **58–59**, **60**, **61**tr; Jeff Goldberg/Architect: Rick Joy: **140–141**, **156**, **157**, **158**tl, **158**tr, **159**; John Gollings/Architect: Glenn Murcutt: **142–143**. **144**, **145**tl, **145**tr; Robert Schezen/Architect: Carlos Zapata: **61**tl

Earl Forbes/Architect: Alan Jones: **52–53**, **52**b

Frank Gehry: **116**b

Sean Godsell: **36**b

Sean Godsell/ Earl Carter: **36**t, **37**

Luis Gordoa/Ten Arquitectos: **34–35**

Grafton Architects: **81**

Hiroyuki Hirai/ Shigeru Ban: **28–29**, **30**, **31**tl, **31**tr

Steven Holl: **95**, **96**b

Tim Hursley/Architect: Wendell Burnett: **70**, **70–71**; Scogin Elam & Bray: **62–63**, **64**tl, **64**tr, **65**

Alan Jones: **53**b

Rick Joy: **158**b

Nicholas Kane/Architect: MVRDV: **150–151**, **152**tl, **152**tr, **153**

Annette Kisling/Architect: Sauerbruch & Hutton: **77**

Lucien Le Grange: **154**b

Ronnie Leviton/Architects: Lucien Le Grange: **154**t, **155**

Lyons Architects: **86**b

Christoph Mackler: **98**

Duccio Malagamba/Architect: Rafael Moneo: **106–107**, **134–135**, **135**

Daniel Malhao Fotografia/Architect: Manuela Rocha de Aires Mateus: **132**, **133**

Mein Photo/Architect: Lyons: **84**, **85**, **86**, **86–87**, **87**b

Denance Michel/Architect: Renzo Piano: **40**, **42**tl, **42**tr, **43**

Miralles & Tagliabue: **139**b

Rafael Moneo: **134**b

Eric Morin/Architect: Miralles & Tagliabue: **136**, **137**, **138**, **139**tl, **139**tr

Harald Muller/Architect: Gigon Guyer: **92**, **93**,

Glenn Murcutt & Associates, Wendy Lewin Architect & Reg Lark Architect: **142**b

MVRDV: **151**

Nacàsa & Partners/Architect: Toyo Ito: **2**

Koji Okamato/Architect: Hiroyuki Arima: **48**, **48–49**, **50**, **51**tl, **51**tr

OMA/Rem Koolhass: **147**

Paramount courtesy the Kobal Collection: **16**

Renzo Piano: **41**

Marvin Rand/Architect: Pugh & Scarpa: **170–171**

Christian Richters: **5**; Architect: Frank Gehry: **116–117**, **118**, **119**tl, **119**tr

Richard Rogers Partnership: **102–105**

Simone Rosenberg & Matthias Broneske/Architect: Hoger Hare: **124–127**

Philippe Ruault/Architect: Jean Nouvel: **38–39**

Hiro Sakaguchi/Architect: Toyo Ito **44–45**

Sauerbruch & Hutton: **74**

Scogin Elam & Bray: **63**b

Vaclav Sedy/Architect: Gmur & Vacchini: **160–161**, **162**tl, **162**tr, **163**

Jussi Tiainen/Architects: Viiva: **25**, **26**, **27**tl, **27**tr

View Pictures/Peter Cook/Architect: Herzog de Meuron: **66**, **67**, **68**, **69**; Architect: Ortner & Ortner: **108**, **109**, **110–111**, **111**; Architect: Michael Wilford: **121**, **122**, **123**tl, **123**tr; Dennis Gilbert/Architect: Benson & Forsyth: Front Cover, **129**, **130**, **131**tl, **131**tr; Architect: David Chipperfield: **56–57**, **57**b; Architect: Grafton: **80–81**, **82**tl, **82**tr, **83**; Architect: Daniel Libeskind: Back Cover, **113**; Richard Glover/Architect: Alsop & Stormer: **72–73**, **88–89**, **90**tl, **90**tr, **90–91**; Paul Rafferty/Architect: Le Corbusier: **18–19**;

Viiva Architects: **24**

Paul Warchol Photography/Architect: Steven Holl: **94–95**, **96**tl, **96**tr, **97**,

Hans Werlemann/Architect: OMA/Rem Koolhaas: **146**, **146–147**, **148–149**, **149**

Michael Wilford: **120**

Takashi Yamaguchi: **78–79**

Carlos Zapata: **61**b